Pastel Painting
Workshop

ALBERT HANDELL
and Leslie Trainor

Pastel Painting Workshop

WATSON-GUPTILL PUBLICATIONS/NEW YORK

This book is dedicated to my beloved Leslie.

First Paperback Edition, 1988
Copyright ©1981, 1988, by Albert Handell and Leslie Trainor.
First published 1981 in the United States and Canada by Watson-Guptill Publications,
a division of Billboard Publications, Inc.,
1515 Broadway, New York, N.Y. 10036

Library of Congress Cataloging in Publication Data

Handell, Albert, 1937–
 Pastel painting workshop.
 Bibliography:p.
 Includes index.
 1. Pastel drawing—Technique. I. Trainor,
Leslie, 1949– II. Title.
NC880.H35 1988 741.2′35 81-10315
ISBN 0-8230-3903-X
ISBN 0-8230-3904-8 (pbk.) AACR2

Manufactured in Japan

2 3 4 5 / 92 91 90 89

Contents

Introduction

Pastel Painting Workshop is a comprehensive guide to pastel painting that can be of use to both the beginner and the advanced student or professional. If you're new to the medium, you can work your way through the book, progressing from the basic information to more complex techniques. If you're already experienced in the medium, you can refer at random to specific chapters for answers to questions.

The material is divided into two sections: six chapters of basic information on pastel, followed by eight demonstrations. Chapter 1 deals with the media itself: its advantages and permanency, types of pastels available, various surfaces pastel can be painted on, working indoors and outdoors in pastel, and so forth. Chapter 2 describes the necessary equipment in setting up a pastel painting studio, including a lengthy discussion of lighting. The third chapter demonstrates various techniques used in applying pastel, from simple linear strokes to more complicated strokes requiring varying degrees of pressure, all designed to increase the range of each pastel color. Chapter 4 discusses essential painting concepts common to all media and describes basic pastel painting procedures such as building up a surface gradually in pastel and working light pastels over dark. The importance of color seen as value, the magic achieved by massing large areas together, and the use of various types of edges are also discussed and illustrated. Chapter 5 examines mixed-media techniques, where pastel is combined with other painting media to increase its range of effects. For example, pastel can be changed to a paint quality by washing turpentine over it. It can also be applied over underpaintings of various washes of opaque and transparent media. Chapter 6 is about color, first discussing basic color terminology, then describing color as it specifically relates to pastel, including information on organizing a pastel palette.

The second half of the book contains eight demonstrations, each showing a different way to apply the medium and involving a different subject, both indoors and outside the studio. The subjects painted include portraits and a self-portrait, a figure in an interior, trees, rocks and rushing streams, waterfalls, fields, barns and mountains, all painted in various seasons. Each painting is composed differently, and the introduction to each demonstration explains in great detail the composition, technique, lighting conditions, colors selected, foreground-background relationships, and other essential basics. Except for the first demonstration (on values), all demonstrations are in color and progress logically from the simplest pastel concepts involving value and color temperature manipulation (Demonstration 2) to the more complex techniques using a mixed-media underpainting and interplaying it with subsequent layers of pastel (as in Demonstration 8).

Since the time of Degas, the universally acclaimed master of pastel, the medium has been relegated to a secondary place and considered less permanent and less important than oil. Artists began to use pastel in preliminary studies for more serious works in other media, rather than as an end in itself. And since many of the earliest work done in pastel was weak in tone and color, the medium had also acquired a reputation for being incapable of powerful, lasting works.

Fortunately these ideas are changing. We now know that pastel is a very permanent paint medium, in many respects more so than oil. We also now know that a full range of rich dark tones is easily possible to achieve with pastel, and the range of beautiful pastel colors available today is unsurpassed by those in any other painting media. Pastel today is enjoying a renaissance, with many excellent artists doing their major work in the medium.

Until recently, pastel was officially or unofficially

designated within the watercolor category in major annual exhibitions throughout the country. Because it was believed that pastel paintings were not accepted in some major annuals simply because they were pastel, in 1972 a group of artists working in the medium decided to organize the Pastel Society of America. The society was an immediate success and today is a thriving organization with an extensive membership throughout the country. Each September, the society holds its annual exhibition for pastels only in the galleries of the famous National Arts Club in New York City. A visit to this exhibit is a must for any pastel enthusiast.

Although only eight years old, the Pastel Society of America's annual exhibition is one of the best shows of its kind in the nation. I was delighted and honored to be asked to be one of the judges of the first exhibit. I have since judged and demonstrated my pastel techniques in subsequent annual shows, and now make a point of exhibiting in their show every year.

The interest in pastel is very strong now and continues to grow, and the Pastel Society of America and recent publications on pastel have contributed a great deal to bringing the medium into the forefront. As a result of my personal involvement in pastel, I have been requested by universities, museums, and art associations to travel to major cities to give pastel demonstrations, workshops, slide shows, and lectures. Collectors are also investing in pastel painting now more than ever before. All this is proof that pastel as a painting medium is truly enjoying a renaissance.

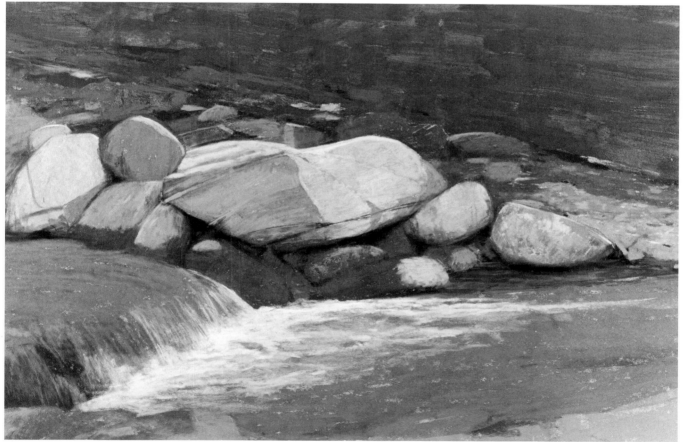

ALONG THE SAWKILL. *Sanded pastel board, gray-tone, 16 × 22" (41 × 56 cm), collection Mr. and Mrs. William Leggett.* This painting gave me the opportunity for an intriguing way to mix media. Working on location on a gray-toned ground, I blocked in and painted most of the rocks and gushing water of the lower two-thirds of the painting in pastel. I left the upper third of the pastel untouched. Back in the studio, I decided to paint the upper third of the painting with diluted casein colors. I used three colors for all of the color mixtures: burnt sienna, cadmium purple, and chrome oxide green deep (all Shiva casein colors). At times the purple showed up as the strongest color, at other times it was the green or the burnt sienna. These colors added a wonderful sense of color to the painting. When washing in the diluted colors, I brushed in the direction of the movement of the rocks and water. The following day, back on location, I painted only a few of the receding rocks of the streambed on top of the casein color wash with pastel, leaving the casein underpainting to show in the rest of the work. The pastel unified the two areas. (Note the subtle transition from casein to pastel in the rocks.) Mixed-media effects will be described in greater detail in Chapter 5.

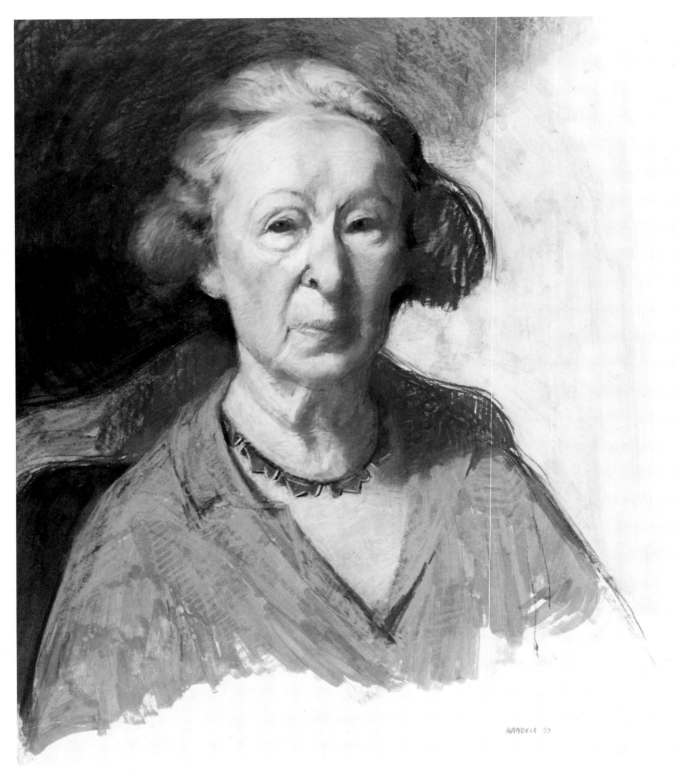

PORTRAIT OF MIMI. *Sanded Pastel Board, 18 × 20" (46 × 51 cm), collection Lucretia Woods Wycoff.* Here is a powerful portrait of my friend Mimi, her expression caught at a special moment. The strong patterns of light and shadow help give the expression its underlying strength. The portrait was painted on a light-toned, sanded pastel board. The red blouse and background were underpainted in rich washes of transparent watercolor, which showed up beautifully on the light buff ground. I then worked on top of the red transparent watercolor blouse, using warm, opaque red pastel colors of the same value. The strong reds of the blouse also reflect into the face, chin, and neck areas and can easily be seen in the shadows of these areas.

Part I
About Pastel

What Is Pastel?

Pastel is colored chalk, composed of powdered pigment plus a binder, usually a solution of gum tragacanth. It is available in a broad range of colors and various degrees of hardness, from soft to semi-hard and hard. The colors used in pastel are the very same pigments used in other paints. Thus a pigment mixed with a solution of gum tragacanth makes a pastel, mixed with gum arabic it makes watercolor, and mixed with linseed oil it makes oil paint.

The degree of hardness or softness of a pastel is determined by the amount of binder. Soft pastels contain just enough binder to keep the pastels in stick form and prevent them from crumbling apart as they are applied to a surface. But hard pastels have a stronger binding solution. The hardness of the particular pigment, plus the mold pressure upon the stick during manufacture, also influence the varying degrees of hardness and softness.

Some pastels (usually the soft) contain talc, clay, or gypsum as an extender, which also serve as whiteners. This is why the soft pastels have so many lighter shades, while the hard pastels are mostly darker colors, for they contain little or no whitener.

Advantages of Pastel

Unlike other painting mediums, where oil or water is the base, pastel is a dry paint. The result is that when pastel color is applied to your painting, you immediately see the color as it will look always. There is no drying time involved, with its inherent potential color changes and its annoying interruptions to your work. Pastel allows you to work quickly, continuously, and for as long as you wish. Pastel also avoids the problems of oil or watercolor, where the wet colors may sink into the surface as they dry. In pastel, your colors will always remain as fresh and vibrant as they were when first applied. They also will not become brown or brittle with age, as oil colors may.

You also have an enormous color range to choose from in pastel, especially in the lighter values. The colors have a beautiful purity and most of them are very stable. Since they don't sink into the surface and get dull when they dry, like oil paint, you never need to bring out their true colors with varnish. Matching colors is no problem either. You simply pick up the same pastel stick each time.

Another exciting advantage to pastel is that it is both a drawing and a painting medium, which is of particular value to artists who are proficient in both media. The many different types of application and surfaces afford tremendous textural variety, from delicate lines to a blanket-type effect (see Chapter 3). Pastel also offers the opportunity for quick, spontaneous work—for using rapid, decisive strokes that capture the essence of a transitory moment. On the other hand, pastel can also be used for a more lengthy, planned composition, allowing a work to be built to a finish as detailed as any medium.

Another consideration in choosing pastel as your medium is that, unlike oil paint, which must be varnished, pastel requires no special aftercare. And since pastel paintings are framed under glass, they are well protected and in that sense more permanent than oil paintings. Pastels are also easy to set up, easy to clean up, easy to store, easy to care for, and portable.

Types of Pastel

Pastel comes in three different forms: hard chalks, soft chalks, and pastel pencils. Each of these three different types of pastel produces its own particular range of textures.

Hard Pastels. Hard pastels are usually rectangular in shape, and their firmness permits lines to be drawn with them. They are also especially good in the early stages of a work because less pastel comes off the stick when using them, so the tooth

or grain of the paper doesn't fill up as quickly. This makes repeated overpainting possible and allows you to control the painting's development. In the beginning stages, the colors can also be easily brushed off with a stiff brush or rag if applied lightly, allowing for corrections and adjustments to be made easily. Hard pastels are very effective used interchangeably with soft pastels and pastel pencils throughout the development of the picture, and are excellent for sharp, delineated details in the later stages of a painting.

To use hard pastels, you can snap the sticks in half—each of the four corners making a useful point, or they may be sharpened to a point with a razor blade. I often begin my pastel paintings with hard pastels no. 293-P Sepia or no. 209-P Warm Dark Gray, and gradually develop the work by intermixing them with soft pastels and with pastel pencils.

I use Nu-Pastels, made by Eberhard-Faber, and there are 96 colors in this series. Carb-Othello also has a beautiful range of colors in both hard pastels and pastel pencils. I use their pencils, but find their hard pastels a little too hard for my needs. The Conté Company also makes crayons (hard pastels). Although they're not too hard for my purposes, they do come in a limited range of colors. Conté makes a fine set of grays, however, in a range from very light to very dark gray, that I think is worth trying.

Soft Pastels. Soft pastels are usually round in shape and fatter than hard pastels. Since they are made with less binder and more pigment, they create soft, more easily smudged strokes. The degree of softness, however, varies with the brand. I prefer the Rembrandt soft pastels made in the Netherlands by the Talens Company, which are neither too soft nor too hard. Grumbacher soft pastels (which at one time were round) are now square in shape. They are harder than the Rembrandt pastels, which I feel alters the special qualities of soft pastels. Other brands of soft pastel available are Weber, the German Schmincke, and the French Lefranc-Giroult. All are excellent, but experiment with these brands to discover the degree of softness and texture most suitable to your own painting objectives. (Recipes for making your own pastels are in the Appendix.)

The range of colors available in soft pastels is extensive. There are sets containing from twelve to several hundred colors. All the above-mentioned brands contain a large assortment of colors, and the Rembrandt pastels in particular are easily replaced on an individual-stick basis. The smooth, thick quality of soft pastels provides rich, broad, painterly effects. I intermix them with hard pastels as I develop a painting. They are excellent for covering the surface and defining rich color areas. (I will discuss Rembrandt pastels in more detail in Chapter 6.)

Pastel Pencils. Pastel pencils are unbeatable for finishing details, since you can produce sharp thin lines with the point and side of the point. In the early stages of a work I sometimes like to draw with them, combining the drawing and painting qualities unique to the pastel medium. They are superb for small pastels (9 × 11"—23 × 28 cm). As an experiment, I have painted entire portraits using only pastel pencils (see portraits of Steve Mercer and Bill Manly on pages 76–77).

Several brands of pastel pencils are available (and information on making your own pencils is in the Appendix). I use the Swan Carb-Othello 1400 series, intermixed with Conté pencils. Other colored pencils on the market have too much wax in them, which prevents their intermixing properly with the hard and soft pastels on the surface. To test pencils for suitability, scratch the tip of the color with your fingernail. It must feel chalky, not waxy, for pastel painting.

Choosing a Surface

In choosing a surface to work on, three important factors will directly influence your pastel painting techniques and procedure: its tooth (roughness or smoothness of the surface); its value and tone (light, middle, or dark); and its color (warm, cool or neutral).

Tooth. The expression "tooth" implies that the surface has two levels, a high and a low. (With only one level, the surface would be smooth, like a piece of glass.) When pastels are applied to a ground that has tooth, the pastel adheres to the surface by digging into the ridges or grooves (tooth) of the surface. As the tooth fills up, however, the surface becomes smoother and smoother. Since it is no longer able to hold onto new layers of pastel, the pastel begins to flake off. Thus the finer the tooth, the fewer layers of pastel the surface can take, and the less overpainting (layers of pastel applied over pastel) that can be

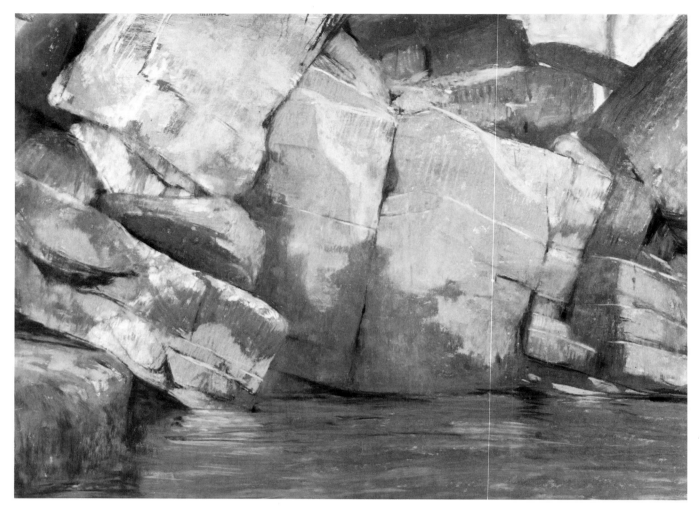

ROCKS ALONG THE SAWKILL STREAM. *Sanded pastel board, 16 × 22" (41 × 56 cm), collection the artist.* I discovered these rocks, all covered with dark green moss and light pink lichen, when they were illuminated by the cool overhead light found in the shadows of a waning summer's afternoon. Since the subject is in the light of a delicate cast shadow area, the value range in this painting is limited. All the colors are quite cool in temperature, except for the bright yellow in the upper right-hand corner of the painting. I wanted to create a sense of space and color contrast, so I used this small bright area to suggest sunlight and distance behind the rocks.

done. On the other hand, the rougher the tooth, the more pastel layers that can be applied, and the greater the amount of overpainting that is possible. The texture of the rougher tooth also often shows through in the finished work, adding special interest and beauty.

While working, to check if the tooth is filling up too much, tap the back of your board to see if the pastel is holding to the surface or flaking off. If it is flaking off just slightly, then a light spray of pastel fixative could help nicely. But if the pastel is flaking off a lot, some of the existing layers of pastel will need to be brushed off or scraped off with a single-edge razor blade before the pastel can be reworked. To scrape off excess pastel, hold the razor blade *flat* to the surface and gently scrape downward. Don't use the edge or sharp corner of the razor, as this can scratch into the surface.

Value and Tone. The word "value" refers to the degree of light and dark in a color, while the term "tone" refers to a color's intensity or saturation. If

you were to take a black-and-white photograph of a typical scene, its tones and colors would be translated into black, white, and many shades of gray—from very light to very dark. Thus light, bright colors like yellow would photograph as light grays, deep colors like ultramarine blue would photograph as dark-value grays, and bright oranges and reds would appear as medium grays.

Pastelists frequently work on toned paper. The tone you work on can be either a lighter value of a color—which is called a "tint"—or a medium or darker grayed color—known as a "shade." (Artists seldom work on a pure, intense-colored surface.) It is important to choose the tone you work on with care because its color (tint or shade) and its value (whether it is light or dark) will affect the overall value relationships established in the beginning of your pastel, and will be the basis for building later stages of your pastel, too. More will be said about this later.

Middle-Value Tones. If you have not had much experience with pastel, I suggest that you work on a middle-value tone, where the color is neither too dark nor too light. This will permit you to establish both your light and shadow values early, since both can easily be seen on this background and thus quickly related. Middle-value tones in the Canson papers I like to work on are: no. 336 Sand, no. 354 Sky Blue, no. 426 Moonstone, no. 429 Felt Gray, no. 431 Steel Gray, no. 502 Bisque, no. 504 Amber, and no. 503 Burgundy.

Light-Value Tones. Light-toned surfaces are best when you want to immediately point out and establish dark and middle values, for light-value tones and colors don't show up well on light papers in the beginning of a work. Light-value Canson papers I like to work on are: no. 340 Oyster, no. 343 Pearl, no. 350 Honeysuckle, no. 374 Hemp, no. 384 Buff, and no. 480 Light Green.

Dark-Value Tones. Just as light values don't show up well on light-toned papers, dark colors don't show up well on dark-toned papers. In pastel painting, you work on dark tones so you can establish light and middle-value areas very quickly. In this instance, the dark tone of the paper can be left unpainted, to serve as rich dark shadow areas. Dark-toned Canson papers I like to work on are: no. 345 Dark Gray, no. 448 Ivy, no. 500 Dark Blue, and no. 501 Tobacco.

Color. Besides the value of your paper, its actual color (hue) and temperature—whether it is warm, cool, or neutral—can affect the development of your pastel. I have worked on backgrounds of all values and colors, and have come to prefer, for most work, a middle-value, neutral (gray) background, because it is easily adaptable to most subjects.

As I mentioned earlier, many colors can have the same value. For example, many browns, grays, greens, and purples could be middle-value tones. Experiment with several different variations of the same color, including warm, cool, and neutral, to see how the same pastels will look on different-colored backgrounds. For instance, take several sheets of paper of different colors at a middle value, such as a bright purple, a dark green, and gray. You will note that as the different colors of the papers vary, so does the intensity of the individual pastel colors when applied to them. Try many pastel colors on these surfaces to see their effects. The same colors will look different in each instance. The Mi-Teintes Canson papers are best to experiment with in this manner, as they come in a wide selection of at least thirty different colors.

It is important to remember that even if the surface eventually will be covered, the color of the paper will still make a difference. This is because in the initial color block-in of the pastel painting, the way your colors appear will be affected by the color of the paper. Of course, the color of the paper is all the more important when the work is a vignette, for here the initial color of the paper will be part of the final effect.

Pastel Papers
There are many different types of pastel surfaces. The most commonly used are the Canson Mi-Teintes pastel papers, sanded pastel papers, and granular pastel boards.

Canson Mi-Teintes Paper. The Canson Mi-Teintes pastel papers are the most widely known and used and the papers most readily available in art supply stores throughout the United States. They are manufactured in France by the Canson-Montgolfier Paper Company of Vidalon, France, known for fine-quality papers since 1557.

Mi-Teintes means "many tints" in French, and this heavy-weight fibrous paper comes in over thirty different colors. It is also available in three different sizes: 19 × 25″ (50 × 60 cm), 21 × 29″ (55 ×

75 cm), 29 × 43" (75 × 110 cm), and 11 yard × 51" (10 m × 130 cm) rolls of individual colors, so it is possible to work as large as you wish. To make the papers more durable, you can dry mount them on wooden (Masonite) panels or 100% rag, acid-free museum boards. Toned mixed media washes (see Chapter 5) can then be successfully applied. The tooth of the paper can also be manipulated by brushing on gesso mixed with marble dust, or by brushing on the gesso first, then sprinkling some marble dust onto the surface.

Sanded Pastel Paper. I primarily work on sanded pastel paper. It has a sturdy, granular surface that comes in a variety of rough and smooth textures. I usually use Snuffingpapier, which is made in Germany by the Ersta Company and distributed by Grumbacher in the United States. The grit is no. 710 for the smooth and no. 510 for the rough. (The rough is only a bit rougher than the smooth.) The paper comes in one size—22 × 28" (56 × 71 cm)—which I can cut into smaller sizes—and in one color—buff—which can be easily toned. (Toning is discussed in the Appendix.) In the past, this paper was made as a board, but this has become increasingly hard to get. However, you can have the same sheet of paper dry mounted onto 100% rag, acid-free museum board with excellent results.

The Morilla Company also has a sanded pastel paper. Made by the 3M Company, it is a flint paper, 22 × 32" (56 × 81 cm) large, and buff in color, which is also easily toned. It has a no. 280 grit, which is somewhat rougher than the Grumbacher paper.

I also use two sanded papers (actually cloths) that are not available in art supply stores, which I obtain on special order through a hardware store. Both are manufactured by the 3M Company.

1. Tri-M-Ite wet or dry, A-weight, waterproof silicon carbide, 600 grit. A very dark gray.
2. Three-M-Ite, Elek-Tro-Cut, J-weight, aluminum oxide, grits 400 (smooth) and 320 (very rough). This paper is actually a cloth. It comes in a lovely middle-value gray.

These cloth papers can be purchased in hardware stores in 9 × 11" (23 × 28 cm) sheets. Larger sizes can be specially ordered in 50 yard × 36" (45.5 m × 91 cm) rolls. But this is feasible only if a large group of artists are splitting the cost.

Velour Paper. Velour paper is a heavy-duty, good-quality paper, available through the Morilla Company in individual sheets or pad form. It comes in one size, 20 × 26" (51 × 66 cm) and in eighteen colors plus white. A characteristic of this paper is that when the colors are applied to the surface they fan out or "run." This creates a "fuzzy" effect that some artists like. I personally don't care for the effect, though.

Other Papers. Many other papers can be used for pastel painting, but all to a more limited degree than those mentioned above. Some charcoal papers like the Michelangelo, Gainsborough, and Strathmore papers can be used, but I feel that they are too lightweight to withstand lengthy pastel work, and that their tooth is too smooth. Watercolor papers and mat boards also can be used, but only to a limited degree because they don't have sufficient tooth to hold many layers of pastel. Much individual experimentation can give you insight into these surfaces and help you to discover your own personal preferences.

Marble-Dust Boards

Granular pastel boards are also a popular pastel surface. Until 1966, fine-quality marble-dust boards were made by the Weber Company of Philadelphia. They were rugged, heavy-duty boards, with a rough, even surface. White in tone, they could be easily stained and were ideal for many layers of pastel and for mixed-media pastel painting. I used to start my pastels with very diluted underpaintings of oil paint and turpentine, or with casein, tempera, or other water-base media, and work on top of it with many layers of pastel, fixing each layer with a spray.

Although marble-dust boards are no longer commercially available, they can be made at home with equally good results. (Instructions for making this excellent surface are in the Appendix.)

Other Surfaces

I work now almost exclusively on sanded pastel papers and boards and at times on paper or marble-dust boards, but you may like to experiment with other less-common surfaces.

Pastel Canvas. The Grumbacher Company makes a pastel canvas of cotton duck with marble dust sprinkled onto a white gesso ground. It comes in

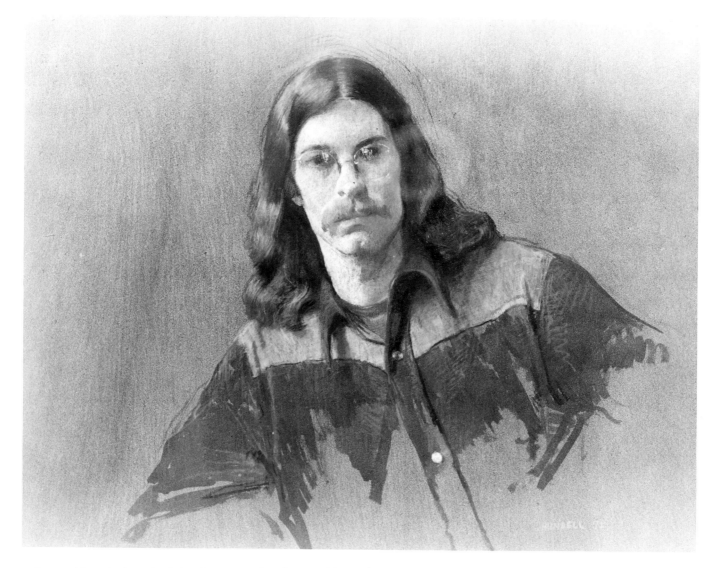

rolls and has to be stretched on wooden bars with a piece of cardboard placed between the bar and the canvas to make a rigid support. The excess dust, which loosens in the handling process, needs to be brushed off before the surface is ready to work on.

Linen, Parchment, Vellum, and Muslin. All of these are possible surfaces for pastel, but I don't recommend them because they are not permanent and are less sturdy than the more traditional surfaces.

Pastel Fixative

Pastel fixative is a thinly diluted varnish that is sprayed onto the pastel at various stages of work to secure the particles to the surface. Used correctly, fixative can be an aid to your work, allowing

PORTRAIT OF JERRY DAVIS. *Sanded pastel board, 24 × 28" (61 × 71 cm), courtesy Capricorn Gallery, Bethesda, Md.* In this delicate portrait, the brush strokes of the mixed-media underpainting of the shirt in diluted casein can still be seen. The portrait itself is pastelled over a middle-value gray-toned background and kept as a vignette. Note how the eyeglasses were literally "dropped in" over the underlying portrait and eyes. I like the challenge of painting eyeglasses. Also, eyeglasses are an important part of the sitter, and I prefer to paint people who wear them with them on. I know that Jerry would not be Jerry as he usually is without his glasses. He would have difficulty seeing without them, too, and his eyes would take on an unusual squint. Also, notice that while there are strong light and shadow patterns on Jerry's face, the values and edges within each area remain delicate and soft.

you to put more layers of pastel on your painting surface. For instance, if after tapping the back of your drawing board lightly, you find a minute amount of pastel flaking off, spraying at this point can be very helpful because it will adhere the particles to the surface and stop the flaking. In this situation, the fixative works as a glue of sorts, allowing you to extend your working time. But fixative won't compensate for flaking that is due to unsound initial pastel application.

To spray a pastel painting, stand about 3 to 4′ (about a meter) from your picture. Leave the painting upright (never lying face up) and with a steady pressure, spray the work gently, moving your hand at all times so that the spray falls evenly and lightly over the entire surface in a delicate arc. It is important to constantly move your arm so that the spray doesn't build up in one spot, or the excess fixative may either start to drip or darken your picture unevenly.

Because spraying a pastel will darken the colors of your pastel painting, I usually spray fix my pastels for the last time, sparingly, fifteen minutes before I think the painting will be completed. I then work over the pastel with no further fixing to keep the colors as fresh as possible. There may be times, however, when you want the darkening effect either on the whole pastel or sections. In that case you can spray the work as much as you want.

In fact, there are no set rules for spraying. The surface, the type of pastels you use, and the way you work all influence the amount you need to spray.

All brands of pastel fixatives on the market are good. I use Blair Spray Fix and Grumbacher Tuffilm, but you can also mix your own fixative (see Appendix) and spray it on with an atomizer. You can also dip your pastels into the liquid fixative before applying them to the paper for interesting results. Experiment with various surfaces and pastels, spraying at different times, and carefully observe the effects you achieve. Experience will teach you a great deal about the use of fixatives.

Drawing Board

Almost any firm, even surface (with no lumps, bumps, or knots) can serve as a drawing board to rest your work on. You can purchase commercial drawing boards in any art supply store for this purpose or use a Masonite board. However, I prefer a more lightweight and relatively soft (though still firm) drawing board, like Homasote. Homasote is inexpensive and comes in 4 × 8′ (1.2 × 2.4 m) sheets, ½–1″ (13–25 mm) thick. It is used for sound insulation in home construction. For a few extra dollars you can have it cut at the lumberyard into the sizes you most often use. I recommend that your drawing boards be a minimum of 1″ (25 mm) larger all around than the painting surface mounted on it, and larger still for easy flow of eye and hand.

Having the correct size board is important for two reasons. First, technically, if the paper overlaps the edge of the board, it cannot be held flat and securely to the board, and you will get waves or wrinkles. This uneven surface will interfere with the application of pastel, preventing the chalk particles from adhering to the surface and making your work vulnerable to the slightest shock. Second, aesthetically, you may find that your work may look better if you have more of a border. A 6″ (15 cm) piece of board, for instance, will act as a frame for your taped-down paper. A large border will prevent your imagination from being cramped, as narrow, impending borders might, and mentally you will be able to draw right "off the page." That is, your stroke will continue with the flow of certain lines, movements or rhythms that extend beyond the edge of your paper.

Being inhibited by the paper's edge is a common problem of students, who work toward the paper's edge as if it were a cliff they might fall off. The result of their fears are two student diseases I call "borderitis" and "sizeritis." Faced with the limitation of the borders, and spurred on by a desire to try to get the "whole world" onto an 18 × 24″ (46 × 61 cm) sheet of paper, at first the student with "borderitis" works well in the middle of the page with relatively good proportions. But as the edge of the paper is approached, the proportions of objects usually become more cramped and the relative sizes of things become smaller, sometimes much smaller, causing serious proportion problems ("sizeritis"). This problem is caused simply by a fear of being decisive when it is time to cut off a subject at the edge of the paper. In the attempt to get everything in, the student then compounds the problem by changing the correct proportions that were first established at the center of the paper. When I point this out, the student is usually amazed.

To correct the problem, I have the student remount the paper on a much larger drawing board (with at least 6″—15 cm—margins all around), and

tell them to draw "off the page," using the drawing board itself as a continuation of the paper. This immediately creates a new freedom. The student begins to draw more free-flowing lines, loosening up and improving the proportions throughout. The larger board also allows imagination and inspiration to flow uncramped.

Mounting Papers to the Drawing Board. When mounting a paper to the drawing board, whether it is Canson Mi-Teintes pastel paper or a sanded pastel paper, always place a second sheet of the *same size* as a bedding under the sheet you intend to work on. This is important because the surface you are working on should have some "give," so it can receive your colors as you dig into it with your pastels. Thus the second sheet acts as a cushion. But make sure that the lower sheet of paper isn't smaller than the top sheet, for the edge would then show through as a line as the work progresses.

There are three basic methods of mounting pastel surfaces to drawing boards: clipping, pinning, and taping. I prefer taping, for it allows me to secure every edge of my surface and there is no movement of the surface while I am working. Also, the lightweight Homasote drawing boards I use don't take clips and pins well. The tape doesn't damage the painting surface because it is only used on a ½″ (13 mm) border at the edge of the paper, and that will be covered when the pastel is framed.

You can tape your papers to the drawing board in the following manner: Take two sheets of the same size paper and, making sure they are lined up evenly, place them face up on a drawing board at least 1″ (25 mm) or larger all around. Also make sure your papers are parallel to the sides of the drawing board, which is properly squared. Don't mount the papers at an angle, or it will confuse your eye. Next, take 1½–2″ (38 to 50 mm) masking tape and secure all four corners with small pieces of tape. This will temporarily pin your papers to the board as you check to see if everything is squared, even, and level. Then take four longer strips of tape (approximately 6″—15 cm—in length) and place them in the middle of each side of your paper, allowing ½″ (13 mm) of the tape to overlap the paper, and letting the remainder of the tape grip the board, always checking that the paper is squared and flat. Now remove the four temporary corner pieces and with longer strips,

tape the remaining edges to the board. Always work from the middle toward the edge to avoid even the slightest buckle. Although you should have no problem with ripples if you follow this procedure, if there are any ripples, simply remove the tape and begin again.

I always stress taking a few extra moments to mount your papers well. I often observe students slapping their papers onto their boards in a rush and beginning to work with edges flapping in the air. Before long, within the hour in fact, they inevitably have problems with flaking pastel. Their only remedy now is to tape the paper securely to the drawing board, as was originally suggested.

Framing Pastels

Pastels must be framed under glass to protect them from being smudged or damaged. Once they are properly framed and sealed under the glass, they are no longer susceptible to smudging or to damage by water and are as permanent as a painting done in any other medium.

When framing a pastel under glass, it is important that the glass not touch the pastel, since the pastel could adhere to or smudge onto the glass. The pastel is therefore separated from the glass by an insert, mat board, or piece of stripping. The glass is secured in front of the insert (between the molding and the insert), and the pastel is secured behind the insert. It is the insert, in turn, that holds the pastel in place. It is best to use clear glass in framing a pastel, except for shipping, when heavy nonbreakable plastic, such as Plexiglas or Lucite, can be substituted.

Nonreflective glass should not be used when framing a pastel for two reasons: (1) Nonreflective glass must touch the pastel in order for it to work and (2) nonreflective glass tends to dull the colors and cast a cloudiness over the painting. On the other hand, Plexiglas, which is a plastic, can be used, especially if the picture is to be transported and moved around a lot. Care must be taken, however, as it scratches easily. Beware also that Plexiglas has an electromagnetic charge which must be eliminated with the proper solution before framing. If not removed, the charge can pull the pastel from the surface like a magnet.

Also avoid jarring or bumping the pastel, which could cause flaking. Remember that to some degree or another, pastels are vulnerable to shock even when framed. And keep the painting away from moisture. For instance, never hang a pastel

over an old-fashioned steam radiator. Under normal conditions, within the protection and environment of your home, however, colors in framed pastel paintings are permanent.

Transporting Unframed Pastel Paintings

Since pastels are vulnerable until they are framed under glass, transporting unframed pastels is best avoided if possible. If shipping is unavoidable, however, the vulnerabilities of the medium can be minimized. If you are transporting six or eight pastels or more, a good procedure is to tape the pastels securely to one side of a large open portfolio. Make sure your portfolio is larger than your pastel painting. Each painting should be secured individually by taping it to the portfolio around the edges before the next one is placed on top. If all the sheets are the same size, place the next sheet on top facing the same direction (front to back). If they are not the same size, then place a clean sheet of protective paper between the pastels. When you're done, close the portfolio and tie or tape it together securely so that there is no movement. Lie the package flat face up when traveling and *do not place* any heavy weight on top of it.

Transporting Framed Pastel Paintings

If you're shipping a framed pastel, have a *solid* crate made. Then stuff the crate with wrinkled paper or foam so that the painting is literally floating on air and is protected from shock. If the picture is framed with glass, the glass should be taped diagonally with masking tape, so that if the glass breaks, it won't shatter into the picture. To be 100% safe, I recommend replacing the glass with unbreakable Plexiglas when shipping a painting in a crate.

If transporting a framed pastel by car yourself, lay the pastel face up in the trunk on 1″ (25 mm) foam padding to protect it from shock, or wrap the entire painting in 1″ (25 mm) bubble foam, which comes in rolls. Always make sure the pastels are face up. The pastels can be stacked one on top of another, with foam in between for added security.

Storing Unframed Pastels

When storing unframed pastels, it is important to protect them from smudging, the most common way an unframed pastel is damaged. One way to avoid smudging is by storing them in a portfolio in the same manner as described for transporting unframed pastels. The portfolio should be kept flat, on its side. This will store your pastels but can be inconvenient if you need to take the pastels out often to look at them or show them.

A second way to store unframed pastels, if you have the space, is to attach each one to a rigid support like a drawing board and stand them against the wall in painting racks. (I use ¼ or ½″—64 or 127 mm—plywood for this purpose.) Just make sure the drawing boards are larger than the sheets of paper you are working on.

A third way to store pastels is in large flat drawers such as map drawers, again with protective paper between each one.

The Studio

Working indoors in a studio allows you to have everything you need at your fingertips. But setting up a well-equipped studio will require consideration of many factors.

Lighting

The most important element in an indoor studio is the quality of the lighting, whether it be natural or artificial.

Natural Light. I prefer a steady, cool north light, with no direct sunlight. The sun is so brilliant and strong that if my studio faced south, for instance, the sunlight would not only alter the appearance of objects as it constantly moved, but it could obliterate or at least throw off the delicate local colors of objects. It is only under the steady, gentle north light that the true forms and local colors of objects can best be seen and studied.

There are several types of north light: (1) a skylight in the roof, at a 45° angle, (2) a high, straight wall, with windows facing north, and (3) a combination of both. All light should come into the studio from one direction, not two, to give your objects strong sculptural light and shadows.

I have worked in many studios during my career and have painted under all three types of north light and personally prefer Type 2. In Type 2 lighting, the windows should be blocked off with black curtains five feet (about 1.5m) or so from the floor and go as high as the physical properties of the studio allow. Windows starting lower than five feet throw a glare of reflected light onto the painting surface and should be blocked off. This is especially true in oil painting, where the wet surface has a reflective quality. It is not as important a consideration in pastel painting, however, since it is a dry, matte, nonreflective medium.

Type 1 lighting, a skylight, is best at a 45° angle. A skylight that is too directly overhead could bring in too much sunlight.

Both Types 1 and 2 involve overhead lighting and provide the most natural outdoor-type lighting. Used either separately or in combination, they give excellent results. In combination lighting (Type 3), the brilliancy of the light is increased even more.

Other factors that can affect the lighting are the overall brightness or dimness of the day and the surroundings outside the studio windows — such as trees, buildings, or snow. Outside objects can reflect sunlight back into the studio for a few hours each day, and thus affect the colors of the object you're painting.

The type of glass in the windows is also a factor. A studio with shatter-proof glass is possibly brighter than a studio with normal see-through glass, for the shatterproof glass diffuses the light and traps it as it comes into the studio, making the studio brighter. Despite this advantage, however, I prefer clear glass because it allows me to enjoy the view outside my studio—a wall of pines and the everchanging sky.

Adapting a Studio with Southern Exposure. The problem in using a studio with a southern exposure is that on a sunny day, the strong, changing patterns of sunlight cut across everything in the room practically all day long. On a cloudy day, however, a studio that faces south is excellent, for the light is stronger from the south and, when there is no sun, it is the same steady light as found in a room with northern exposure.

If you work in a studio with a southern exposure, you can eliminate the problem of sunlight simply by hanging lightweight white cotton drapes over the windows. The drapes will keep out the sunlight while allowing light to come through, resulting in quite a steady and beautiful light.

Artificial Light. Artificial light is used for night work and when a good studio with natural light is unavailable. It is definitely less preferable to natural

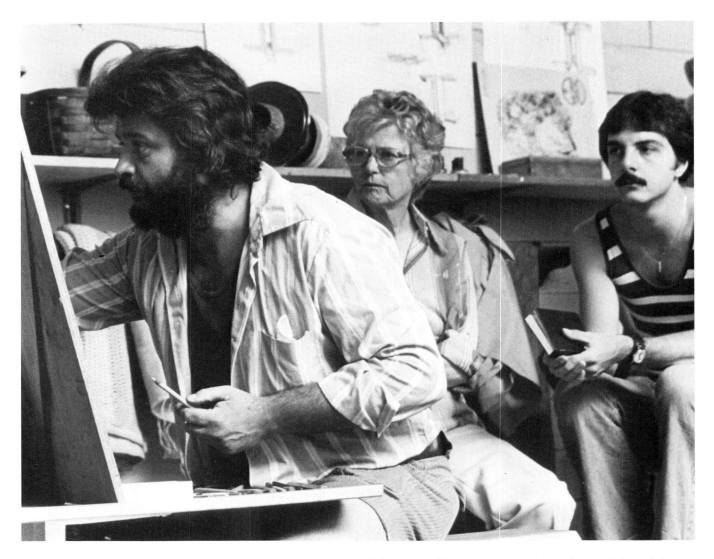

THE WOODSTOCK STUDIO. A critique/demonstration given during a pastel painting workshop. (Photo by Janaan).

light, but with proper consideration, it is a valid way of working. It is becoming more and more common today, as traditional studio space is increasingly less available.

For best results with artificial light, I suggest that you use two light sources: one for the subject and one for the painting surface. You can use either an ordinary 100 watt light bulb, or a fluorescent light; both work fine. Secure the lights from above or in a tall stand, keeping the light bulbs hidden from view behind a shade or visor so they don't distract you from analyzing the light areas of the subject. You can also wear a visor similar to the one on a baseball cap to prevent the light from shining in your eyes.

I use the same type of lighting for both the subject and painting surface. But because the ordinary light bulb gives a warm light and fluorescent lights give cool light, don't paint under fluorescent lights while your subject is lit by a warm light bulb

and vice versa. Also, keep in mind when working in artificial light that the colors are altered by the light. The result is that a painting may only look good in artificial light and not as good in natural light (or vice versa).

Combining Artificial and Natural Light. I sometimes like to let both artificial and natural light shine simultaneously on the same subject. The effect can be quite beautiful, especially in midwinter when the cool, natural light is very weak and the light in the studio is low in key and very bluish. I usually set my studio up as a living room with comfortable chairs, rugs, special pieces of furniture and, of course, reading lamps with shades on them. During November, December, and January, the natural light is so weak that I often have to light a lamp while I am painting. This gives me two sources of light on my subject: the low-key, cool, weak light coming in from the windows, and the warm, stronger light of the lamp. Comparatively speaking, the warm lamp light is so bright that the dark cool natural light falls on the subject as bluish shadows. This combination of lighting is very beautiful and I recommend that you try it. The range of colors it creates is also enormous. This type of lighting can be set up at other times of the year too, but only for a short time at the end of each day, or possibly very early in the morning when the light is also quite weak and low in key.

Effect of Walls on Studio Light. The tone and color of the studio walls can also affect the lighting in the studio. White or very light-colored walls are a problem because they can throw reflections into the shadow area and raise the value to such a point that you will have difficulty differentiating between light and shadow. Squinting at the shadow area of your subject will help play down this reflected light and make the shadow colors mass together.

Dark walls, on the other hand, cause the opposite visual effect. They make the light appear too strong and make the shadows so dark that the color and details there seem to get lost. Therefore, walls toned a middle value seem to work best. They help distribute the light of the studio evenly, allowing you to see into both the lights and darks on a subject.

Similarly, if the color of the walls is too strong, it can also affect the appearance of objects in the studio through its reflective power. Blue walls, for example, will cast a bluish light onto the objects,

red walls will cast a reddish light, and so on. Therefore a middle-tone neutral gray color is best because it influences the local colors of the objects in the studio least and allows you to see the local color of each object best.

My memory as a student at the Art Students' League is of walls painted a battleship gray—a neutral, deep, rich, middle value. Cool light there showed up beautifully, shadows and edges were soft, and there was a dreamy quality to the light that filtered in through the skylight. I have never forgotten this experience and vision.

Lastly, the type of paint used on the walls and ceiling is also an important consideration. Gloss enamel should not be used because it is too shiny and creates a reflective surface that gives off reflections at times like a mirror. Paint your studio walls with flat paint instead because flat paint does not cast reflections. These same considerations hold true for the floor, if that is also painted.

Easel

A solid, sturdy easel that can be raised and lowered, and tilted backward and forward is best for pastel painting. Since pastel is applied with varying degrees of pressure, it is important that the easel not shake or wobble. It should also be capable of being raised and lowered so your surface can be kept at eye level. You will have to tilt it forward and backward to allow superficial flaking to occur as you work. Also, if you're working incorrectly, the pastel will flake off easily if the easel is tilted slightly forward. This will allow you to compensate for and be aware of the flaking problem and let you correct the situation before it is too late.

I also have a tray on my easel to hold the chalks I am using for that particular pastel painting. (The tray also is adjustable to different heights.) As I work, I choose my colors from a large assortment of pastels laid out on a separate table at my side and put each color I use on this tray, eventually creating a palette of colors for that particular work. By separating the chalks I am currently using from the others, I can easily find the color I need when I resume work the next day, without having to search through my complete array of colors. When the work is completed, I return the pastels to their proper places on the larger table.

Table

I usually have two tables, approximately the same height, near me as I work. One holds my pastel

tray with all its soft and hard pastels (see the Appendix for directions on making a pastel tray), and the other holds cans of assorted pastel pencils and other materials I need close at hand. All of my studio furniture has wheels for greater mobility.

The tables also have drawers for storing materials. There I keep small pieces of my original soft pastels with the labels still on them, and an empty box of Nu-pastels, with small pieces of Nu-pastels that also have the numbers on them. The numbers and the labels are for reference, so I can easily find the colors I need to replace.

When choosing your own table or tables, make sure they are big enough to comfortably hold all the materials you will be working with.

Model Stand

The most common way of working is to have the subject at eye level. Thus, if you work standing and the model is seated, you will need to have a model stand to keep the subject at eye level. If you prefer to work seated, however, you might eliminate the model stand to avoid problems in proportions and perspective that may occur when the subject is above or below your eye level. Once you are experienced, though, you may wish to alter the levels purposely to create different effects. For example, a standing nude on the model stand is slightly above eye level. In this case the raised pose gives the nude a slight touch of elegance and avoids a problem of awkward perspective that would exist if the standing nude were slightly below eye level.

The only way to get a model stand is to have one constructed to order. If you are working alone or with a friend in a private studio, the model stand need not be too high. But it should be large and strong enough for room and strength to support substantial pieces of furniture, like Victorian couches, carved chairs, tables, or whatever else you wish your model (or models) to sit on and be surrounded by. My model stand is 18″ (46 cm) high and 6′9″ (3 m) wide, perfect proportions for my painting needs. The model stands for my school are slightly higher since the school studio is large and many people situated at various distances from the stands need to see well. The stands are heavy and I have them mounted on wheels that lock to allow for easy mobility.

Backgrounds

It is a good idea to have many different types of backgrounds on hand. Then, as you study your subject from many different angles, you can also choose the background that best complements or contrasts with the subject, according to the mood you wish to capture in the work.

The fastest way to acquire a large selection of backgrounds is by visiting a good fabric store and purchasing many different draperies. The pieces of drapery should be at least 3′ × 4′ (91 × 122 cm) or larger. I have my fabrics hemmed so they will last longer and have more dignity. I also have rings sewn along one edge so the fabrics can be hung with ease on walls or over parts of windows to eliminate unwanted lights when necessary. You'll need a closet or at least a few shelves for storing your fabrics.

Begin by acquiring drapery in an even-toned rich gray at middle value, then add a dark gray and light gray. These even-toned colors, especially those of middle value, are best to start with because it is easiest to relate the values and colors of the foreground to a simple middle-value background. As you become more experienced in pastel, you can expand and acquire black draperies and very dark colors like navy blue, sap green, or alizarin crimson. Then you can buy white draperies and very light-colored drapes.

Next experiment with all sorts of textures: for example, corduroy, silk, fur, leather, and wool. You'll find the play of light and reflected lights on silk or other shiny materials intriguing and challenging to paint and quite different from the somber absorbency of light on more matte fabrics like wool.

When you feel confident enough, try multipatterned fabrics: stripes, plaids, flannels, and tapestries. You will eventually find that you have preferences, but it is always good practice to vary your backgrounds. I myself like to have old, beaten-up rugs nailed to my studio walls, especially if they're a bit faded. Then the colors won't advance and fight for attention, competing with a foreground

GIRL READING. *Canson paper, 20 × 26″ (51 × 66 cm), private collection. Girl Reading* is one of my early pastels, done on a light gray-tone Canson pastel paper, no. 426 Moonstone. (In those days, Canson paper was made of 100% rag and was heavier.) Here the light-gray tone acts as a delicate harmonizing background for the entire interior. The details are played down and everything is translated into tones and color harmonies. The model, the table she is leaning on, and the other objects in the room have a good sense of weight and form. A strong, flat light illuminates the subject and the room, so there are no deep shadows cutting across the subject.

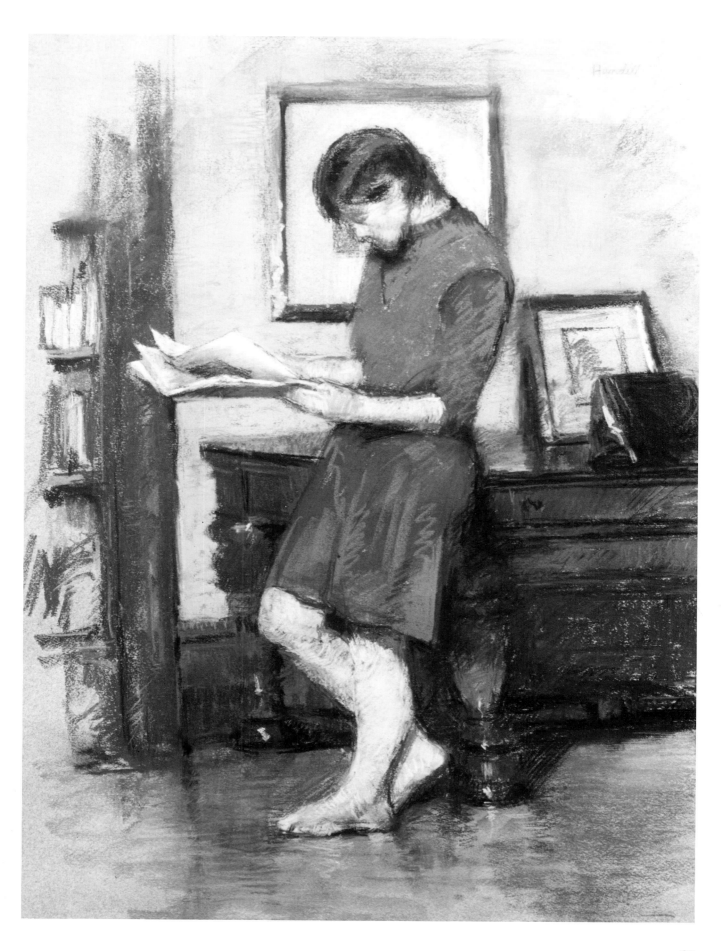

portrait. I sometimes use the reverse side of the rug, too.

To paint a complicated multipatterned background, such as a rug, I mentally put the entire pattern on an imaginary roulette wheel and ask myself: If this pattern were to spin slowly on a roulette wheel and all these patterns and colors were to become a blur, what color would prevail? (It's a bit like taking all the color mixtures that are on your palette after a day's oil painting and mixing them together to get one overall color mixture.) The resulting color and value that I sense is the color I use to block out the entire background rug pattern with. I then pick out the strongest colors of the rug pattern, and paint them into this block-in, making sure they hold their place and are not too prominent in the overall design. (See Demonstration 4, *Portrait of Carol*, for more information.)

Props

Props are a common sight in the artist's studio, and are as individual as the artist himself. I believe in making the studio a total visual delight, your own private fantasy world. Gradually acquire and surround yourself with objects you genuinely love and respond to emotionally. They will enhance your painting experience and be an endless source of inspiration.

You can find props anywhere: antique shops, boutiques, even the Salvation Army. I've managed to collect an assortment of chairs: white wicker, natural wicker, high and low chairs, carved oak with velvet cushions, couches, and more. I also have still-life tables, old wooden barrels, pots and pans of all sizes and shapes, china and glassware, and lamps. I'm particularly fond of blue and white china, and so I have a wonderful collection of plates, vases, ginger jars, and dishes. To this I add pictures and mirrors, baskets, and plants. The number of props you can collect is endless, and all these objects will offer a varied background material for your paintings.

Mirrors

I strongly recommend having at least two mirrors in the studio: A small hand mirror that permits you to easily pick up and view your painting in reverse without stepping back, and a larger mirror either mounted on the wall or on a frame or easel with wheels so it can be positioned about the studio.

Viewing your work through a mirror enables you to see your painting in reverse, which gives your eye a fresh look and points out areas in need of adjustment. A large mirror placed at a distance also gives you the opportunity to simply turn around and see how your painting carries at a distance. This is especially helpful if you angle the mirror so you can see both your painting and the model reversed at the same time. Interesting comparisons can be made this way, for it enables you to check lighting effects, angles, drawing, proportions, values, and relative tones and colors. Experiment with mirrors as part of your model setups, too. It will give you the opportunity to study and paint unusual light effects that can be achieved in no other way.

Viewfinder

A viewfinder is another very handy piece of equipment. You can easily make one by cutting two L-shaped lengths of cardboard 6 × 8″ (15 × 20 cm) in diameter. (The wide border acts as a frame for your composition.) To decide how to frame a composition and determine what to include in it, hold an L-shaped piece in each hand and overlap the edges to duplicate the proportional shape of your paper. For example, a 3 × 4″ (8 × 10 cm) opening in your viewfinder will show the composition of a subject as it would look on an 18 × 24″ (46 × 61 cm) surface. The sides of the viewfinder thus frame the picture you are about to paint.

The closer you hold the viewfinder to your eyes, the more of your subject you will see as you view it through the opening. As you move the opening away from you—at arm's length, for instance—you will start to see a particular composition, arranged as it would look on your paper. The viewfinder shows you where the edges of your paper will crop the scene. It also helps you eliminate parts of the subject you would normally have difficulty omitting. You'll see less through the opening when the viewfinder is held at arm's length, and see more as you bring it closer to your eye. When working outdoors, you may find a smaller viewfinder more practical to transport.

Magnifying Glass

An ordinary hand magnifying glass can be a wonderful studio aid in viewing the progress of your

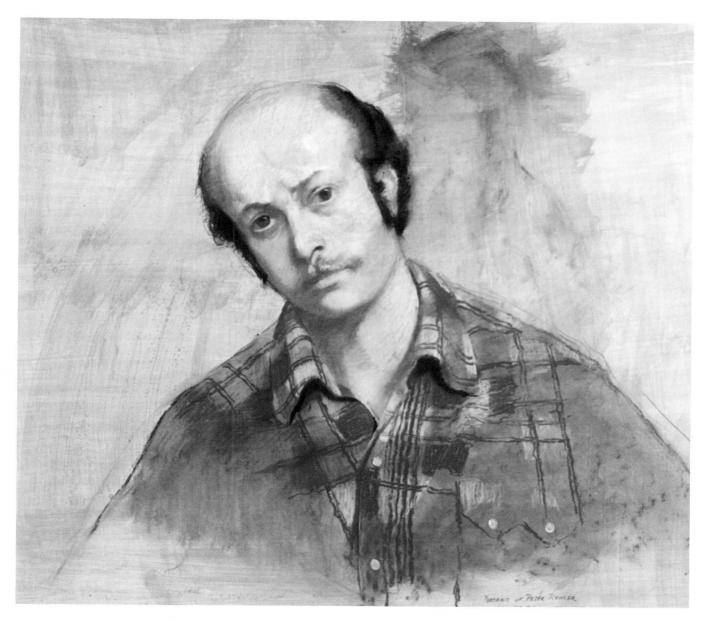

PORTRAIT OF PETER REMLER. *Sanded pastel board, 24 × 28"
(61 × 71 cm), private collection.* This portrait of my friend
Peter was painted a number of years ago and is a very sim-
ple portrait. It was painted on a warm reddish tone, which
comes through even in the portrait areas of the painting,
harmonizing all of the lightly applied flesh tones. The plaid
shirt was blocked in with charcoal and overpainted with
pastels. Peter's delicate yet strong features attracted me.
His head naturally tilted to his right, a mannerism I decided
to make use of. I kept expecting his left eye to look to the left,
and still feel that sense of expectation as I look at the portrait
now.

pastel. When held close to the picture, it works as it
is designed to, magnifying the details so they can
be seen clearly. But its most valuable use is at
arm's length, where it reduces the picture and in-
verts it. This gives your eye a totally fresh look at
the carrying power of your painting at a distance.
In this inverted position, you can examine the pat-
terns of color, light and shadow, the total color
harmony, shapes, placement, and composition. Er-
rors in proportion will also show up readily. The
Omega Company of New Hyde Park, N.Y., puts out
a 3.8× magnifier (no. 195), which is not only good
for studio use but folds to pocket size for handy
use outdoors.

Miscellaneous Equipment

The following items are also useful to have in the studio.

Charcoal. Soft vine charcoal (not the hard, compressed charcoal pencil) is very compatible with pastel. It is excellent in the beginning drawing stages since it easily rubs off without leaving heavy smudges. Using charcoal in the preliminary stages will relax you and let you draw freely as you lay out the composition. I often refer to charcoal as my thinking tool: I can draw with it as I mentally work out elements of my painting. Don't work too long with the charcoal, certainly not more than half an hour in the beginning stage. If you work much longer than that, you may end up with the problem of converting the charcoal into a full-color pastel painting.

In the later stages of the work, charcoal can be used to gently and very subtly harmonize and tone down the intense, rich color that can get too garish in the pastel painting.

Tortillons (Paper Stumps). Tortillons are pencil-like tubes of soft rolled paper that are used for blending. They are rigid and pointed at the tip to facilitate blending in small areas. They are sort of the equivalent of having an extra long, lean, pointed finger to work with, except that the tortillon "finger" sheds. Paper stumps are best used on smooth surfaces like the Canson papers. I don't recommend them for rougher surfaces like sanded pastel papers or marble-dust boards because these surfaces are too rugged, and the paper stump will shed and become imbedded in your colors.

Mahlstick. A mahlstick is a long narrow stick about ½" (13 mm) in diameter, with a ball or pointed tip at one end. The tip is leaned against the side of your drawing board while the other end is held firmly in your free hand. The mahlstick provides a steady support for your painting hand, without letting your hand touch the painting surface. You can make your own mahlstick, if you wish. Purchase a 3' (1 m) length of ½" (13 mm)-thick dowel at a hardware store or lumberyard. Nail an ordinary nail with a head onto one end of the stick and bend the nail into a right angle. The nail will catch onto the edge of your drawing board. As you work, if you rest your working forearm on top of this mahlstick, your hand will be very steady for applying details to your work.

Masking Tape. In addition to securing painting surfaces to your drawing boards, masking tape has many other useful functions in the studio. You can use it to record the positions of your easel, model stand, and setups, should you need to move anything between painting sessions. Marking the position of your easel is especially important when you are working with a group of other artists.

Photographer's Glass or Filter. A photographer's glass is another handy tool. It is basically a blue glass that, when looked through, reduces the size of your subject slightly, plays down its colors, and plays up its values and value relationships. Looking at your subject through the glass allows you to see the values of the entire subject very easily, without being distracted by their colors. You can then look at your pastel to see if you have the same strong value relationships.

A Kodak Wratten gelatin filter, no. 90. which measures 2½ × 2½" (75 mm × 75 mm) also works quite well. This is an excellent guide for establishing the correct value relationships throughout the pastel. After using the filter or glass for a while, you'll be able to do this mentally, and you'll be well on your way to developing your own inner vision.

Clips and Pins. If you prefer to clip or pin your painting surface to your drawing board, you can get spring or clamp clips in hardware, stationery, and art supply stores. Pushpins can also be used.

Razor Blades and Brushes. It is not a good idea to erase pastel because the eraser can shed. Then the eraser bits can become part of the painting surface, and create a problem when you try to remove them from your pastel. When erasing or correcting is necessary, a couple of careful procedures may work easily and successfully.

One correction procedure involves a single-edge razor blade. Hold the blade flat (long edge) across the surface (be careful that the corners do not dig into the surface) and gently scrape downward once or twice to remove the excess pastel. You can then rework this area later with pastel.

Another method involves using a stiff brush and rubbing in a downward motion to remove the pastel. These processes will not disturb the painting surface at all. I keep on hand a no. 9, round bristle brush for most areas, a no. 12 flat bristle brush for large areas, and nos. 2 and 3 bristle brushes for smaller areas.

When the excess pastel is removed, I can either rework the pastel with other pastels or I can apply a bit of turpentine or pastel fixative with a brush to the remaining pastel on my surface and change the pastel chalk to a paint quality. When the surface dries, the tooth remains unaltered, and I can then rework the areas with pastels again for lovely effects.

Another reason I don't recommend using an eraser is that it sometimes contains grease. Once it smudges and becomes part of the surface or makes it slick, there is no remedy for this problem.

Pencil Sharpener. Any good pencil sharpener will do for sharpening pastel pencils. To keep the points from breaking, just be sure to hold the pencil steady and not force it into the sharpener with too much pressure. An electric or battery-run sharpener that can be kept on your pastel tray is also excellent. It sharpens well with the fewest broken points, and is almost self-feeding. Self-feeding crank sharpeners can also be used. In other words, you don't have to sharpen pencils by hand or razor blade unless you enjoy spending lots of painting time sharpening tools that can be done mechanically and easily in very little time.

Taking Pastel Outdoors
Pastel is very adaptable to outdoor painting. I have a French easel that folds up into a compact box, with room inside for all the materials I need.

Before I leave the studio, I mount my painting surface to my board, which also can be attached and carried on my easel. I usually just take one type of surface along, but I may take it in different sizes and leave some of the extras in the car until needed.

My easel box contains a tray with three compartments, one for light values, one for middle values, and one for darks. I primarily use soft pastels intermixed with a few hard pastels for landscape work. But I don't take pencils, which I find so useful for portrait work, into the field with me because I like to work more broadly and with less detail outdoors. To keep the pastels clean and prevent them from knocking around in transport, I have put three pieces of 1″ (25 mm)-thick foam, cut to the size of each compartment, over the pastels. When you work outside with pastels, you will probably have to clean them more often than under stable studio conditions. (I clean pastels by wiping them off periodically with a tissue or napkin.)

Below the sliding tray, I carry my duplicate colors, brushes for erasing, and rags, plus small bottles of turpentine and pastel fixative. I find this arrangement completely satisfactory for working outdoors. In addition, the ease with which pastel is set up, cleaned up, and quickly applied, makes it ideal for the ever-changing lighting conditions you find in outdoor work.

Methods of Applying Pastel

There are many ways pastel can be applied, and each method possesses its own particular beauty. Also, within each method, great variety can be achieved according to the type of pastel (soft or hard, or pastel pencil) used. The roughness or relative smoothness of the surface also influences the visual impact of pastels. On a rough surface the stroke is more open, and on a smooth surface it is tighter. These effects are caused by the degree to which the tooth of the surface is filled.

I encourage you to experiment freely with the following methods, using the three types of pastel on many different surfaces to get the feel of the different effects that can be achieved.

Linear Strokes

In pastel, linear strokes are achieved in two ways. One way is by holding the pastel with the point or corner edge against the surface and creating straight lines of varying lengths. A soft pastel will make a thick linear stroke; a hard pastel a fine thin line; and a pastel pencil an even finer, more delicate line. The second method of creating linear strokes is by drawing straight lines with the entire long edge of the pastel held against the surface. This will give you a strong, solid linear effect. Again, the type of pastel (soft, hard, or pastel pencil) and the surface used will cause the quality of the strokes to vary greatly.

A linear stroke can be used to block in the painting, especially in the beginning stages of a work. (Hard pastels are the best for this.) On the other hand, linear strokes applied with pastel pencils are usually best for the details in the finishing stages of portraiture. Except for the smallest details, soft pastels can and should be used from the beginning—or during the first half hour after starting a pastel with hard pastels—to the very end.

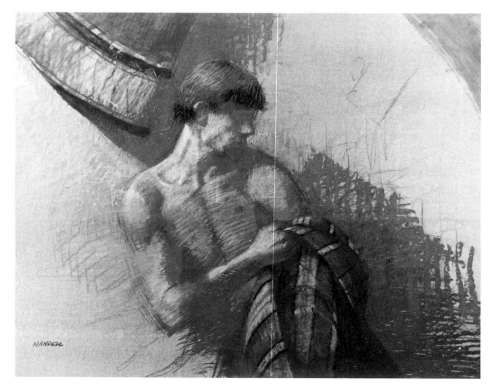

MALE NUDE WITH A BATHROBE. *Sanded pastel board, toned red mahogany, 20 × 24" (51 × 61 cm), private collection.* The rich middle tone of the surface, a reddish brown stain, shows through in the painted and unpainted areas of the painting, giving an underlying harmony to all the colors and tones. The figure was outlined and laid out using charcoal and was then worked in linear fashion with pastels. I used charcoal throughout the pastel buildup, floating it gently over the entire figure to help keep the colors harmonious. As the work progressed and became unified, the linear work, which is intrinsic to the form, became more subtle. But it can still be seen clearly in several areas of the finished work. Notice how I used long linear strokes to suggest the chest area. Since there is no heavy buildup of color, the underlying surface shows through.

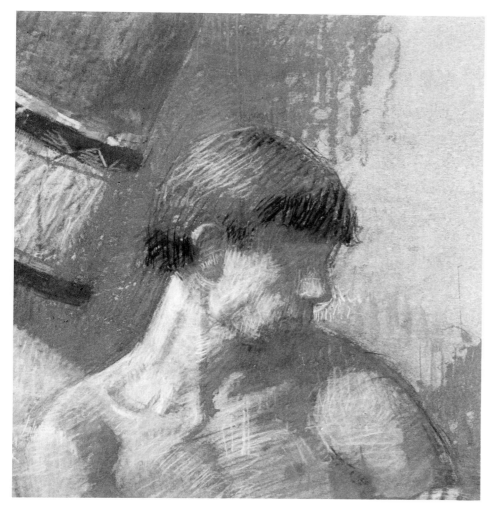

MALE NUDE WITH BATHROBE, DETAIL. In this detail, you can appreciate the subtle but substantial linear aspects of this pastel. Notice how the lines float in and out of the figure, tying in the different areas. The head, especially the hair, is subtly developed linearly, and gives a sense of depth and form to the painting, although practically no details are specifically stated. Notice also the subtle delicate lines that cross the cheek and that are in the neck and ear areas.

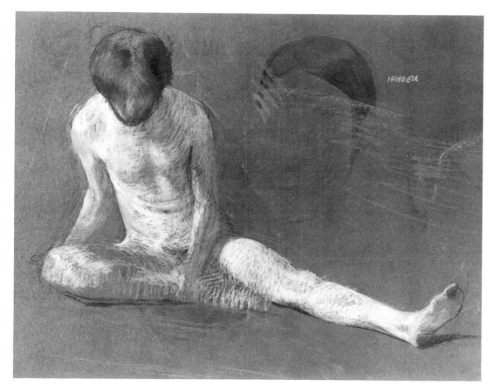

SEATED MALE NUDE. *Pastel on sanded board, toned red mahogany, 18 × 24" (46 × 61 cm), collection Mr. and Mrs. Joel Sklaroff.* This nude study, also done on a red mahogany tone, was expressed almost exclusively with a linear technique. Starting with a feathery touch, I laid out the entire pose. Then working more heavily with the pastels (mostly with hard pastels combined with pastel pencils), I developed the strong light on seated nude. As the figure is built up with many layers of different-colored pastels, a sense of rhythm and form is developed through the linear strokes. Notice the abdominal area, for instance, where the strokes capture the form and twists of the muscles.

Side Strokes

One of the most beautiful and widely used strokes in pastel painting (and incorrectly presumed at times to be the only way of applying pastel to the surface) is the side stroke. Done only with hard or soft pastels by holding the pastel against the surface on its side, this stroke creates a lovely blanket effect which is excellent for covering large areas in a painting.

When the side stroke is applied with varying pressure and different motions of the wrist, numerous effects can be achieved. It can be applied heavily, covering the tooth of the surface, for a dense quality. Or it can be applied with less pressure, to let the tooth of the surface show through, giving an accidental or broken effect that possesses a special charm otherwise unobtainable.

I recommend that you take the time to practice this stroke, using soft and hard pastels with varying amounts of pressure. Also, experiment with dark-colored chalks on light grounds and light-colored chalks on dark grounds. The tooth of the paper is also very important when using the side stroke, so try it on a variety of rough and smooth surfaces.

The side stroke can add wonderful contrast to a pastel painting when used judiciously. But when it is applied too heavily and too often over the entire painting (a tendency beginning pastel students have), the impact and beauty of the stroke is lost.

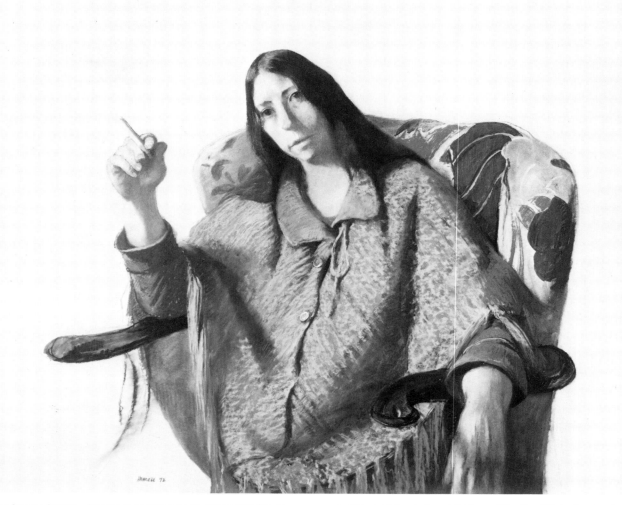

THE GREEN SHAWL. *Sanded pastel board, 20 × 24" (51 × 61 cm), collection Tim and Roberta Remy.* The painting was completed with a combination of hard and soft pastels and pastel pencils over a watercolor wash. The shawl was first underpainted with a dark, rich blue-green watercolor wash of Davy's gray mixed with Hooker's green light, applied rapidly and broadly and allowed to dry. When it was dry, I went over the shawl with a lighter green soft pastel. I used the side stroke extensively, working in short, broken strokes applied in the directions of the weave. The final effects are quite interesting and beautiful.

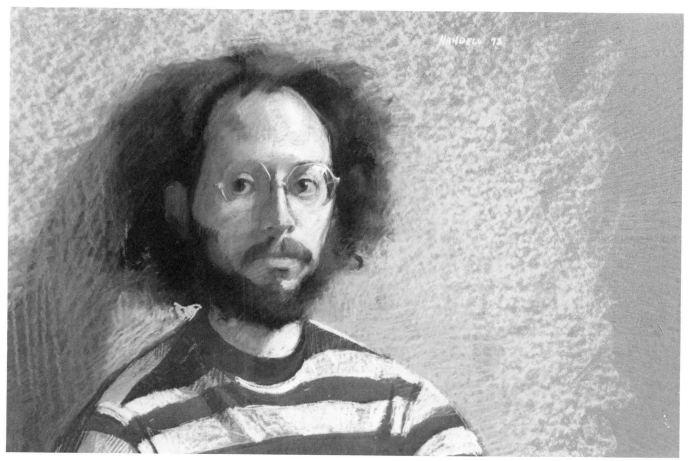

THE GREEN SHAWL, DETAIL (*top*). Here you can clearly see how the side stroke was used to capture the weave of the shawl. The short strokes convey the feeling of the shawl's woven wool. Notice that the texture of the tooth of the sanded paper shows through the side stroke.

PORTRAIT OF JAY SADOWITZ (*above*). *Sanded pastel board, toned ebony, 24 × 30" (61 × 76 cm), collection Aaron and Rochelle Zohn.* The side stroke is used broadly in the background area of this portrait, lending contrasting texture to the face. I applied the pastel with a light hand so the texture of the tooth of the sanded board and some of the ebony stain would show through. Here the side stroke is applied in long, flowing strokes, which also add a sense of rhythm to the background.

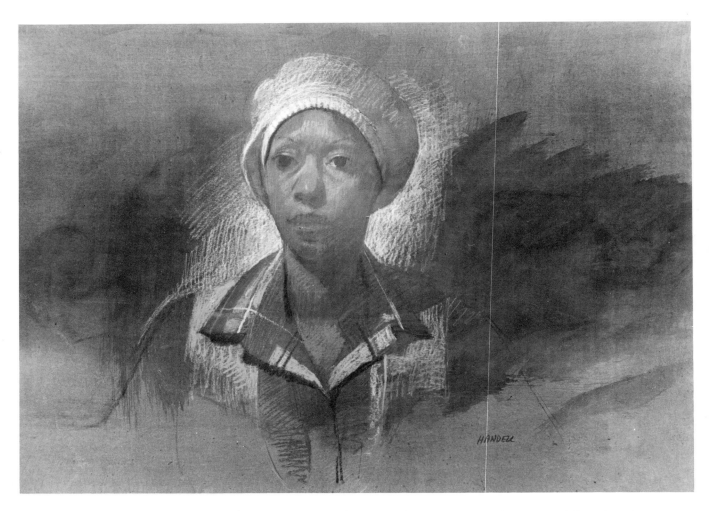

AGATHA (*above*). *Sanded pastel board, toned dark red mahogany, 24 × 30″ (61 × 76 cm), collection the artist.* The portrait was painted on a dark, rich, reddish brown-toned board. The rich colors in her face contrast strongly with the light-colored clothing and background. To reduce the contrast, I used delicate cross-hatched strokes for the background, rather than side strokes, worked with hard pastels and pastel pencils of different hues.

Cross-Hatching

"Cross-hatching" is basically a linear technique, with lines criss-crossing each other in opposite directions—at right angles or any other angle. Tremendous variety and subtle density are obtained with cross-hatching. It can be done with all three types of pastel used separately or in combination. I prefer to use hard pastels when cross-hatching for the crisp lines I can get with them. You can achieve tremendous variety through cross-hatching, since the pastel can be applied in open strokes, dense strokes, or in broad or fine lines. You can also intermix and overlay the cross-hatched strokes with different colors for subtle and beautiful color mixtures.

The lines of cross-hatching should usually go with the form—that is, they should describe the surface of the form they are on. Cross-hatched strokes are mainly used to build up the pastel as the work progresses. They can be used both in the background and the foreground. In the background, you can let these strokes show, without softening them. But in the foreground, as in a portrait, the cross-hatched lines can be distracting and break up the beauty of the form, so you should modify them somewhat.

You can also blend colors through cross-hatching. Criss-crossing and overlapping different colors at different angles and very close to one another results in a muted blending of color, though the actual cross-hatched lines are hard to see in the finished work.

Soft pastels create a thicker linear cross-hatching than the hard pastels and pastel pencils, which offer a finer, more delicate cross-hatching.

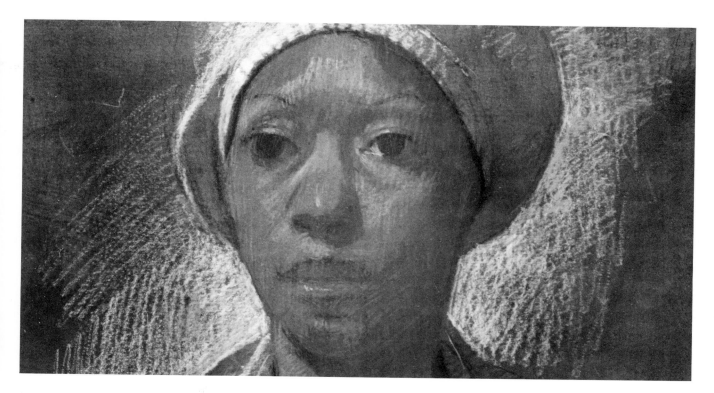

AGATHA, DETAIL (*above*). You can see my strokes more clearly in this detail. Notice that I used up and down strokes in the head, with no cross-hatching, while I cross-hatched the background areas above the shoulders and next to the cap for variety. Free strokes (strokes that go in any direction at whim) were lightly floated over the cross-hatching to keep it from being too obvious. But if you look closely the initial cross-hatching can still be seen.

STANDING MALE NUDE (*right*). *Sanded pastel board, toned dark walnut, 22 × 32" (56 × 81 cm), private collection.* In this pastel, the figure is built up and developed by a lot of cross-hatching, which follows the form and rhythms of the figure. When done subtly, and repeated over already cross-hatched areas of different colors, the cross-hatching becomes finer and finer. It is a beautiful and subtle way to blend colors and achieve a unique denseness. Dense cross-hatching can be seen in the left thigh area. But in the chest and lower left leg, where the cross-hatching was left more open, the strokes are quite obvious.

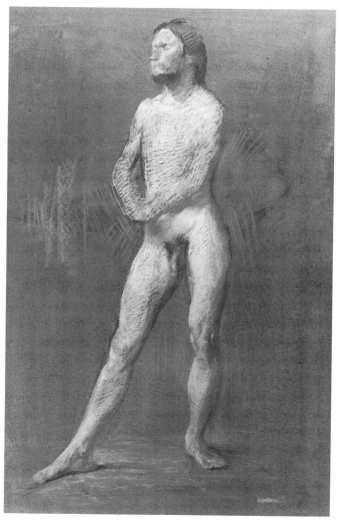

Blending

In pastel painting, "blending" is the mixing of two or more colors either next to or on top of each other, on the pastel surface. You can blend colors with a paper stump or tortillon, or your finger. When blending with a finger, make sure there is no grease or sweat on your finger which could get onto the surface you are working on. Pastel will not adhere to an oily surface.

When blending colors, you also must see that there is enough pigment on the surface or the blending will be premature and the effects will be weak. The blending technique works best with heavily applied side strokes of different-colored soft pastels placed near each other.

Pastels are blended where edges soften or turn—as on round forms, and for subtle color transitions. You can also use the blending technique to mix colors by applying one color over another and rubbing them together to make up still another color. For example, putting a yellow over a blue and blending them together will give you a shade of green. Be cautious when blending, though. Beginning students often have a tendency to blend their colors too much, which dulls and deadens some lively pastel qualities. But, used with care, blending can add richness to a pastel painting and unify its colors.

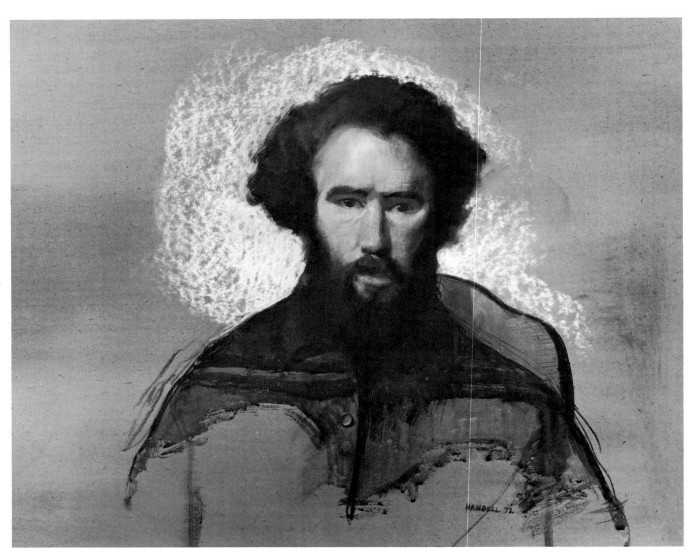

PORTRAIT OF SAUL KROTKI. *Sanded pastel board, toned red mahogany, 24 × 30" (61 × 76 cm), private collection.* After laying in the portrait using a sepia-tone hard pastel, the beard, hair, and shirt are underpainted using diluted watercolors. I use black for the hair and beard, and a combination of black and green for Saul's shirt. Soft areas like hair and fur, which are very delicate, are excellent textures to capture with the technique of blending. Here the blending on the hair and beard was done with different colors of soft pastel. Although the hair is black, subtle cool blues and red, dark browns are also found there. I applied these colors heavily with soft pastels, then blended them together with a finger.

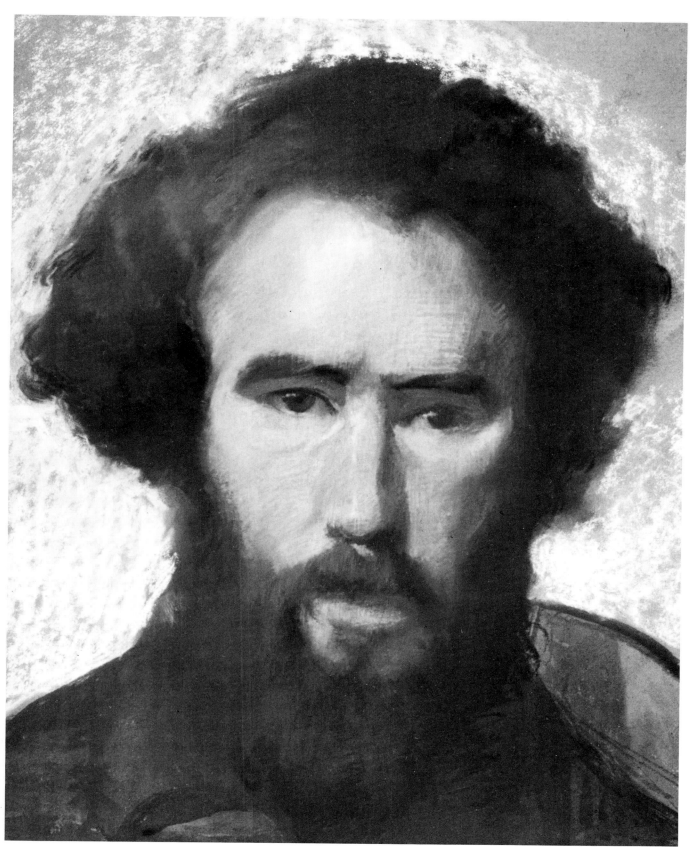

PORTRAIT OF SAUL KROTKI, DETAIL. This detail shows the intensity of the expression. This is often the case in non-commissioned portraiture, where the sitter stares out into space, letting emotions come to the surface. Notice the blending in Saul's beard and hair, which also acts as a dark frame for his face. The colors there seem to float together. The beard also blends into the collar of the shirt.

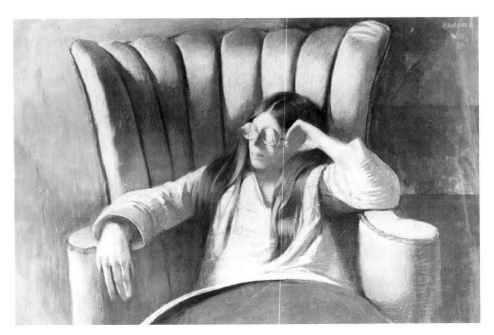

PORTRAIT OF SUSAN (*right*). *Sanded pastel board, 22 × 32" (56 × 81 cm), private collection.* Blending is a wonderful way to capture gradations of reflected light, as in the chair above Susan's right arm. The chair was an ugly pinkish color that, in shadow, turned into a rich, beautiful reddish brown. Susan's chemise was a bright chartreuse green in strong light, which reflected back into the shadow of the pink chair, slowly disappearing into the rich dark shadows. Blending was an ideal technique for this area. It was done simply with a finger, once all the colors were *heavily* established with soft pastels.

THE FUR HAT. *Sanded pastel paper, 16 × 20" (41 × 51 cm), collection the artist.* Seated against a dark greenish gray background, the model was wearing a whitish fur hat and heavy dark brown fur coat, both excellent textures for a blending technique. Here the dark colors bring out the small portrait. I blocked in the entire pastel with heavy applications of soft pastels. The blending was accomplished very simply, again using only a finger. For the small details of the eyes, nose, and mouth, I switched to pastel pencils.

Free Strokes

When I am painting a portrait I often get an insight or a sudden glimpse of that intangible inner spirit which is so much a part of each individual. I focus on capturing this essence of character, working quickly in rhythms full of vital energy. The resulting strokes, which are linear and very free flowing, zig-zag following the direction, flow, and energy I am sensing.

PORTRAIT OF ANNE. *Dark gray sanded pastel paper, 16 × 24" (41 × 61 cm), private collection.* The pastel is small and there is a lot of space around the figure. Many types of strokes were used throughout. I delicately built up the portrait with pastel pencils and hard pastels, layering one color over another, with an occasional side stroke of soft pastels in various flesh tones. The wall behind Anne was suggested by vigorous free strokes in order to capture the rhythms and energy that surround her. Her velvety blue blouse contrasts beautifully with the background and sings with vitality.

THE FARM GIRL (*right*). *Sanded pastel board, ebony stain, 18 × 24" (46 × 61 cm), private collection.* There was some classical music playing on the radio, and the sitter listened, intently absorbed in the music. It was a special moment and I wanted to capture it. I underpainted the red dress with thinned-out watercolor washes of alizarin crimson. When they dried, I blocked in the light areas of the dress with broad strokes of soft pastel of a lighter red. The free strokes around the portrait convey a sense of energy, yet the model is serene. The head is built up with small, free strokes in different directions. Except for the red dress, the work with soft pastels was held to a minimum.

PORTRAIT OF JOAN (*below*). *Sanded pastel board, 20 × 24" (51 × 61 cm), private collection.* I used many different kinds of free-flowing strokes here, mostly done in soft pastel. I intermixed the pastel with soft artist's charcoal (note the cast shadow on the white shirt hanging over Joan's left shoulder, and the shadows directly above her head). The open, free flowing strokes help to create an airy, open effect.

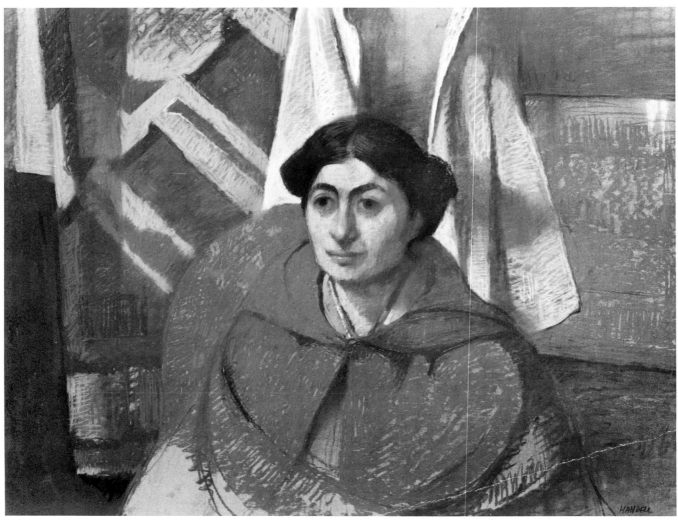

Drawing in Pastel

A unique quality of pastel is that it is both a painting and a drawing medium. As a painting medium, through an extensive use of color and tone, a completed painting can be accomplished. But through very limited use of color, a pastel can be kept in a drawing stage, too.

When drawing with pastel, I recommend limiting the colors radically, using only as few as two to four colors. You might choose, for instance, a dark brown and a light flesh (two colors) or a warm brown and a cool brown for the darks, and a warm flesh and a cool flesh for the lights (four colors). By limiting the colors to four and by concentrating on the lines and suggestion of light and shadow, by keeping your work loose and free, and by incorporating charcoal (which is especially beautiful in pastel drawing and highly recommended) instead of other pastel colors, you can obtain beautiful drawing effects with pastel.

RECLINING NUDE. *Sanded pastel board, red mahogany tone, 24 × 30" (61 × 76 cm), courtesy Gallery of the Southwest, Taos, New Mexico.* This pastel drawing was done with a very limited number of hard pastels and one pastel pencil. I used a rich reddish brown, no. 363-P Garnet; a dark muted blue for darker accents, no. 305P Spanish Blue; a flesh pink, no. 286P Madder Pink; and a no. 29 Flesh Carb-Othello pencil. By varying the degree of pressure of the madder pink and the pastel pencil, I was able to get a lot of mileage out of my two flesh tones. Using only these colors, I could get a good sense of light on the entire figure. The left leg shows how the drawing was begun and developed, following the initial lines (as in the heel), and working into the color of the hip area. The unfinished areas add to the impact of the pastel.

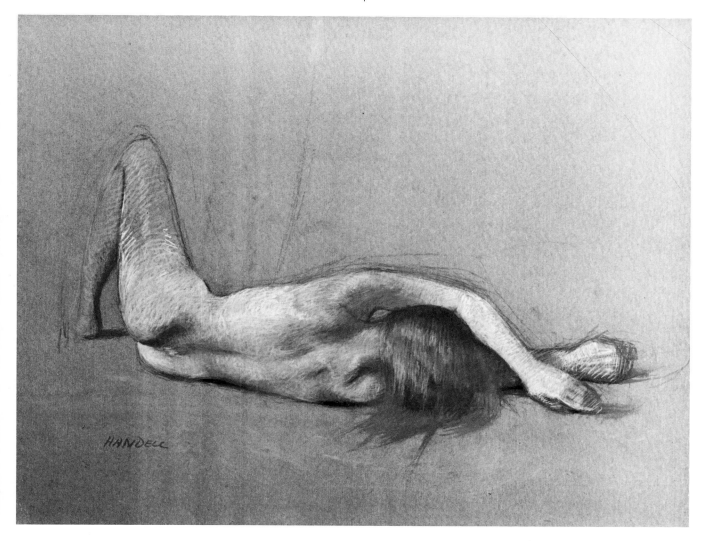

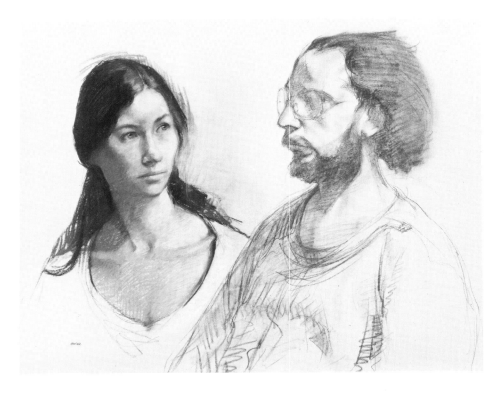

MORIN AND JAY (*right*). *Sanded pastel board, 24 × 30" (61 × 76 cm), private collection.* The combination of charcoal and pastel works especially well. Morin, the lovely girl on the left, was first sketched in with soft charcoal. Over the charcoal drawing I used a combination of hard pastel, soft pastel, and pastel pencil to capture the delicate drawing and expression of her face. I began the portrait of Jay the same way, but left it as a drawing done in soft vine charcoal. Notice how softly and beautifully the charcoal blends, as in the hair and beard. This portrait is typical of the effects achieved by drawing with charcoal on sanded pastel paper.

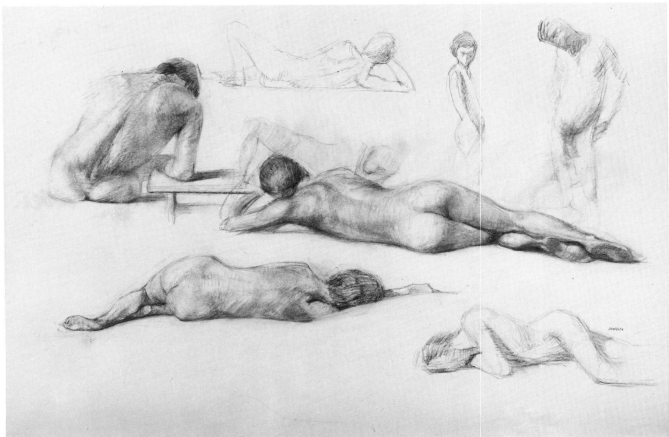

NUDES ON A PAGE. *Sanded pastel paper, 24 × 32" (61 × 81 cm), collection Mr. and Mrs. Christopher Carajohn.* I love to draw on sanded pastel papers with a limited number of colors and charcoal. The effects are lovely, and the buildup of shadows is rapid and uncomplicated. In *Nudes on a Page*, I used soft vine charcoal, and the tooth of the paper allowed delicate blending. The accents are reinforced with a dark brown pastel pencil, a no. 59 Carb-Othello.

Feathering (Glazing)

When blocking in a pastel, it is a good idea to separate the color areas at first. But later the colors of the painting have to be harmonized and unified. You can accomplish this by "feathering."

I think of feathering as "glazing with pastels," for it is similar to glazing in oil painting. In feathering, a color, usually darker than the one to be covered, is softly painted onto the dry underpainting to tie the painting together and subtly change its color. To feather one color over another, you should use a hard pastel or pastel pencil. (A hard pastel or pastel pencil is best for feathering because a soft pastel may tend to cover the underlayer instead of harmonize it.) With a light hand—a "feathery" touch—you float the color over the pastel color that is already there. You will be surprised at how effectively and simply this technique harmonizes the painting.

Feathering is an excellent technique for subtly enriching the color of the pastel or enlivening areas that are weak or deadened in tone, perhaps because of too much blending. Feathering can renew lost vitality and freshen a pastel.

Scumbling

The oil-painting technique known as "scumbling" can also be applied to pastel. "Scumbling" is the application of a light color over specific areas of a painting (or over the entire painting) to lighten the values and subdue the color of a painting. Again, hard pastels and pastel pencils are best for this technique. If you use hard pastels, a very light side stroke should be employed If you use pencils, use the side of the point, not the tip. Soft pastels can also be used, but it will take care and practice to develop the light-handed feathery touch that is required.

Bloom (Color Gradations by Pressure)

Much can be done with chalk of a single color, simply by varying the pressure used when applying it. The "bloom effect"—a gradual grading of color—is best done on smooth sanded pastel paper, rather than rougher surfaces, because its smooth tooth is best for showing the graduated effect of bloom.

To create a bloom effect, take any type of chalk (soft pastel, hard pastel, or pastel pencil), and press very lightly for a fine tone, gently adding more pressure as you move the chalk across the surface, to get more intensity of color. For best results, try to maintain a steadily moving motion, like drawing a violin bow across the strings. By merely varying the pressure of the pastel, each color will seem to have a visually harmonic aspect to it, like the grading notes of a musical scale. The secret of getting bloom, then, is in varying the pressure. But the stroke itself is steady and continuous. Any type of stroke may be used, except one that calls for lifting the chalk off the surface (like a cross-hatch).

Bloom is not a useful device in the central areas of painting, where much building is done, because it will eventually get absorbed into the painting and won't show up. But it's an excellent technique for the background of a painting, where you want to achieve variety without using too many colors. It is definitely the best way to get as much variety as possible from a single color.

Basic Concepts and Painting Procedures

The following basic painting concepts are essentials to successful painting.

Values and Masses

As I explained in Chapter 1, "values" are the relative lightness and darkness of all colors. For practical purposes, artists limit the number of values they work with to ten, on a scale that ranges from white, to the lightest gray (1), to middle-tone grays, to the darkest gray (10), to black. Of course, there are many more values in nature, but trying to capture them all would be as confusing, frustrating, and impossible as trying to duplicate nature itself. So organizing color into a limited number of values (light, middle, and dark) gives you a means of reducing a subject to simple artistic terms. Understanding the relationship between value and color

is paramount to successful realistic painting, although I often treat them separately in the lessons in this book for the sake of clarity.

"Massing values" means organizing all the areas of a painting that are similar in value into simple shapes and large groups. Massing the values helps unify a painting, giving it much intrinsic strength. It also simplifies the shapes in a painting, thus giving the painting its carrying power.

When considering color as value the medium of pastel is unique because you are not mixing colors but you are working with individual hues that may look like one color in the pastel tray and yet another one when applied to your surface. It is therefore a good idea to always check your colors before using them by testing them at the corner of your working surface. I leave a ½" (13 mm) border

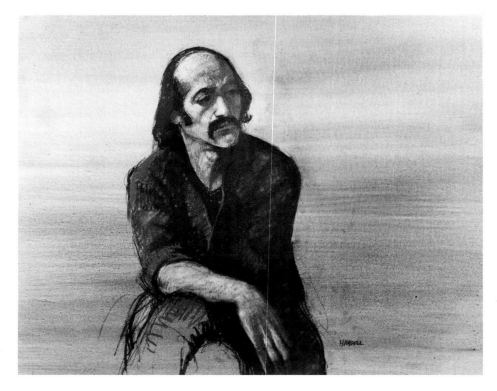

PORTRAIT OF MICKY WOLNER. *Grumbacher sanded pastel board, 22 × 28" (56 × 71 cm), collection Annemarie Barron.* In this portrait, the simple, strong massing of dark patterns brings out the sitter's head and pose beautifully. Notice how the hand is framed in front and back by dark, simple masses. The values of the shirt and pants are so close that you can hardly see where the shirt ends and the pants begin. Notice how the hair on the right side of the head relates to the cast shadow of the shirt on the neck, and how the shadow of the neck flows gently into the left shoulder.

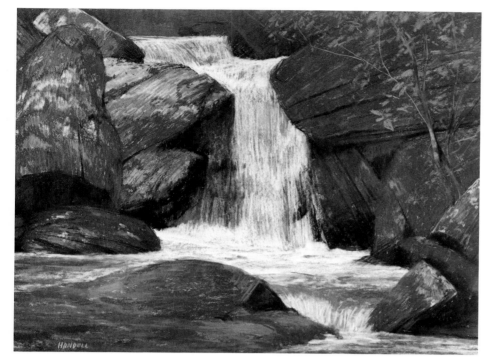

ALONG THE KAATERSKILL. *Sanded pastel board, 16 × 22" (41 × 56 cm), collection Mr. and Mrs. John Carter.* This waterfall is found along the Kaaterskill Stream, which leads to the magnificent Kaaterskill Falls in the eastern Catskill mountains. The carefully planned massing of a few simple values gives the painting its underlying power. The entire painting, except for the gushing water, consists of two dark, rich values delineated by the dark accents. Other lighter values, besides those found in areas of the water, were held in reserve and used sparingly to paint in the rock bed that surrounds the water. Look at the lower left of the painting and squint your eyes to eliminate the white of the water for a moment. Notice how the water and the lower rocks are the same value.

on the edge of my painting surface for this purpose. It is later covered by the frame, so it does not interfere with the painting at all.

To keep a painting unified, it is important to properly assess the values of the colors you see and simplify them into large masses. I start with the shadows first, which are the dark values. I see if the shadow area of one object relates to the shadow area of another object, and if these areas are touching, I squint my eyes to see if I can relate the shadows of both objects into one large pattern. This process is referred to as "simplifying and unifying the shadow masses."

Working on a middle-value surface facilitates this process. On a middle value, the darks and lights of the subject can be compared equally. Painting the dark shadow masses and other darks of the subject first also allows you to build light colors over dark colors. This helps avoid the tendency (a common one in pastel) to work too high in key (value), resulting in weak, washed-out colors. The high-key effect is due to the abundance of light colors in pastels, which predominate strongly. By concentrating on the shadow masses and dark values first, you establish a strong, solid, dark-value key in the beginning of the painting. The lights can always be established and made lighter later, as the work progresses.

Foreground-Background Relationships

The foreground-background relationship is extremely important to the harmony and unity of the entire painting. The secret of acquiring this unity lies in properly massing your values. To do this, you establish all the colors of the foreground and background that are similar in value and paint them in. Then, you consciously join (or mass) them by playing down (softening) their adjoining edges. When you have filled in all the colors of a similar general value, you then add colors of contrasting values.

Working Light over Dark

Because pastel colors are brilliant, opaque, and especially numerous in the light values, the procedure of applying light colors over dark ones works best. The light colors sit on top of the darks and add freshness, sparkle, and vitality to the color. When dark pastel colors are applied over light colors, however, the vitality of the dark colors is lost. The chalkiness or opacity of the light colors seems to eat up the richness of the darks and water them down.

To achieve rich pastel colors by applying light colors over dark ones, you must first establish the darks of the painting using different colors of similar values. Middle-tone and light areas of the painting are then related (in hue) to the darks and are

THE INSECT TREE (*right*). *Sanded pastel board, 22 × 28" (56 × 71 cm), collection the artist.* A few simple, beautifully integrated values create a strong picture. Although the colors here are translated into grays, you can see that the same values in the tree slip in and out of the background. Only the colors are different, not the values. The separation of foreground from background is deftly achieved through careful application of dark accents as, for instance, those along the base of the fallen trunk. Remember, the simple massing of similar values connects the foreground to the background. It also gives the painting unity and carrying power. Varying the colors within these value masses, on the other hand, gives you variety.

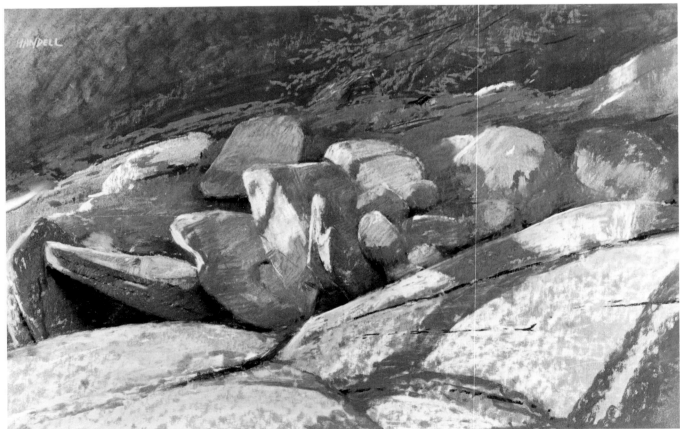

PLATTEKILL COVE. *Sanded pastel board, 16 × 22" (41 × 56 cm), collection the artist.* Here, late afternoon sunlight sparkles across a rugged assortment of rocks painted over a middle-value, gray ground. I kept the key of the entire upper two-thirds of the painting low by using dark, rich colors and tones. I also used soft vine charcoal freely in the initial establishment of the pastel. To establish the dark accents in the rocks, I drew into the dark masses with still darker colors, getting as close to black as possible, without actually resorting to black. The bright, soft sunlight color was then applied over the dark buildup during the last ten minutes of work. I wanted the sunlight colors to remain fresh, and working light over dark was the only way to achieve this.

44

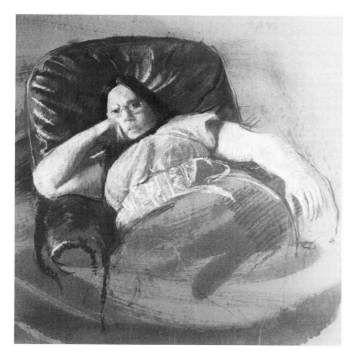

TERESA (*left*). *Sanded pastel board, 24 × 30" (61 × 76 cm), private collection.* On a middle-value, homemade, sanded pastel board, I established the rich, dark leather chair first, then the glistening highlights of the chair, and then the skin tones, working light over dark. Open side strokes and linear strokes of lighter values over darker values were used to obtain the reflected lights on the chin, upper lip, and base of the nose. Similarly, the light accents in the blouse are later applied over dark colors.

PORTRAIT OF JOHN BROWN (*below*). *Sanded pastel board, 22 × 28" (56 × 71 cm), private collection.* In this portrait vignette, the play of highlights and the simple shape of the vignette against the solid background, work together to hold the viewer's eye on the portrait. Except for the highlights and a few select lights here and there, everything in the portrait is darker than the background. The highlight on the forehead is like a gentle explosion of light, while the highlights of the right brow and eye socket are delicately played down. The highlight that travels up and down the entire nose strongly accentuates it, while the highlights on the lips, especially the lower lip and teeth, are again played down. Note how effective a variety of highlights is in capturing the viewer's attention.

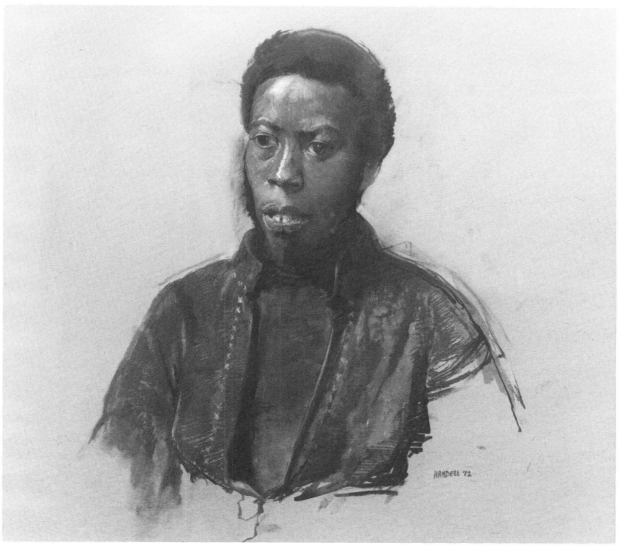

worked on top of them. This also avoids the problem of getting transitional areas—where the light, middle, and dark tones meet—too light. Should an area get too light, however, you can bring the value down a bit with darker colors.

Highlights

Highlights, which are actually reflections from the light source, are usually the brightest reflected lights in the light area of the subject. The highlights from a cool north light are cool or bluish. If they are reflections of an artificial light source, such as a 100-watt light bulb, they are generally warmer and yellower.

Highlights can be a source of pleasure and at the same time a curse. Because they can be easily seen, they are thus often added too soon in a painting and are usually overemphasized. Highlights should be considered accents that add to the vitality of the painting, not distractions that break up the tonal harmony.

As a general rule, I suggest eliminating as many highlights as you can, and carefully positioning the ones you do decide to use. It is also a good idea to play down the whites of the highlights, which make the highlights scream and jump. Instead, use high-value grays or very light-value blue-grays.

Pastel highlights can be kept crisp and controlled by varying the pressure and method of application of the pastels. Single, crisp strokes with the edge of the pastel will often produce the most effective highlights.

Reflected Lights

"Reflected light" usually refers to light bouncing back into the shadow area from some nearby light-colored reflective surface, such as a light wall or drapery near the sitter. Reflected light gives the shadow areas a lot of variety by adding its lighter values and beautiful colors to the shadow. But you can also break up the shadow mass with reflected lights if you forget that the entire shadow area should be close in value and make your reflected light too light.

To judge if the reflected light is important enough to include in your painting as a separate value and to decide how light to make it, squint your eyes to see if the reflected light merges with the shadow mass or if it asserts itself as a separate value. This is an important step.

Squinting is one way to check the value. Another way to avoid making the reflected light too light is

by painting it a contrasting or complementary color of the same value as the shadow area instead of using a lighter value of the same color. This will create the desired effect without breaking up the unity of the shadow mass.

Edges

Edges, a study in itself, play an important role in realistic painting. Essentially, an edge is created wherever two colors meet. The sharpness or softness of the edge depends upon the degree of difference between the values and intensity of the colors. For instance, in a portrait of a dark-haired person against a light background, the edges of the hair are sharp. If the background was dark rather than light, the edges of the hair would be closer to the background values and therefore more blended. Understanding edges and using them effectively will add much to the unity and power of your painting. This is true of any paint medium, not only pastel.

Rhythms

The longer I paint, the more I see in terms of rhythms. Rhythms can be defined as movement but not necessarily motion. There is an innate duality to everything in nature, and to me rhythm is a reflection of this. Objects are at the same time both stationary and in motion. We are able to perceive the essence of this motion as rhythms—the quiet sense of motion in objects as seen through light and shadow, proportions, color and texture, enhanced by the inner silence of existence. More and more in my paintings I strive to make this aspect of life a reality and an integral part of my artistic expression.

Atmosphere

Combining the elements of values and masses, color, light over dark, rhythms, and composition, I work to create still more of a sense of atmosphere in my pastels. All of these elements in proper balance create a feeling, an aura, about a picture. This is perhaps where painting passes from mere mechanics into art. For example, in pastel painting, I work with a light, feathery touch over pastels I can consider finished, with a technique that most closely resembles glazing or scumbling. This adds a subtle unity of color that adds to the sense of atmosphere. In areas of similar values I eliminate sharp lines, letting them slide away and slip into each other. I work in areas with different colors but

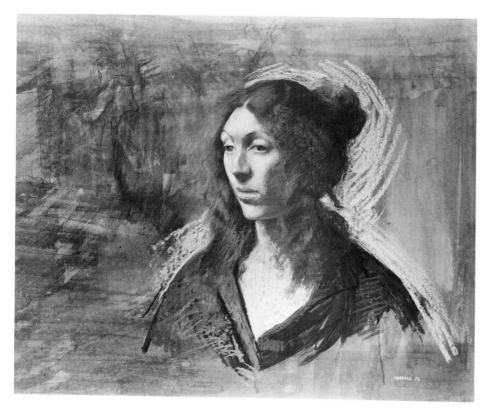

PORTRAIT OF MOE. *Sanded pastel board, 22 × 28" (56 × 71 cm), collection Eileen Kuhlich Gallery, New York City. First Prize, National Arts Club, 1973.* The subtle play of edges and their intermingling, even in a vignette type of pastel portrait, is clearly shown here. The portrait is painted on a dark, middle-value ground, with a portion of the light background painted in. The edges here are sharp and the portrait stands out against the light background. On the right side of the head, the background is left alone and the reddish brown hair, which is the same value as the background, merges very subtly into the original background tone. This acts as a dark contrast to the light on the right side of the face.

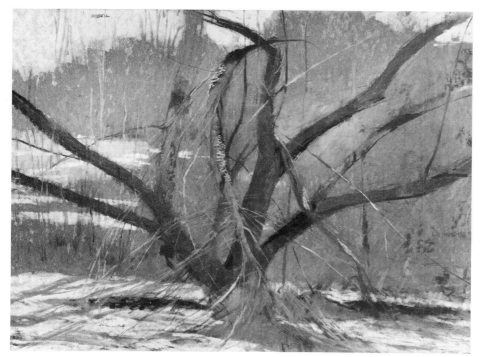

WINTER TREE IN SNOW. *Sanded pastel board, 16 × 22" (41 × 56 cm), courtesy Gallery of the Southwest, Taos, New Mexico.* The values in this painting are kept extremely simple. The painting is composed of the dark values of the tree trunk and branches, with a dark middle-value making up all the patterns behind the tree. The snow and the light gray of the sky are the same value and function as patterns to help relieve the simplicity of the value structure. However, it is precisely this utter simplicity of value that allows me to introduce another element into the pastel — rhythm — that gives it interest and excitement. Although the tree is stationary, notice the sense of life and motion of the trunk. The trunk is low to the ground and the branches are spread out reaching upward. This upward movement or rhythm of the tree contrasts with the dead limb that leans downward. The downward sweep is joined by the smaller branches and twigs, all repeating this same movement. This entire movement catches the eye and is sensed as a rhythm contrasting with the general growth of the tree and slope of the earth.

with similar value, playing down edges, allowing the colors to slide or float together in and out of each other. All of these aspects are very subtle and add vibrancy and a strong sense of beauty and reality to the paintings.

Standing or Sitting
Sitting or standing while you work is a personal preference. I prefer to stand since it is more my nature to move about as I work. It also allows me to better keep the subject at eye level, and to move back to view the progress of the painting when necessary. At times, especially when working on a portrait or still life 12 × 16″ (30 × 41 cm) or smaller, I like to sit. It is a relaxing way to work and good for working in close proximity to your subject.

Selecting a Subject
Capturing the essence of a particular subject requires much patient study and understanding. If you find yourself wanting to paint everything, you must learn to limit yourself, especially outdoors, where the subject matter is endless and the lighting conditions are forever changing. I myself have centered my outdoor work on a few select aspects of nature—closeups of trees, rocks and streams, and architectural subjects. I am strongly drawn to the dynamic quality that these closeup views provide. I also find that the closeup helps reflect the individual "sense of being" that each of these elements possesses. I never feel limited by my selective choice of subject matter. On the contrary, the possibilities open to me with just these few subjects are always new and exciting.

Likewise, indoors I am strongly drawn to the portrait and portrait pose more than the nude. I am also fascinated by the casual arrangements of items I find in the corners of my studio. Again, it is the dynamic quality of the closeup that excites and inspires me.

Whatever subject you choose to paint, listen to your innermost feelings. You won't always be able to verbalize why you choose to paint a particular subject in a particular manner, but when the feeling is there, you will know instinctively what you're looking for.

Working from Drawings
Drawing provides an excellent way to observe and study nature. You learn to see and feel as you draw. After a while it becomes second nature, a sort of language and lifelong habit. Carrying a sketchbook with you at all times and drawing whenever something catches your eye is a good practice.

As you continue drawing from life, your ability to recall subject matter will develop and you will be able to envision the subject again as you look at the drawing. Painting from your drawings is also a good way to acquire a thorough knowledge and understanding of the subject.

Working with Photographs and Slides
Today, many people are working from photographs and slides instead of nature. There are both advantages and drawbacks to this. On the positive side, a photograph or slide has many details you may lose sight of, and referring to it may prove very useful. On the other hand, photographic images are limited in scope and lack the excitement and movement that prevails when painting from life. Often I see beginning students becoming too dependent on photographs and slides too soon. The resulting paintings usually have washed-out colors embroidered with insignificant details, with little understanding of the underlying masses.

Thus, I feel that beginning students should stay away from slides and photographs and work from life as much as possible. In this way you will develop a personal vision not stultified by the photographic image. Once you have developed a vision all your own, you will find that using a photographic image will be an aid to your vision, not a hindrance.

Working from Life
Whether you are working indoors or outdoors, painting from life is an exhilarating experience. For me, it is the most exciting way to paint a landscape or street scene, and working from the live model gives you that human contact and energy flow that injects life into your painting.

Composition
I follow no set rules of composition but design each painting with a fresh eye. Although the paintings in the book offer a wide range of composition, they all share three qualities. First, they have a center of interest which draws you into the painting, capturing your attention. Then, apart from the specific techniques I use to accomplish this, simplicity is stressed to the utmost. Finally, the combined elements of the entire painting are developed harmoniously around the center of interest, a procedure known as "selective finishing."

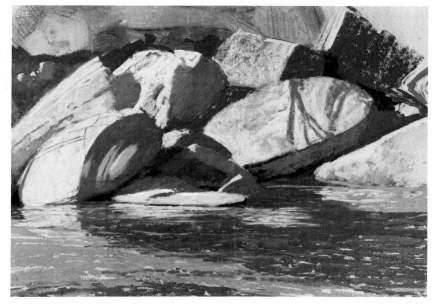

WOODLAND VALLEY. *Sanded pastel board, 18 × 24" (46 × 61 cm), collection the artist.* Pastels are excellent for quick, outdoor paintings done under rapidly changing lighting conditions. These rocks, located on the bank of a streambed in Woodland Valley, New York, were painted very simply using the open side stroke for the rocks and using linear strokes of different colors for the stream. The direction of the horizontal strokes alone was sufficient to give the water the necessary textural contrast from the rocks. The pastel was painted rapidly over a gray-toned sanded pastel board over a previously painted work. The old painting shows through in spots — notice the horizontal portrait in the upper left-hand corner, adding to the life of the pastel. Also note how simply and boldly the light and shadow patterns on the rocks are painted. I had to work quickly, for the light was constantly changing. By the time I finished, the subject matter was unrecognizable, as often happens outdoors.

Selective Finishing. Selective finishing involves determining the center of interest, zeroing in on this area and painting it to completion, then placing a lot of detail and strong contrasts there. I leave the surrounding areas relatively unfinished so they don't compete with the finished area. This gives the center of interest breathing space and forces the viewer to look there first. I then complete the rest of the painting, varying the amount of detail throughout the work.

Finishing a Painting

A painting should be carefully planned and each stage of development savored and enjoyed. When I work toward the finish of a painting, I develop it slowly, reflecting often as I work. The progress in the early stages is not abrupt, and I slowly feel my way around the painting, not getting too involved with details at first. Then, I suddenly reach a point where I feel in control; I know where I am and where I want to go with the picture. At this point, instinct and feeling take over, and I carry the painting to completion, establishing details and accents.

Basic Procedure for Outdoor Landscapes

Whether I am painting a landscape or a portrait, there is a certain basic procedure that I follow. I will now discuss many of the considerations that go into a pastel painting, from planning a composition to the use of the various pastel strokes. These elements will then be exemplified and clarified in the demonstration at the end of this chapter.

Outdoors the light changes quickly, and working with a fast, dry medium like pastel can make the difference between getting a picture or getting nothing. Because of the time factor created by the changing lighting conditions, I usually work smaller on location than I do in the studio—16 × 22" or 11 × 16" (41 × 56 cm or 28 × 41 cm). There is so much variety in the landscape itself, that I prefer to keep the background color of my paper constant and let nature create the variety. So I don't vary the color of my paper much but prefer a neutral ground—either a middle-value gray or a buff tone. Because of the necessity of carrying materials on location, I keep my palette simple. I work mostly with soft pasteln and some hard pastels, using a slightly different approach from my indoor work.

Blocking in a Landscape. When blocking in a landscape, I separate the foreground from the background, looking at them as two different areas merging into one picture, as in Demonstration 1, *The Old Shed*. I also establish everything darker than the value I plan to end up with, working with the pastel concept of light over dark. I establish all the darks in the picture first, using two colors of the same value, one warm and one cool. I use two colors rather than only one because there are so many rich colors outdoors, that if the painting is too monochromatic in the beginning I may have difficulty transferring the layout into full color. Most of the work at this stage is done with linear strokes, as I lay out the composition and drawing.

Establishing Light Areas. After the initial layout is set, I begin establishing the light areas. If a light area is in sunlight, I use light warm colors. If it is an overcast day, I use light cool colors. In this stage of the painting's development, I begin to use the open side stroke to establish the large color masses.

Developing the Center of Interest. At this point of the painting, I have already decided what will be my center of interest. I now begin to develop and establish it as clearly as I can. When I have built up the area to some degree, I start working on other areas of the painting and relate them all to the center of interest. As the picture continues to develop, I also begin to relate the initial center of interest to the rest of the painting. I work back and forth in this manner to develop an overall harmony. When both elements are united and the painting is nearly finished, I accentuate selected details.

Basic Procedure for Pastel Portraiture

The first thing that concerns me in portraiture is getting the right pose. To find a natural, informal pose, I relax the model, either with simple, pleasant conversation or by doing a drawing or two. First, I place the model in the lighting I want—flat light, where there is little or no shadow on the portrait, is the most desirable lighting in portraiture. Then, I have the model look straight at me at eye level and then turn from left to right very slowly. As the model turns, I observe how the dynamics of the proportions of the portrait change with each little shift of the face from left to right. Sometimes I am reminded of other types of people, or even of animals or birds. Each angle from left to right will either accentuate this peculiarity or play it down. I go after these aspects, considering them important to the character of the portrait, and I build the likeness around them. I feel that when an artist can merge the peculiarities and the specifics of the sitter with technical virtuosity, then portraiture becomes an art.

Positioning the Easel and Subject. The distance that the easel is placed from the subject varies with individual preferences. It also influences what you see in the subject. Painting close to the subject you can better concentrate on colors and details. Positioned farther back from the subject, the overall values, masses, and proportions are more evident. You may find it helpful to place the easel at a distance from the model three or four times the height of your painting.

When painting a portrait, I first make sure my subject is correctly lit, and then I position my easel appropriately. I like to keep the model at eye level in a portrait. I also like to use a sight-size approach, which eliminates problems of size reduction.

Sight-Size Painting. "Sight-size" is used when artists want to concentrate on proportions and don't wish to scale the sitter's portrait up or down in size. By positioning the easel at a distance from the subject so that both the sitter and the portrait itself appear the same size, you will automatically get accurate proportions because the lines on the sitter's head and your painting will match. In other words, the top of the heads will line up, the bottom of the chins will end at the same point, the base of the noses, and so forth. The objective here, of course, is to get the portrait as close to life as possible.

Angle of the Easel. The angle of the easel is unimportant in pastel painting because it is a dry medium and therefore won't have the annoying reflections found in a wet medium like oil paint. If anything, you should have the easel tilted slightly forward (counter-gravity) rather than slightly backward. This will allow improperly applied pastel to flake off easily.

Preparing to Work. Working indoors on a portrait, I first lay out all of my pastels on my pastel tray according to light, dark, warm, and cool colors. My pencils are laid out nearby in separate containers. Their order resembles a colorful crescendo-decrescendo. Like the musical notes, the colors build slowly from light, bright yellow to darker muted yellows, to yellow ochres; then to raw siennas and reds, warm and cool browns, reaching to black. They then start descending slowly into rich, dark blues, then lighter blues and blue-greens to purples and finally lighter values of green and purple. I also always have some soft vine charcoal on hand. I choose my surface from several I keep nearby of various sizes, textures, and tones so I can instinctively or immediately relate the surface to the subject matter. If I sense I will be working on the painting for two to four weeks, I will choose a rough surface that will allow me to work longer with pastel. If I feel the work will be completed in three or four sittings, I choose a smooth surface. At this stage I also determine whether I will be standing or sitting. Unless I am working very small, smaller

than 12 × 16″ (30 × 41 cm), I almost always stand because I work with much energy and excitement and can move more freely when standing.

Laying Out the Basic Composition. Before picking up any pastel sticks, I begin to work mentally, letting my fingers float over the blank surface as I get a feel for the painting I will be doing. I then pick up a dark-value brown hard pastel (no.203 P Burnt Sienna), and lightly indicate the composition and placement of the portrait. I then locate the features of the face, measuring constantly as I aim for an initial likeness. I then separate the light and shadows into shapes, and fill in the shadows with a color that works as a basic tone for the shadow area, letting the untouched part of the surface work as the light area. I keep developing the portrait as a drawing, working lightly and separating light areas from shadows. Once lights and darks are established, I look for small specific dark colors or very colorful areas, usually found in the clothing of the sitter, and block them in as two-dimensional patterns.

Developing the Center of Interest. All through the development of the pastel portrait, and especially during the beginning stages I am constantly drawing, measuring, and trying to capture a reasonable likeness. I now focus on the center of interest, usually an eye or both eyes, and define them, paying close attention to their shapes. I then constantly measure and compare the other features of the portrait to this center of interest. In this stage, everything is still very flexible and can be changed around. But as details are added, the picture gradually begins to tighten up, and the portrait likeness gets more exact. Instinctively, I keep this in mind and work as loosely as possible to allow for adjustments and changes. When the subject has been carefully and accurately drawn in and the light and shadows indicated I am ready for the next phase—building with color.

Building with Pastel. In the beginning stages of a pastel (the first half hour), I mostly use the hard pastels as I lay out the painting. Most of the development at this stage is accomplished with very few colors. I stress working lightly in the beginning to avoid cluttering the tooth of the painting surface with too much unnecessary pastel too soon. As the work progresses and I am more sure of what I want, I start working more heavily, using mostly the soft pastels. I keep developing the painting in this manner, working as long as needed to carry it to completion. In the final stages, the pastel pencils are useful for details.

The Portrait Vignette
The portrait vignette is a completed or detailed head on an unpainted or partially painted background. The body and clothing also may only be partially indicated, and the original tone of the paper is left untouched to act as the background. While a vignette may look unfinished in an oil painting, it has a special effect on toned pastel paper and often adds a strong sense of reality to the portrait.

Although the vignette approach has the advantage of letting you concentrate on the foreground portrait without concerning yourself with choosing the background colors, the portrait vignette tends to look cut out from the background. Therefore the edges where portrait and background meet are very important here. As you come close to the edges of the portrait, you'll be working to keep the rest of the paper clean while trying to avoid a cutout effect by keeping a sense of atmosphere that blends certain values of the portrait into the background tone. If your surface does become scarred with mistakes that are easily seen, however, they can be covered effectively with a few simple side strokes of a pastel of the same tone and value as the background.

Still Life and Other Indoor Subjects
The procedure for painting other indoor subject matter, such as groups of objects, is basically the same as that for portraiture, since the indoor setup and studio lighting are identical.

Demonstration: Portrait of Jack
To describe my painting procedure, I will now show you how I paint a typical portrait.

Materials
Sanded pastel board, 16 × 22″ (41 × 56 cm)
Limited number of hard Nu-Pastels:
 Sepia, no. 293-P
 Bottle Green, no. 298-P
 Ultramarine Blue, no. 275-P
 Tuscan Red, no. 273-P
 Olive Green, no. 248-P
 Cocoa Brown, no. 253-P
 Van Dyck Brown, no. 283-P
 Burnt Sienna, no. 203-P
Full assortment of soft pastels

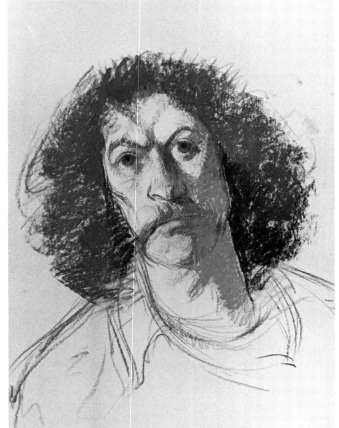

1

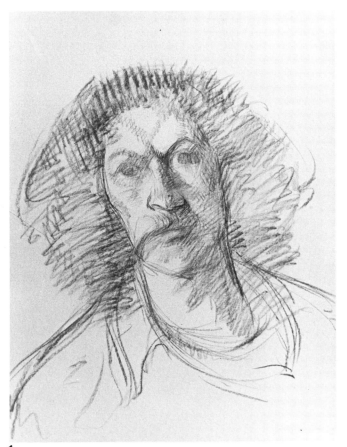

2

Step 1. Working on a middle-value gray background, I begin to sketch the portrait using two hard pastel colors: sepia (no. 293-P), a warm, dark color; and bottle green (no. 298-P), a cool, dark color. Both colors are very close to each other in value. I establish the size, placement, and the general proportions of the portrait basically by applying linear strokes with a light, free hand.

Step 2. Expanding my pastel colors to six or eight chalks, I block in the shadow area of the face and neck, again using different colors of the same value: Tuscan red (no. 273-P), olive green (no. 248-P), and cocoa brown (no. 253-P). I then use three darker colors to block in the hair mass: Van Dyke brown (no. 283-P), burnt sienna (no. 203-P), and ultramarine blue (no. 275-P). These colors are also close in value and, used as a group, create color variety yet maintain the value unity of the shadow mass as a whole. I also use Van Dyke brown and ultramarine blue to define the center of interest—the eyes. The portrait is now ready for the next phase, building with color.

Step 3. Switching to soft pastels, I translate the shadow areas of the portrait into creamy beautiful colors. I also linearly block in the lights of the portrait with light fleshtones, letting the strokes follow the forms and rhythms of the head. With a deep, blue-green, I block in the sweater with sweeping side strokes. From now on, the hard pastels and pastel pencils are secondary and used only for details.

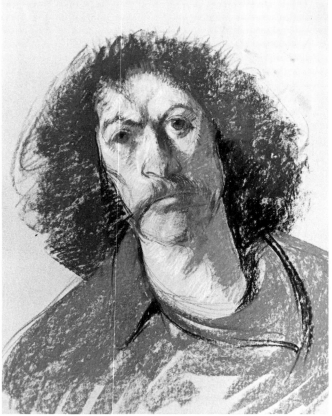

3

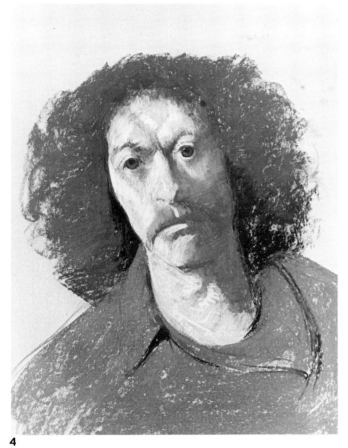

4

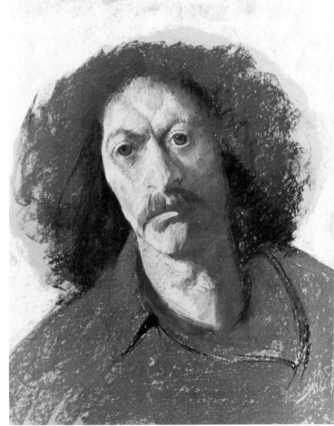

5

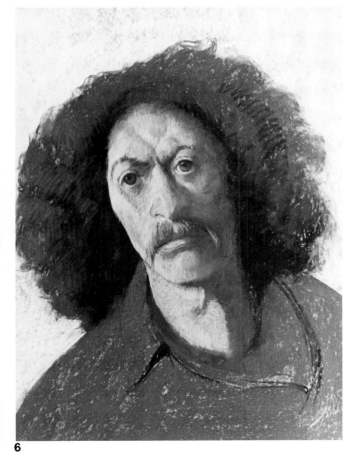

6

Step 4. I slowly develop the portrait, painting the strong colors in the light area with Rembrandt soft pastels—for example, no. 235.9, a light orange; no. 331.9, a light tone of madder lake deep; and no. 339.9, a light tone of English red. I further develop the shape of the hair with a rich reddish brown, offset with cool olive greens, its complement at the same value. I darken the shadows on the hair with ultramarine blue to balance the warm colors. Until this point, I have concentrated on the buildup of the portrait. I now begin to harmonize the values and colors in the painting.

Step 5. I establish the light background using the side stroke so that it clearly clarifies the entire shape of the head and relates to the light area there. I must also harmonize the colors in both areas. I work more detail into the neck and darken and densify the shadows of the hair with dark blues.

Step 6. Now the shape and boundaries of the hair are defined, painted to completion, and harmonized with the background so the strong contrasting values of dark hair and light background can flow a bit. Then I gently glaze a flesh-tone Conté pastel pencil over the head, floating the color on lightly to harmonize all the colors there. I finish the portrait with a combination of soft and hard pastels and pastel pencils, pulling out select details and accents.

Using Mixed Media

Although pastel alone can create strong, rich paintings, I often like to mix pastel with other paint media to achieve an extra dimension of life and excitement.

In painting a complicated subject, when I try to cover large color areas of the painting solely with pastel, the work often gets chalky, dense, and lacks textural variety. Also, the tooth of the surface fills in long before I'm finished. By using another medium to lay in these same large color areas, and work on top of it with pastel when it dries, I can avoid the overworked appearance that can otherwise result from working with pastels alone. The tooth of the painting surface is also preserved this way and I can then work even longer on the pastel if I wish. I like to use other media to lay out the tones and colors of my underpaintings to establish deep, rich, dark colors I can build upon with pastel colors. The mixed-media approach also permits me to lay out the entire color design of the painting in terms of color patterns, using thin transparent color washes.

Texture and Color Effects

The greatest effects that can be achieved with mixed-media pastel painting are in the areas of texture and color. Since the underpainting becomes part of the underlying tones and colors, these colors remain separate yet blend with the layers of pastel on top of them. These underpainted colors could be left partially visible to vibrate through the pastel in the finished work or they can simply be used as a color base upon which to completely work over with pastels. For example, if you want the underpainting colors to vibrate through, you can use an "open" side stroke with soft pastels when covering these large areas. This is a light stroke that catches only some of the tooth, leaving some areas uncovered and is very effective, especially on a rough surface like a sanded pastel paper or marble dust board. On the

other hand, you can have a completely closed side stroke where none of the underlying colors shows through. This is because the closed stroke is heavier and thicker than the open one. The closed stroke is used more frequently over an underpainting of weak color tones that are laid out essentially to give an early sense of the color scheme of the painting. I often vary the side strokes, using both open and closed strokes in combination.

When working over an underpainting, you also can use pastels to get textural variety or built-up color effects. Or you can use contrasting colors in the underpainting to get optical color effects with the pastels. Another effect is to float just a small amount of pastel over an area underpainted with another media, so that the area can breathe, be united with the rest of the pastel painting, yet stand alone for color and textural contrast. Remember, pastel is an opaque medium that tends to be dense, so you must do the underpainting with *lean* color washes. Using mixed media in the above manner can give a sense of transparency that will greatly enhance your pastels, giving them the appearance of being more dense without their actually being denser.

Technical Considerations

Pastel will not adhere well to a slick, oily surface. So whatever mixed media you choose, be sure the surface does not become oily.

As a general rule, it is best to use mixed-media techniques on mounted surfaces such as sanded pastel boards or marble dust boards to avoid buckling. All papers should be mounted, too, especially when using water-based media. The only exception to this is the 3-M wet and dry sanded pastel paper, which will take water without buckling. The Grumbacher and Morilla sanded pastel papers will take turpentine and turpentine-based media without buckling, but will ripple when used with a water-based medium.

Another consideration is the tooth of the surface. A rougher surface is better suited to mixed media techniques than a smoother surface. Also, I recommend that you apply the underpainting in thin color washes, free of lumps, to further preserve the tooth.

Lastly, always be sure to allow the underpainting to dry thoroughly before applying pastel. Otherwise you may damage the tooth of the surface, or the pastels may come apart. The drying time varies with the type of paint used: from 15 to 45 minutes for all water-base paints and longer for thinned-out oil paints. Experiment with the various types of paint and surfaces to learn more about the way they work.

Recommended Mixed Media Approaches

The following ways of mixing other media with pastels are ones I have experimented with over the years and have come to prefer. Each medium possesses its own unique qualities and characteristics in adding that "something special" to a pastel painting.

Pastel and Charcoal

Pastel and charcoal applied together create a magical combination. When I speak of charcoal and pastel, I always mean the soft vine charcoal, never the hard compressed charcoal pencils. The charcoal, when used as a unifier, is applied in much the same way as the pastels themselves,

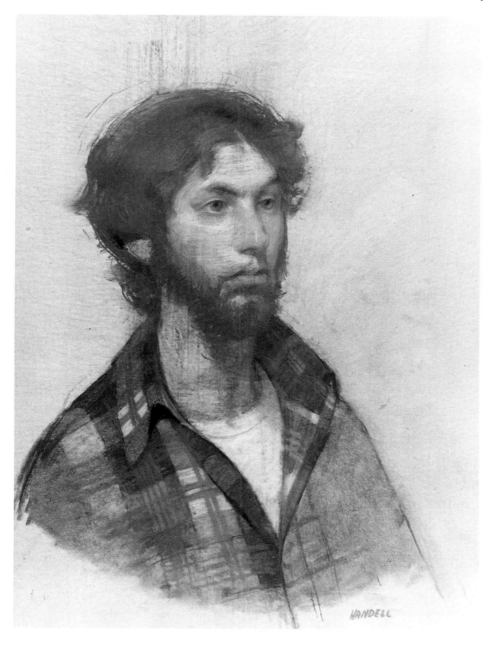

PORTRAIT OF BRUCE. *Sanded pastel board, 18 × 24" (46 × 61 cm), collection the artist.* Although both soft artist's charcoal and pastel are dry media, mixing them creates special luminous optical color effects. In stark contrast to the multitude of colors of the pastels, the charcoal is ashen and colorless. In this portrait, I laid in the plaid shirt with charcoal and gently blended it with the edge of my thumb to achieve a characteristic muted ashen gray tone. I worked the other colors of the plaid shirt on top of this tone using soft pastels. The shirt by the sitter's left shoulder was left unfinished to show the beautiful contrast and harmony of the two media. On the other hand, the head was first painted using only pastels. Then, to harmonize the pastel colors and to lower the tonal key of the entire portrait, I gave the entire head a delicate glaze of soft charcoal, gently applied with a light feathery touch. Here the blended charcoal is absorbed and hidden from the viewer's eye in the finished work.

and adds a soft velvety unity and harmony to the overall colors of the entire painting. I also often refer to charcoal as a "thinking tool." When planning out the beginning stage in the painting's development, many times I pick up charcoal rather than a pastel to work with. In this way I can work out the basic drawing and patterns of light and shade before getting involved with color. (See *Portrait of Tony*, Demonstration 2).

Pastel and Turpentine or Fixative

Using turpentine or pastel fixative as a dilutent is a way to mix another medium with pastel directly. You may use pure gum spirits of turpentine or liquid pastel fixative that is sold in jars—not spray fixative. (You can also mix your own fixative at home,

as described in the Appendix).

The procedure is to apply the pastel a bit heavily at first, establishing all the local color areas to be underpainted. An open side stroke with soft pastel is excellent for this. Then, taking a clean brush and clean turpentine, wet down a color area of the painting. Clean your brush again and brush clean turpentine on the area(s) where you want the pastel colors to look like paint. As the pastel mixes with the turpentine, it takes on the quality of paint and the color becomes richer and darker than it was originally. When dry, the color will remain this way—a bit darker and richer. Reapplying the same color on top of this underbase will then give you a tremendous variety of color and texture from the same pastel color.

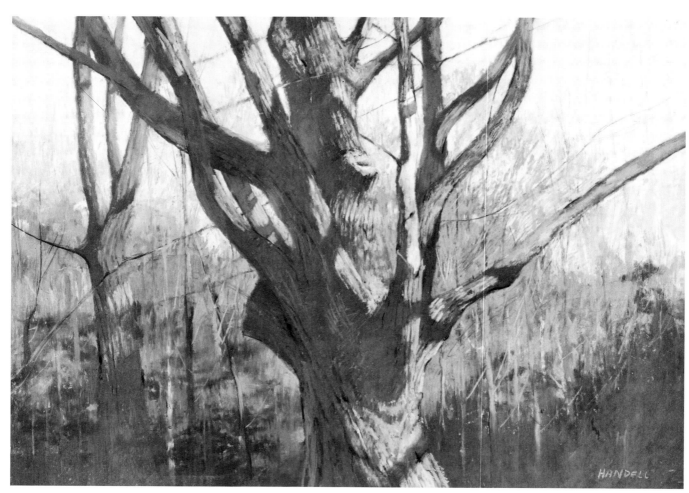

ANTLERS. *Sanded pastel board, 18 × 24" (46 × 61 cm), collection the artist.* I first blocked in the large color areas with soft pastels and an open side stroke. Then I dipped a brush into clean turpentine (you may also use pastel fixative) and wet each area of color, using a clean brush for each, to change the pastel to a paint quality (see also Demonstration 4, *Portrait of Carol*). When the turpentine was dry, I worked over the multicolored washes with pastel. The pastel sits beautifully on this type of underpainting, allowing wonderful textural effects that are very conducive to painting the back of trees.

This technique is best for blocking in the background, clothing, hair, and everything that has rich colors and frames in the portrait. But I don't recommend this technique for the very light-toned areas, such as the lighted areas of the portrait, since the colors become darker and could turn these areas muddy.

Turpentine combined with pastel is a fast-drying technique and works on sanded pastel papers, sanded pastel board, and marble-dust board. For added textural variety in the pastel buildup, you can dip your pastel into the turpentine or pastel fixative before applying it to the surface. Only be careful not to tear the surface as you apply the wet pastels, and don't apply too much pastel, or it could become muddy on the surface.

Pastel and Diluted Oil Paint

When using diluted oil paint as an underpainting for pastels, always mix it with fast-drying turpentine. Never use a slow-drying paint medium like linseed oil, which would take a long time to dry and would leave the surface too slick to accept pastel.

To apply the oil color wash to your surface, dilute a small amount of oil paint, any color, with lots of turpentine either straight from the tube or any color mixed on the palette. Mix them together until you achieve the consistency of a thin wash, making sure the paint is thinned and there are no lumps. The resulting color washes will be transparent and should not be pasteled over until they are completely dry. A good rule of thumb here is to wait until the following day before working over it.

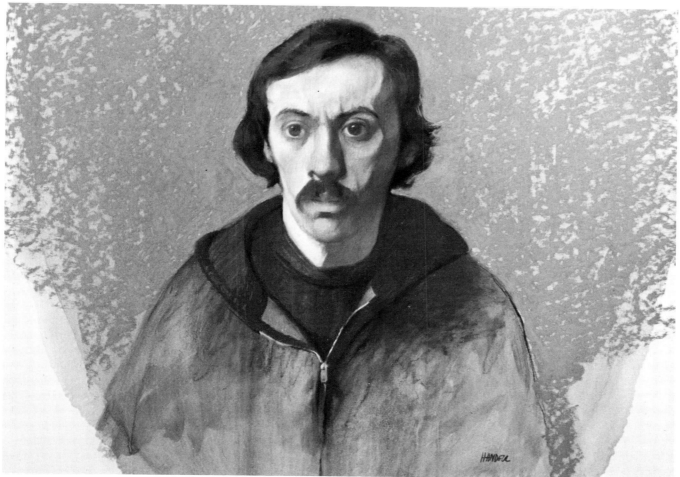

PORTRAIT OF JOHN. *Sanded pastel board, buff tone, 22 × 28" (56 × 71 cm), collection the artist.* Although the portrait was developing well, I felt that the buff-toned ground was not contrasting strongly enough with the head. So I decided to stain the board with a diluted oil and turpentine wash. (This approach is not recommended for beginners, but can be done successfully with practice.) I diluted burnt sienna oil paint with turpentine until the paint was the consistency of turpentine and added some diluted cadmium green light to tone down the sienna. Then I washed in the background loosely, taking care not to touch the head. When it was dry, I blocked in the sweater with chrome green deep, no. 609.5, a soft pastel. I then brushed turpentine over this pastel, changing the chrome green pastel to a paint quality. Again, when it dried, I reworked the sweater very slightly with pastel.

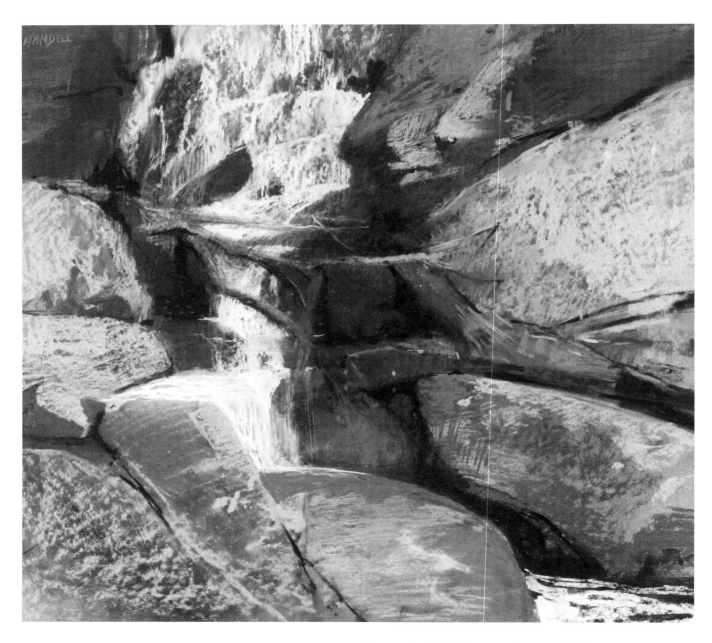

PEEKAMOOSE FALLS. *Sanded pastel board, 24 × 24" (61 × 61 cm), collection Peter B.T. Houghton, High Falls, N.Y.* Running water is a difficult subject that requires much study to paint. Peekamoose Falls is one of my favorite painting areas in the Catskills and I go there often. The technique I used in laying out the painting worked out well for me, for I had often observed the subject and actually had been thinking about the painting for some time before I began to work. Working in the studio from a detailed drawing I did on location, I first laid in all the colors of the painting with oil colors very diluted with turpentine, so that the entire painting had a beautiful loose quality. The following day, when the oil washes were completely dry, I went to the falls with my pastels and finished the painting on the spot. The advantage of using a mixed-media technique is the lovely underlying color washes. They gave me a good sense of the entire design, composition, and color scheme before I made my first stroke with pastels. On location I was then able to concentrate on capturing the fleeting moment of the cascading, flowing water and the delicate colors of the rocks and boulders.

Pastel with Watercolor and Ink

Watercolor and ink are both transparent paint media with similar beautiful, rich, luminous color effects. The transparency of these washes gives the underpaintings a brilliancy of color which is best appreciated on light-toned grounds. The watercolor needs to be diluted and greatly thinned out, but the inks can be used directly from the bottle or diluted with water for lighter values. Both media should always be used on mounted surfaces because water will cause papers to buckle easily. An added advantage of using watercolor and ink is that you can lay out the design and composition of the painting entirely through these color washes. Then when dry, you can work the pastel on top of the washes in an interesting way, combining the

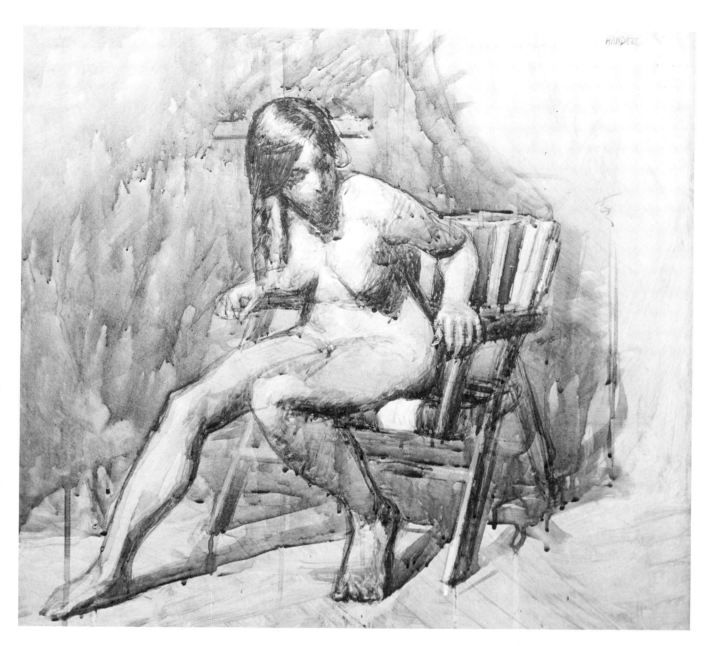

subtleties of both media.

When using ink, I tend to use richer, darker colors. I usually choose black, sepia, and ultramarine blue, and at times some rich red or green. Avoid light washed-out ink colors. All of the Winsor & Newton watercolors are good, and Higgins and Pelikan artist inks are the brands I prefer. Both ink and watercolor are relatively fast drying, and tend to dry lighter than when first applied.

Pastel with Acrylic, Casein, Gouache, and Tempera

In contrast to watercolor and ink, which are transparent media, acrylic, casein, gouache, and tempera are comparatively opaque. All four media are fast-drying, and since water is also the medium

SEATED NUDE. *Diluted inks on sanded pastel board, 24 × 24" (61 × 61 cm), private collection.* Underpainting with diluted inks on sanded pastel boards for pastel, or on Masonite panels for oil paints is one of my favorite ways to start a painting. Many of my finished pastels and oils looked just like this wash drawing at one point. The advantage of this type of underpainting is that it allows me to work with pastel over a beautifully established tonal drawing, on which I already have worked out the design of the painting in diluted ink. At this point I have a good idea of what the finished picture will look like right from the start. Perhaps the only disadvantage of using this mixed-media technique is that, like me, you may fall in love with the ink drawing itself and stop painting at this stage without ever touching it with a single pastel.

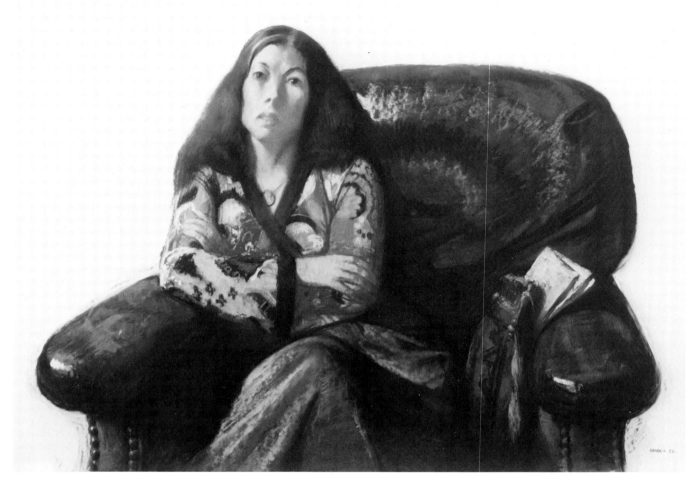

PORTRAIT OF HARRIET. *Sanded pastel board, buff tone, 22 × 32" (56 × 81 cm), collection Mr. and Mrs. Jan Dymant.* The sitter was surrounded by many rich colors and the smooth texture of a large leather chair, all of which were ideal for a mixed-media pastel painting. After laying out the entire painting on a buff ground, I decided to leave the whole pattern of the subject seated in the chair as a vignette. This called for delicate brush manipulation. I blocked in the colors of the reddish brown leather chair, the dark hair, and the colors of the multipatterned robe with transparent watercolors. When the colors were dry, I concentrated on the head, then carried the painting to completion by working the pastel to capture the texture of the chair, the hair, and the colorful patterns of the robe. Here the watercolor underpainting works as a color base for the pastels.

for diluting these paints, any water-soluble paint can be interchanged with another. This is an important point. Even though I use all these media as underpaintings for my pastel demonstrations, they are actually interchangable with each other for the final effects. I chose different media only to show you how they all can be used.

Acrylic is an insoluable, flexible, polymer medium made with a synthetic resin. It is extremely permanent and is available in a great variety of colors, all of which are suitable for pastel under-painting. To make an acrylic wash, you dilute the paint with water or acrylic medium (or a combination of the two) to a *thin* consistency in a small jar or dish, making sure there are no lumps in the paint. Then you brush the mixture evenly over the painting surface.

Casein, gouache, and tempera can also be used on mounted surfaces with satisfactory results. Casein has a skim-milk binder and dries with

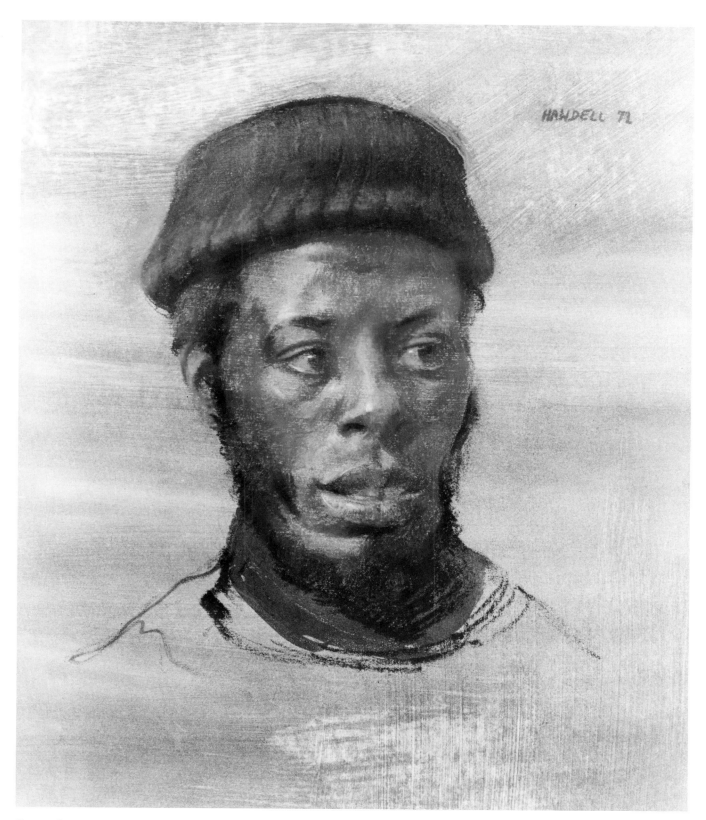

EMILIO. *Sanded pastel board, 18 × 24″ (46 × 61 cm), collection Mr. and Mrs. Harold Fried.* Here is a lively pastel portrait of a subject in a turtleneck sweater and wool cap. I blocked in the head, shoulders, and hat with just a few lines, then focused again on the head, carrying it close to completion. I then brushed in the turtleneck of the sweater and wool cap with ultramarine blue Higgins ink. When dry, I painted and finished the wool hat with pastel, using the blue as an underbase that was later completely overpainted. However, the turtleneck, which was not overpainted with pastel, still shows my ink brushstrokes.

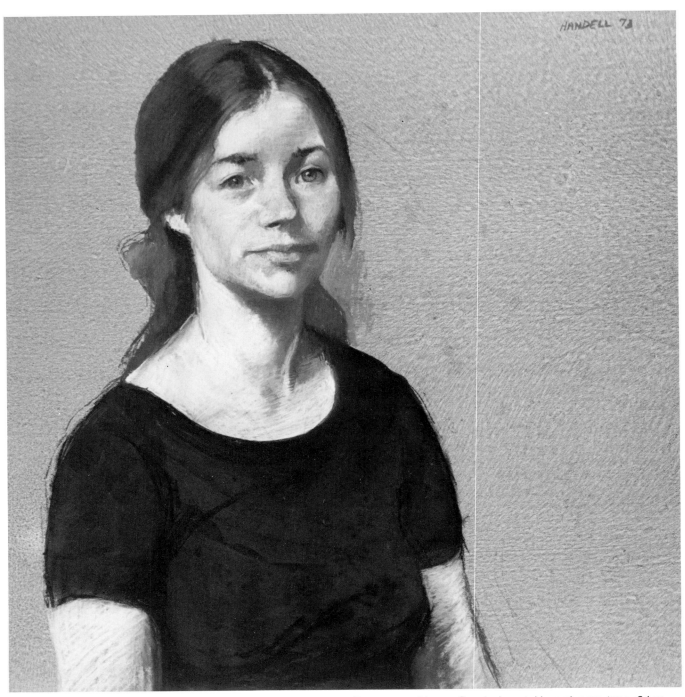

PORTRAIT OF MORIN. *Sanded pastel board, gray-tone, 24 × 24" (61 × 61 cm), private collection.* This pastel vignette of Morin was painted on a gray-toned ground. I laid out the entire portrait a bit to the left of center, since the pose indicates that she could easily be turning her head and looking to the left. First I blocked in the head with a sepia pastel. Then, with diluted acrylic paint, I added a bit of ultramarine blue to ivory black to produce a very cool black. I brushed this black over the hair and sweater and, when it was dry, I worked over the hair with pastel, using the underpainting as a tonal base. The underpainting of the sweater was left practically untouched for variety, with only slight accents of pastel delineating creases and folds. The sweater therefore provides a wonderful opportunity to see what a mixed-media underpainting looks like before it is overpainted with pastel.

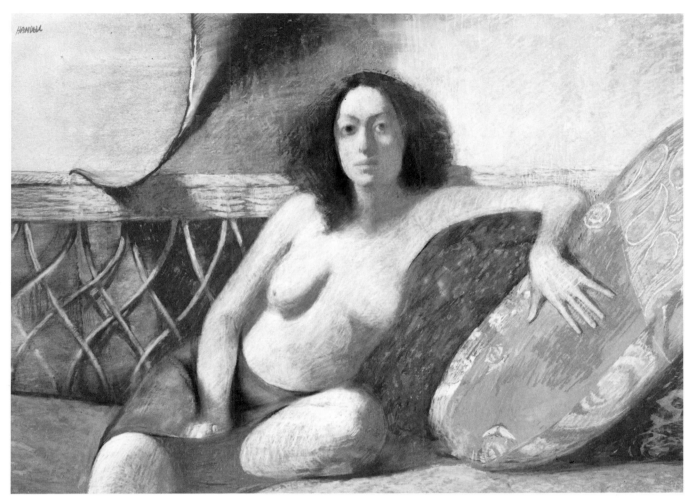

SEATED FEMALE NUDE. *Sanded pastel board, 22 × 32" (56 × 81 cm), courtesy Gallery of the Southwest, Taos, New Mexico.* Begun as a demonstration for one of my pastel workshops in Woodstock, I later worked on this painting in the studio for quite some time. I started the pastel by working on the portrait first, then on the figure, and then on the background and surrounding objects. After that I went back to the portrait, developing it further, and blocked in the hair with black Higgins ink. I then diluted the ink, and using half ink and half water, I blocked in the pillow the sitter was leaning on. The black ink was used again for the design in the bottom pillow in the right-hand corner of the painting. As these areas were drying, I worked on other parts of the pastel. The background was established with pastel colors and later washed over with a clean brush dipped in turpentine, which made the pastels look like paint. The entire painting was then worked over with pastels. Toward the final stages of the pastel, I used soft vine charcoal to help harmonize and unify the rich colors of this painting.

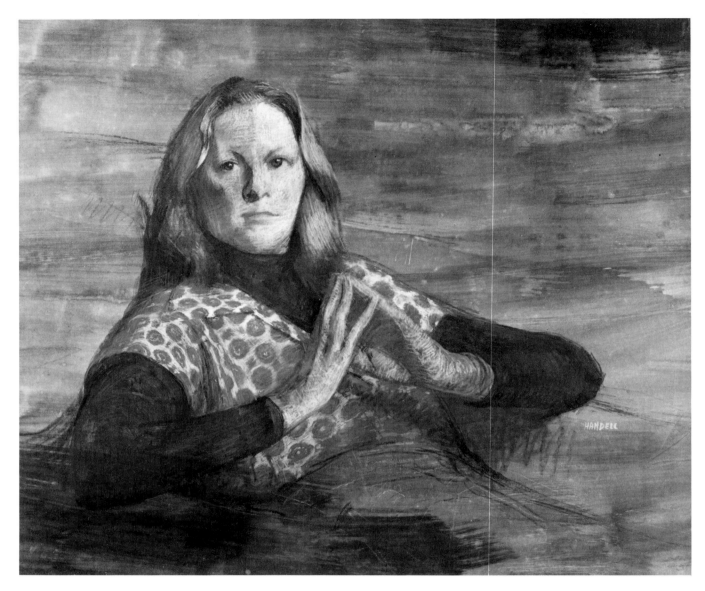

MARIANNE. *Sanded pastel board, 24 × 30" (61 × 76 cm), collection Dr. Suzana Bouquet Chester.* The tempera background was first brushed in to get an irregular, haphazard texture. The colors were greatly diluted with water, however, since tempera is very opaque. When the background was dry, I blocked everything in freely with soft pastel. The purple tempera of her sweater was thinly applied and complemented her dark blond hair, which was also initially underpainted with purple tempera. I also harmonized the colors with soft charcoal, as in the cast shadow under the sitter's left arm.

a mat or semi-mat finish. The Shiva Company makes a good quality casein paint.

Gouache is opaque watercolor. It can be applied in diluted washes like transparent watercolor.

Egg-emulsified tempera can no longer be purchased in tubes, but tempera can be bought in jars as poster colors. Tempera poster colors can be used as a pastel underpainting if they are properly thinned out in color washes.

Working with Color

After years of studying and painting in pastel, I have evolved an approach to pastel color I find most rewarding. I will first discuss basic color terminology and review the colors in the various types of pastel and their permanency. Then I will describe how to organize your own palette, use limited and full-color palettes, and finally, discuss how to work with color in pastel.

Basic Color Concepts

An understanding of the following color terms will help you use color successfully:

Primary Colors. Primary colors are basic colors that can't be mixed from any other colors; they simply exist. The primary colors are red, yellow, and blue. By mixing all three primary colors together in equal and unequal amounts, you can produce various tones and shades of browns on your palette. These are known as tertiary colors.

Secondary Colors. Secondary colors are formed by mixing any two of the primary colors together. The results are:

Red + Blue = Purple
Red + Yellow = Orange
Yellow + Blue = Green.

Tertiary Colors. Tertiary colors are produced by mixing a secondary color with the primary color that was not used to make it. For example, by mixing a warm red (a primary color) and a warm green (a secondary color, and also the complement of red), we get one kind of brown. Tertiary colors are endless, for we can also mix a warm red with a cool green and make still another brown. And, of course, we can change our browns again by mixing a cool red with a cool green. This goes on and on with all the complementary colors that exist. Another example would be yellow (a primary color) mixed with purple (a secondary color and the complement of yellow). Just imagine the different browns you would get by mixing different yellows with different purples. So, as you can see, tertiary colors are extensive. They basically comprise all the browns that exist on your palette.

Complementary Colors. The primary color not used for the mixture of any secondary color (green, purple, or orange) is its complement. For example, orange is mixed from yellow and red; the primary color that is missing in this mixture is blue. So blue is the complementary color of orange.

In pastel painting, a color stroked over, on top of, or into its complement will tend to neutralize the original color without losing much of either color's intensity. But if they are blended rather than stroked, the two colors will lose their essential hue and become grays or browns. Placed next to each other in color areas of different sizes, they will appear to intensify each other through color contrast. So if I am painting a bright red barn surrounded by its complementary color, the green of summer foliage, the two complementary color areas will intensify each other. The red barn will appear to be very red and the surrounding green foliage will seem even greener. To harmonize and soften the colors in a situation like this, I slip some red into the green foliage and add some green to the red barn.

Local Color. Local color is the actual general color of an object (such as a "red" dress), with or without the modifying effects of the color from the lighting or reflected light on the object. When we say trees are green, we are referring to a generalized local green color, for they are a light yellow green color in the springtime, yet another color green in late summer, another on a gray day, and yet another color green in sunlight and in the shade.

Hue. "Hue" is another word for "color," and commonly refers to the local color of an object.

HAY BALES. *Sanded pastel board, 17 × 22" (43 × 56 cm), collection Dr. and Mrs. Richard Stevens.* The colors here are built around strong, simple, clear value relationships. The composition and the effect of the sunlight were grasped as light and dark patterns, made up of colors that were either very light or very dark patterns, and either warm or cool. Again, the patterns of light and shadow changed quickly under this type of lighting condition, and I had to work rapidly. The warm gold bales of hay contrasted with the cool light purples of the wooden structures of the barn in sunlight. Even the background green behind the wooden fence contains some purple.

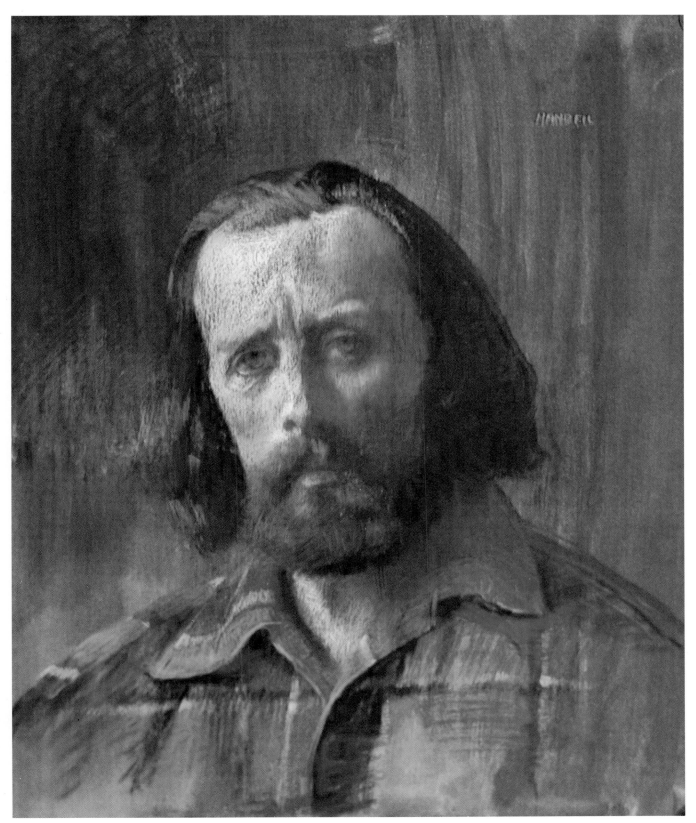

PORTRAIT OF PHIL HAVEY. *Sanded pastel board, 14 × 18" (35 × 46 cm), private collection.* The halftones in the forehead plus the strong value contrasts on the portrait playing against the dark background and dark blue shirt allowed me to use striking color contrasts in each area of the painting. The shadows on the face are dark, warm, reddish browns, while the halftones on the forehead have lots of green and gray nuances in them. These red shadow areas and green halftones are complementary colors, and thus add to the vibrancy of the skin tones. The cold dark gray background color is also repeated in the plaid shirt.

THE SLEEPING ROCK. *Sanded pastel board, 18 × 24" (46 × 61 cm), private collection.* When I paint rocks or trees, I sometimes like to fantasize that they are strange creatures. In *Sleeping Rock*, I imagined the foreground rock as some large water mammal, partially out of the water, sunning himself asleep on a rock. Here the sunlight values are strong and intense, aided by the strong, rich shadows in the foreground. Directly behind the sunlit rock, a large area of the painting lies under a cool shadow, and the water contains many reflections illuminating the cool colors found there. Playing warm against cool in conjunction with light against dark, as I do here, is always a good way to intensify the contrasts in a painting.

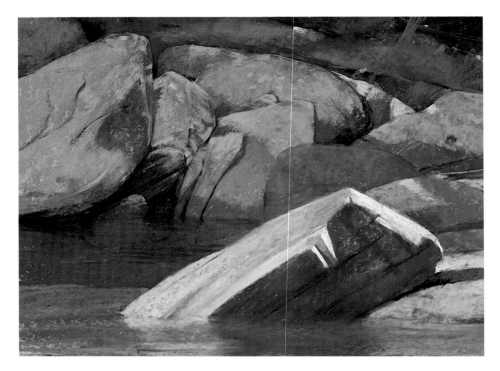

ROCKS ALONG THE SAWKILL STREAM. *Sanded pastel board, 17 × 22" (43 × 56 cm), courtesy Gallery of the Southwest, Taos, New Mexico.* The light of a gray day illuminated these rocks along the Sawkill Stream. Lighting conditions like this allow you to see the true local color of the rocks and surrounding areas. But because of the cool overhead sky, all the colors in this painting are on the cool side. The horizontal slabs of rock are a cool, rich, reddish purple, with heavy cool-gray rocks sitting on top of them. The colors of these two areas intermix. The reddish purple slabs contrast beautifully with the green background foliage. These complementary colors, all kept very cool in this painting, are separated by the delicate grays of the rocks.

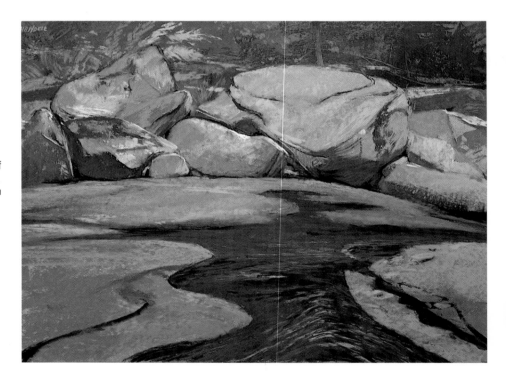

Value. Every color can be seen as a value. You can determine the value of a color by translating it into its degree of lightness or darkness on a scale of grays ranging from white to black. To understand the concept of color seen as value, picture a black and white photograph of a colorful scene. The myriad colors that normally would be seen now appear only as gradations of gray, with black as the darkest dark and white as the lightest light.

Intensity. Intensity refers to the color at its purest and brightest state, for example a bright yellow. If you were to take this yellow and mix it with a gray at the same value, its intensity would be lessened, but its value and hue would remain the same. This would be true of any color mixed with the same-value gray.

Color Temperature (Warm and Cool). All colors fall basically into either a warm or a cool category. Warm colors are essentially the yellows, oranges, reds and reddish purples. Cool colors are essentially the bluish purples, blues, and greens. Naturally, within these categories, there is room for many subdivisions. For example, when comparing greens to each other, there are warm greens, cool greens, and greens that are in between that could be considered neutral greens.

The use of warm and cool colors to create the illusion of colors advancing and receding is an important way to manipulate color. For example, a warm, intense, light-value color like cadmium yellow light will vibrate and advance forward. But if you place a light blue of the same value next to it, the blue will look darker and heavier than the yellow and will therefore seem to recede. Of course, since the values of both colors are the same, a black and white photograph would reveal them to be two patches of the same gray tone. This proves that some effects produced by color are due to a difference in color temperature rather than a difference in value.

Color in Pastel

Although I described hard and soft pastels and pastel pencils in Chapter 1, I would like to review the specific colors available, discuss how the manufacturers code them, and say a few words about their permanency.

Color in Hard Pastels (Nu-Pastels). As I said earlier, Nu-Pastels are available in an assortment of 96 colors. They do not come in varying tints of lightness and darkness of individual color as do the soft pastels. Many of the Nu-Pastel colors are dark rich colors, and are especially plentiful in the middle and dark range—values 6 to 9. Hard pastels can be added to your soft pastel palette to broaden your range of colors and values.

Color in Pastel Pencils. I use both Carb-Othello and Conté pastel pencils. Both brands come in fine assortments of very light to very dark colors. Carb-Othello pencils are available in 96 colors, and Conté in 36 colors.

Color in Soft Pastels (Rembrandt Colors). The best way to work indoors with pastel is to buy a complete set from one manufacturer, purchased in tiers of trays. All manufacturers have a different system for naming and numbering their pastels, and lists of the complete range of their colors are available from each manufacturer. Since I prefer and use the Rembrandt brand of soft pastels in the demonstrations in this book, however, I will describe their coding in more detail.

There are thirty-six different colors—with four or five tints of each color, plus black and white—available in the Rembrandt brand, making a total of 150 colors. The pure pigment is lightened in four steps with white and darkened in two steps with black, producing a series of seven tints for each color. Each stick is labeled with a color reference number, a decimal number which refers to the tint, and a group price code that permits the price of the pastel to be seen at a glance. The cost of a pastel stick depends upon the cost and amount of pure pigment used to make it.

To see how the system works, let's look at the classification for cobalt blue. (Of course, the same method of classification applies to all other colors in the series as well.) Since the color reference number of cobalt blue is 512, each stick of cobalt blue is coded as follows:

with 40% black	512.3A
with 15% black	512.4A
pure pigment	512.5A
with 15% white	512.6A
with 40% white	512.7A
with 60% white	512.8A
with 80% white	512.9A.

The decimal number refers to the amount of black or white in each color gradation (value) of cobalt

blue. The .5 decimal after the number is always the pure pigment. The decimals above .5 contain various percentages of white added to the pure color for lighter shades and the decimals below .5 contain various percentages of black added to make darker shades. The price series for 512 could also vary according to the cost of an individual pigment and the amount of that pigment needed for a particular shade. Thus 512.7A, for instance, would be less expensive than 512.3C.

Lightfastness

Correctly framed under glass, pastel color is permanent. The only possible problem is the lightfastness of some individual colors. "Lightfastness" means a color's resistance to fading over an indefinite period of time.

Pastel manufacturers usually indicate the lightfastness of each pastel on the label of each color. Grumbacher has a lettering system, and Rembrandt uses a code. For example, the Rembrandt code is as follows:

+ + + = Highest degree of lightfastness
 + + = Normal degree of lightfastness
 + = Low degree of lightfastness.

The Eberhard-Faber Company, makers of Nu-Pastels, offers a chart that rates each of their 96 colors according to their performance under a 72-hour Fadometer Test, involving continued exposure to extremely strong lighting conditions. (Upon request, they will mail you a copy of the test. Write Eberhard-Faber Company, Wilkes-Barre, PA 19773.)

If printed information on a particular color is unavailable, you can make your own colorfastness test. Simply draw an 8″ (20 cm) line across a sheet of white paper with the side of the pastel color you wish to investigate. Block off half the line by covering it with an opaque sheet of black paper and tape the entire sheet to the inside of a window with a southern exposure, letting the colors face outward to receive the light of the sun. Keep the paper in the window for about thirty days, then remove it. Uncover the part of the line protected by the black paper and compare the two areas of the 8″ line. If the color exposed to the sun has changed, then it is not permanent; if it has remained unchanged, the color is permanent.

Organizing Your Pastel Palette

I separate all the colors of my pastel painting palette into two of the three compartments on my pastel tray, according to warm and cool colors. All the cool colors—purples, grays, greens, and blues—are put in one compartment, and the warm colors—reddish purples, reds, oranges, yellows, and browns—are placed in the other. I leave the third and largest compartment for the chalks I am presently using. But when I'm finished with the painting, I return the colors to the other two compartments. Since, when I paint, I intermix warm and cool colors to achieve the color mixture I want, organizing the palette this way facilitates my use of color.

Control over values eventually will become second nature, but if you are new to the medium of pastel and unsure of the values of your chalks, it may be a good idea to organize your palette according to values rather than color temperature. To do this, I suggest keeping all colors that are light in value to your left, all colors that are middle value in the center, and all dark colors to the right. With this method, the value structure of your painting will predominate, with color temperature secondary, facilitating the study of color as value. Once you thoroughly understand this, though, you may want to emphasize color more and will be able to take better advantage of a palette divided into warm and cool colors.

Choosing a Palette

There is no limit to the colors you can accumulate for a full working palette of pastels. Because the colors are pre-mixed into individual sticks, any tonal variation of a specific color requires another pastel. Just be sure each color area of your palette is well balanced with both warm and cool colors of various values.

Working with a Limited Palette

Working with many colors, especially when you're new to the pastel medium, may be confusing at first. Until you become familiar with values and color temperatures, a limited palette can be helpful. Under indoor lighting conditions, a limited palette gives you more control over the painting's development and prevents you from getting lost in too many colors. Outdoors, limited palettes are necessary for practical reasons, since it is impossible to carry all your pastels with you. Organize your outdoor palette according to the predominant color of the season and area you're painting.

Several Old Masters used limited pastel palettes for preliminary studies for oil paintings that stand

on their own as beautiful works of art. For example, the French artist Jean-Antoine Watteau (1684–1721) did many studies using one to three colors, plus white. He usually worked on a toned paper, which served as an additional color. Another Frenchman, Jean-Honoré Fragonard (1732–1806), also did beautiful studies with sanguine chalk (a rich, red brown pastel), plus white and black. The gray of the paper was used as a general middle tone, the white for light planes or highlights, and the sanguine for the darks. When there was a need for a darker shade, he used black or Van Dyke brown.

Experiment with limited palettes to study your subject in simple terms. Then extend your colors a bit. Try substituting ultramarine blue for black, raw umber for Van Dyke brown, or just add the six shades of raw umber, from very light to very dark. Also have one general color for flesh, plus white. True, you will be drawing mostly, but there is a point where studies done with such limited palettes pass from being drawings to paintings. Simply, adding a few more colors to your palette can do this.

Also try a limited palette consisting of only one color, such as raw umber, plus the six or seven gradations of that color. Doing a study with these tones will be like making a painting in opaque grays. Then add some flesh colors to your study. The result can be very informative. When you're ready for more sophisticated limited palettes, try the one suggested in Demonstration 2, *Portrait of Tony*.

Choosing the Right Colors

When I see a color on my subject and try to match it with a chalk on my palette, I automatically ask myself: What color am I seeing? What is the local color? How dark or light in value is the color? Is the hue very intense or is it weak? I also determine its color temperature, asking: Is the color warm, cool, or neutral? When I finally select the chalk that rep-

resents the color I am searching for, I also mentally make note of its complement, as I may need it to round out (soften or neutralize) the color when I start painting.

To simplify the colors in a pastel painting, I first group the colors of my subject together in terms of their values. Since I like to work with the darkest tones first, I group all the dark chalks together. For instance, I may begin to lay out the work with a dark neutral gray, one that is neither very warm nor very cool. I then may pick up a blue of the same value that is cooler than the gray, or I may choose a brown, which is warm but also of the same value. As I develop and finish the beginning stage of the pastel, the picture basically consists of warm, cool, and neutral colors of the same dark value. I then block in the large areas of local color, drawing constantly with the different colors.

Keeping Colors Rich. To avoid a watered down, washed out look in pastel paintings, I try to work with darker values and brighter, more intense colors. I also always try to make color (hue) changes without changing the value of an area. That is, I avoid toning down intense colors with colors of different values or lighter shades but instead try to use a warm or cool complementary color of the same value. Also, keep in mind that, technically, pastel colors work better when light colors are applied over dark colors, rather than the reverse.

Building a Palette for a Particular Painting. As I work, I place the colors I've selected for that particular painting on the easel tray in front of me or on a separate section of my pastel tray, instead of returning them to my larger tray. In this way I build a palette for each individual painting, so every time I need a color that I've used before, it is readily at hand. Only after the painting is completed do I return the colors to their proper place.

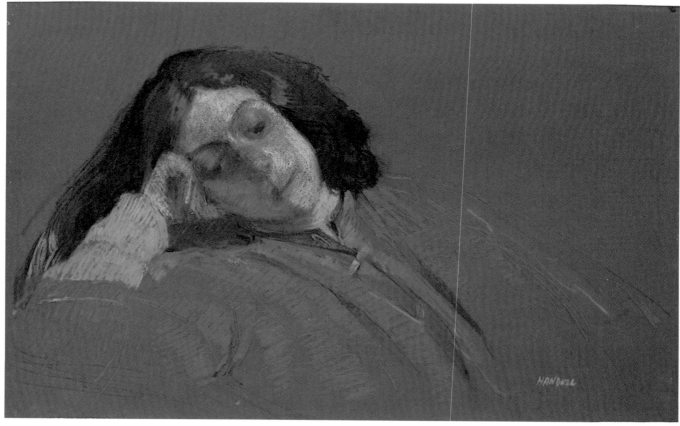

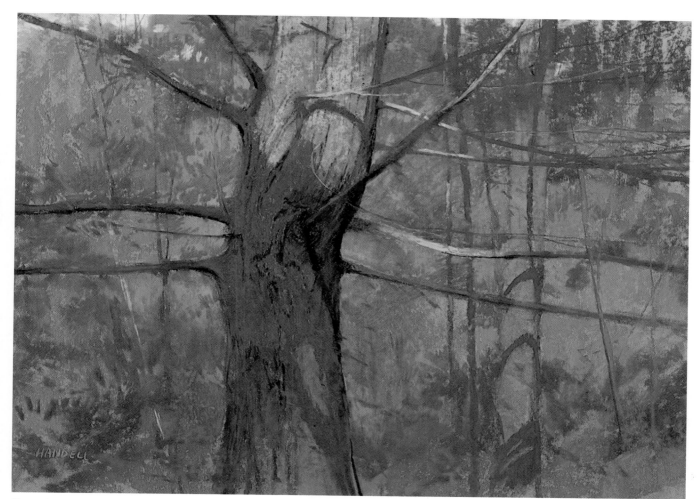

STREAM BED AT MT. TREMPER (*opposite, top*). *Sanded pastel board, 18 × 26" (46 × 66 cm), collection the artist.* The relationship between the colors and textures of the soft pastels and those of the hard pastels is important to the strength of this painting. Working outdoors, I laid out the entire scene using only the hard pastels, with relatively light pressure. The middle stages were developed slowly, using a combination of colors from the hard and soft pastels. As I was working, the sun suddenly broke through in the middle background and I shifted to rich, soft pastel colors, applying them vigorously to obtain the effect of sunlight on the rocks in the middle distance. I then worked on the foreground rocks in shadow, building their textures and colors with soft pastel. I finished by adding a few strokes of dark green to the background.

GAYLA (*opposite, bottom*). *Sanded pastel paper, 12 × 18" (30 × 46 cm), collection the artist. Gayla* is a small picture, painted on a very dark sanded pastel paper with hard and soft pastel colors. It was first laid out with dark hard pastels. The flat pattern of the hair was then blocked in with soft, velvety black chalks. The corners of the hard pastels were then used to build up the light areas of the portrait. Since Gayla is looking down, her eyes are not clearly seen, and so the pose takes on a personal character. Soft reddish brown pastels were used to paint her jacket, and the gray sweater below it was blocked in with hard pastels for color and textural contrast.

WHITE PINE (*above*). *Sanded pastel board, 17 × 22" (43 × 56 cm), courtesy Gallery of the Southwest, Taos, New Mexico. White Pine* is a section of a tree just outside my studio. It was painted in late April, when the winter color harmonies were changing to the light yellow-greens of spring. I captured the shadows first, blocking them in quickly with neutral-gray hard pastels. I used rich, dark purple hard pastels in the background. In contrast, I used numerous light tints of soft pastels in the sunlit areas of the trees to achieve meaty textures. Then I painted the light areas of the main tree trunks with light tints of raw umber, burnt sienna, and yellow ochre soft pastels.

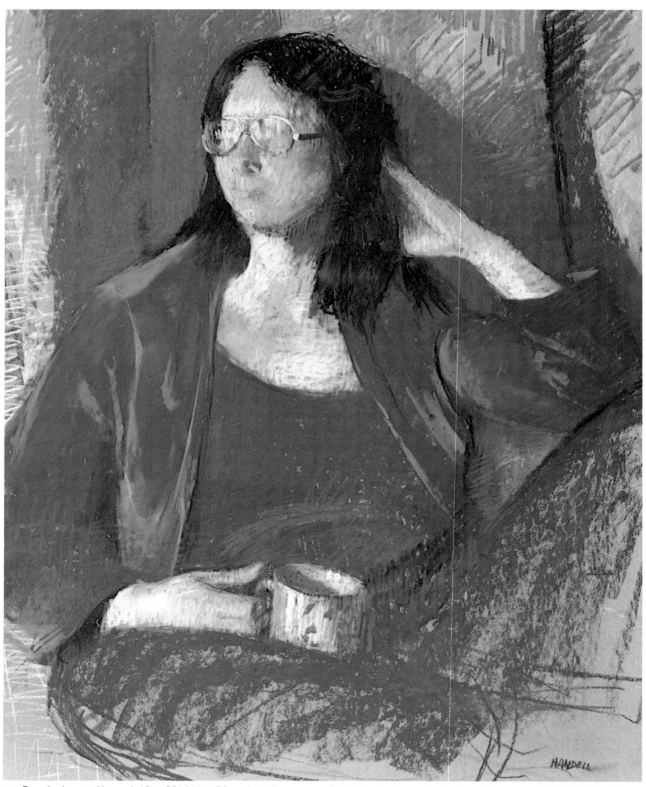

LESLIE. *Sanded pastel board, 16 × 22" (41 × 56 cm), collection the artist. Leslie* was painted on two consecutive mornings. The portrait is handled broadly and loosely. The pastel strokes suggest the features and planes of the head, but the details of the features are played down and not emphasized. Nonetheless they work subtly to give an excellent sense of Leslie's persona. *Leslie* is painted in a rich flat light, with a minimum of shadows. Her clothing is also simplified — all the different tones of reddish browns are the same value, with a slight change of color for each article of clothing. The texture of the velvety chemise is brought to a fine finish, while the rest of her clothing is merely suggested.

LESLIE. *Sanded pastel board, 16 × 22″ (41 × 56 cm), collection the artist. Leslie* was painted on a cloudy summer day when the sun peeped out from behind the clouds, producing lighting conditions that were exciting but difficult to express. I achieved a likeness by stressing color patterns and broad general shapes. I reduced her features to boldly suggested shapes and lines by squinting to eliminate details. The background was made up of a play of dark cool greens and light warm greens. Reds and greens were mixed into the flesh tones, and the clothing was handled simply by blocking in the light and shadow pattern of the chemise and expressing the slacks as a dark pattern.

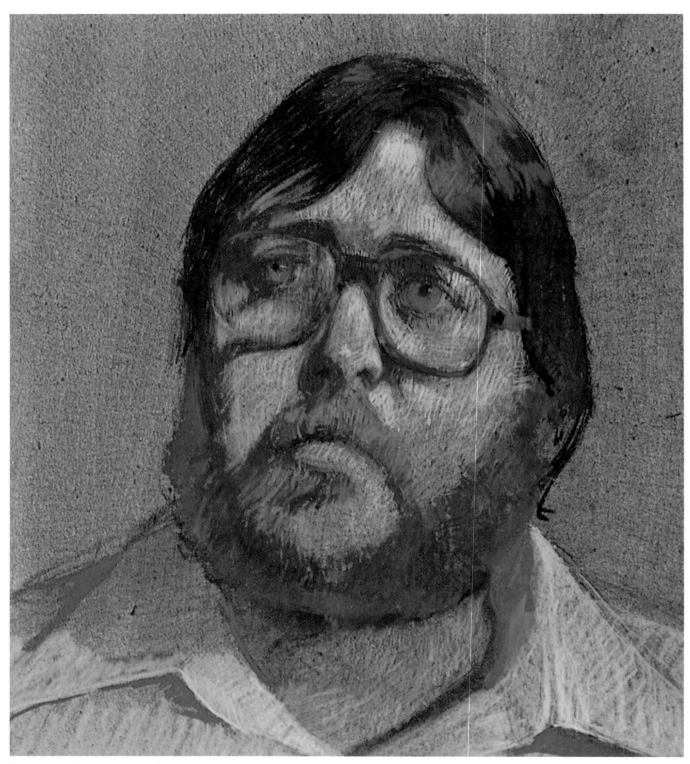

PORTRAIT OF STEVE MERCER. *Sanded pastel cloth, 16 × 20"* *(41 × 51 cm), private collection.* Steve and I first met on the volleyball court (we're both volleyball buffs). I had always wanted to paint his portrait, so when he agreed, I was delighted. Steve is 6'6" and weighs over 300 pounds, so my first concern was how to paint this rather large person on a relatively small sheet of paper. I decided to compose the portrait to give the sensation that his head is about to break through the paper's borders. Once that was decided, the rest of the painting simply involved getting the correct measurements and knowing pastel techniques. I worked on sanded paper (actually cloth) that has a beautiful linen-like texture, comes in a rich gray tone, and is ideal for working with pastel. By using a light touch of soft and hard pastels and pastel pencils, I was able to incorporate the cloth's wonderful texture into the portrait. You will learn more about the cloth on the following page.

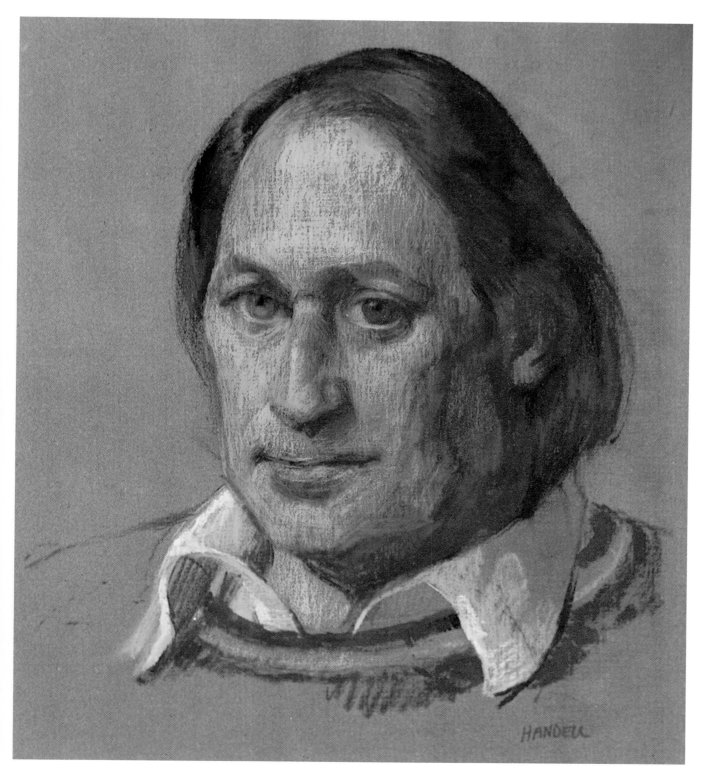

PORTRAIT OF BILL MANLY. *Sanded pastel cloth, 9 × 11" (23 × 28 cm), private collection.* This is a small portrait of my friend Bill, done as an experiment on a new sanded cloth I discovered at the hardware store. The cloth—which feels somewhat like a medium-weight paper—comes in a rich gray tone and has the texture of linen. On the back it is described as a 400-grit electrocut cloth of J-weight aluminum oxide, manufactured by the 3M Company. Because of the cloth's small size, much of the work was done in pastel pen-

cil, with an occasional restatement of colors with soft or hard pastel. In fact, the whole portrait could have been done entirely in pastel pencil. I was careful to keep my touch delicate and light to make sure the cloth's underlying woven texture showed through. A pastel head like this one usually takes two sittings: the first sitting to get the likeness as close as possible, and the second to adjust and finish the portrait by combining likeness with three-dimensional form, and by expressing the delicate light that illuminated the subject.

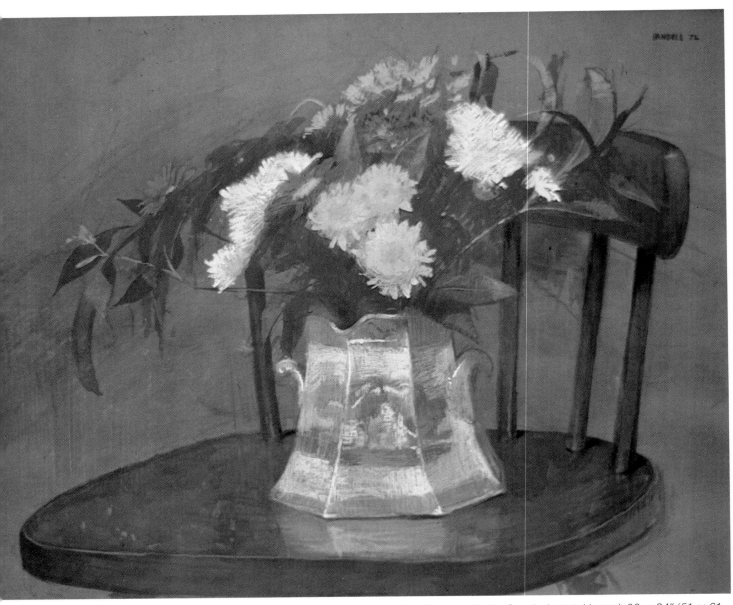

THE ORIENTAL VASE. *Sanded pastel board, 20 × 24" (51 × 61 cm), collection Mr. and Mrs. David Cohen.* It is always exciting to paint flowers in pastel. The intense yellow of the foreground flowers and the light purple of the background flowers allowed me to slip either purple or a touch of yellow into all the surrounding floral colors. The background, which was just a gray, became a purple gray, and I gently floated purples into the blue and white colors of the vase. The chair itself was washed in first with a diluted brown casein paint, then kept simple. I blended brown pastel with a little purple into the area when the casein was dry.

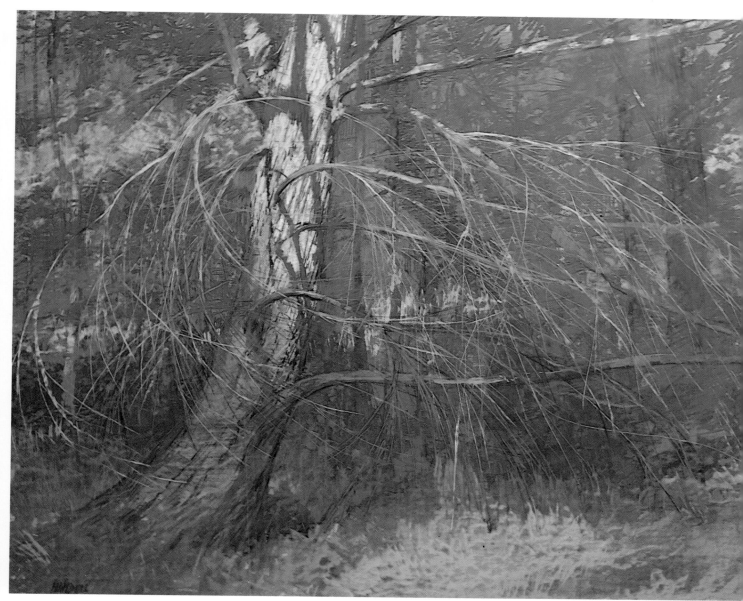

A SUMMER'S MOMENT. *Sanded pastel board, 22 × 28"
(41 × 71 cm), courtesy Gallery of the Southwest, Taos, New
Mexico. A Summer's Moment* was painted indoors from a
detailed drawing of a tree done on location in early
November. The greens of summer were gone, but the expe-
rience of working all summer with greens and variations of
greens was in my mind. I began the painting by blocking in
the main trunk of the tree, bringing out light and shadows
on it with a reddish brown hard pastel. I then laid in the
background with diluted, warm, reddish-brown watercolor
washes of raw umber and burnt sienna and diluted cool
tones of dark greens and blues. These colors formed the
mysterious cool green wooded foliage of the background.
When the watercolor dried, I translated the background
tones of the underpainting into pastel with dark-green col-
ors applied in broken strokes, letting the colors of the
underpainting vibrate through to the surface for an optical
sensation. I then switched to lighter greens and light tans
and finally, using a lighter, warmer reddish tan, I painted the
sweeping movement of the dead branches in the fore-
ground.

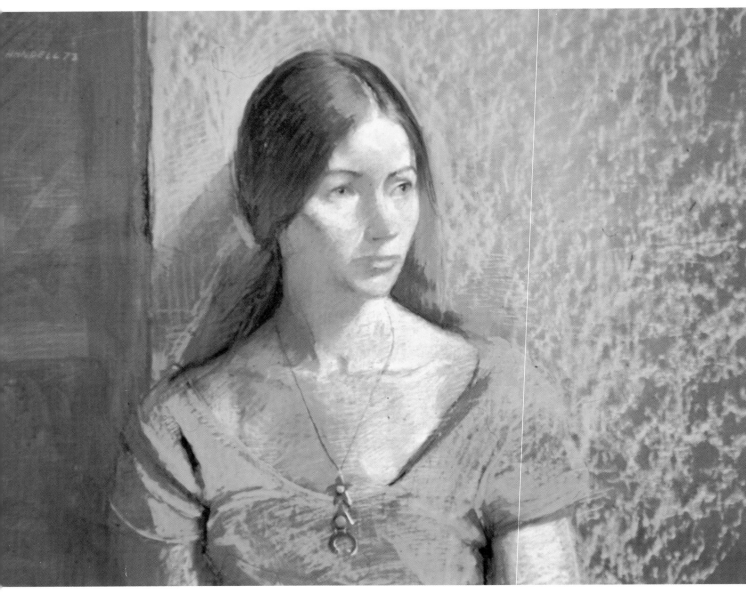

PORTRAIT OF MORIN SERENE. *Sanded pastel board, 18 × 24"
(46 × 61 cm), private collection.* The cerulean blue dress
Morin wore gave me the opportunity to drift blues into the
other colors in the painting. I reflected blue into her milky
white complexion and used a gray with a lot of blue in it in the
tan background. I also ran the complement of blue-orange
and orange-brown—into her dress and throughout the
pastel.

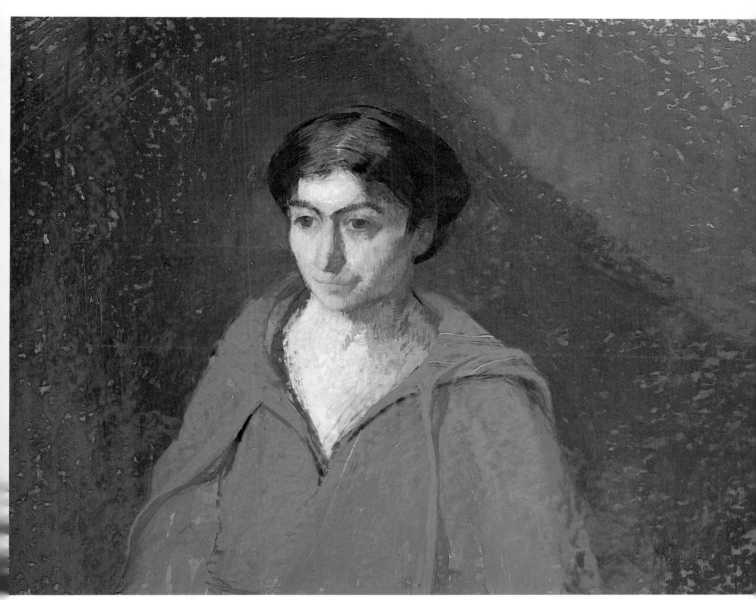

PORTRAIT OF JOAN. *Sanded pastel board, 24 × 28" (61 × 71 cm), collection Glenda Sue Florio.* This lovely mixed-media pastel painting was done as a demonstration for one of my summer pastel workshops. The portrait is framed in a nebulous swim of deep rich colors, all of the same value. These colors float in and out of each other, making the surrounding colors of the portrait very dark, which helps bring out and illuminate the portrait. All the surrounding colors of the portrait are very close in value. Notice how the rich gray in the upper right-hand corner is the same value as the purplish drape directly behind the sitter. Because the values of these objects are so close, the lines that separate them become indistinct and allow tones of each of these colors to slip in and out of each other. The robe, a rich, vibrant, intense blue, is also close in value to the mauve color directly behind it. Because of this, the colors of both areas intermingle easily to harmonize the painting and produce an extremely rich background of color for the beautiful, delicate, lighter colors of the portrait.

JEFFRO (*above*). *Sanded pastel board, 24 × 28" (61 × 71 cm), collection Mr. and Mrs. Gennaro J. Basile.* This lively pastel was done on a warm reddish background. Since I liked the total shape of the subject against the general tone of the background, I decided to leave the background vague. The jacket was washed in with a blue wash of casein. The thin flat transparent color acts as a strong contrast to the light, airy opaque pastel colors in the light areas of the face and hands. The sitter was in a cool light, and to accentuate this, I made the shadows quite warm. Within the cool light areas of the hands and head, I floated in some warm red colors to keep the areas in harmony with the colors in the rest of the painting.

BACKVIEW OF STANDING NUDE (*right*). *Sanded pastel board, 24 × 28" (61 × 71 cm), collection Ms. Lisa Stasi.* Since the beginning of my art school days, I have always been intrigued by painting a back view. The model here is a wonderful figure model. Her beautiful forms are emphasized by a strong flat light that trickles down her body and brings out her rich coloring and delicate skin tones. I painted her skin red and yellow, with delicate complementary green and purple colors. The light, airy colors of the nude stand out handsomely in front of the dark rich background. The background is kept very simple. A brown casein wash, with a few strokes of pastel over it, suggests the patterns on the rug.

PORTRAIT OF SAM KLEIN. *Sanded pastel paper, deep gray tone, 10 × 14" (25 × 35 cm), collection the artist.* I worked small here on a very rough sanded pastel paper that was deep gray in tone. I achieved the rich colors of the complexion with pastel pencils, intermixed at times with soft charcoal. Because of the rough surface, the textures look as if they were made with soft pastels rather than pencils. When blocking in the portrait, I first overstated the color nuances of the planes of the face. Then, toward the end, I gently feathered a fleshtone over the portrait with a no. 29 Carb-Othello pencil. This harmonized all the colors of the portrait and allowed me to finish the portrait by restating the details.

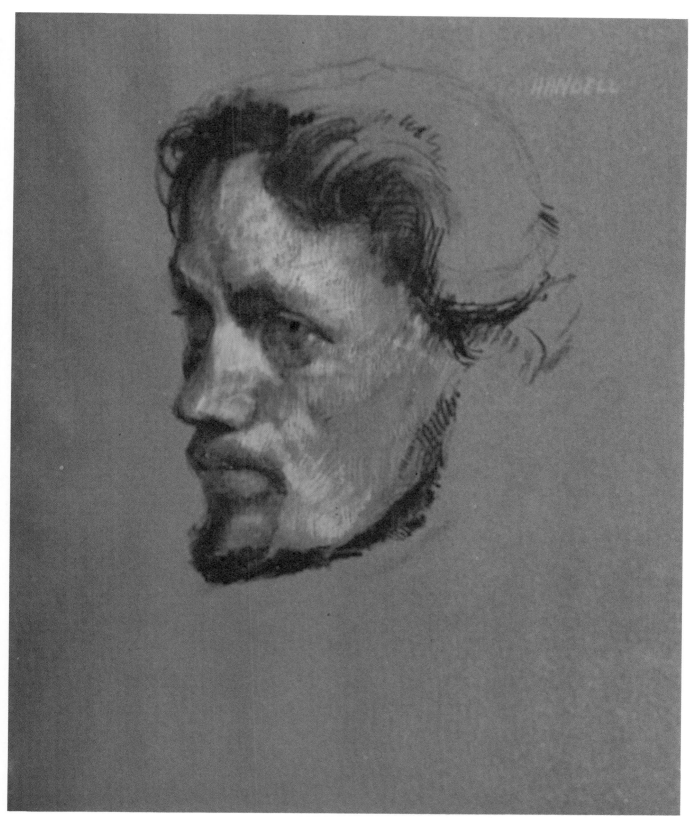

PROFILE OF STEVE SMITH. *Sanded pastel paper, 12 × 16" (30 × 41 cm), collection the artist.* Steve's interesting profile is painted with a limited number of colors (no more than twelve or fourteen pastels). It is done on a very dark-toned, sanded pastel paper, using mostly pastel pencils. The pencils are applied in linear strokes of different directions that can be clearly seen as they build the planes and features of the portrait. The colors of pastel pencils are often weaker than those of hard and soft pastels, although they still can create a harmonious, rich, colorful portrait.

THE LOVERS (*above*). Sanded pastel board, 24 × 30" (61 × 76 cm), collection Helen Scungio. I enjoy working with two models at the same time, especially when they are close together. But the overlapping bodies can cause extra problems when shapes and proportions are worked out, and the general drawing does become more complicated, with more attention than usual needed to keep everything in proportion. However, I enjoy building and designing the color of the picture around the contrasting complexions, different hair colors, and varied colors of the clothing of the two models. Once the colors of each area are established, I put colors from one color area into other color areas of the painting, which helps me achieve the broken color effects I like so much. I then further develop the colors of each area by adding a little bit of the complementary color into each area. Here the colorful underlying tones of the background washes act as a strong, harmonizing base for the rich colors of the rest of the painting.

BRAIDING (*right*). *Mixed-media pastel on corrugated cardboard, 24 × 30" (61 × 76 cm), collection Helen Scungio.* This was an exciting experiment. I worked on ordinary corrugated cardboard, which is rich brown and textured. I blocked in the pose with pastel, then suggested the model's dungarees with an acrylic wash. When it dried, I worked over the entire pose with a combination of soft pastels, pastel pencils, and soft artist's charcoal. Because cardboard can be difficult to preserve, it was extremely important to frame this pastel correctly. Before I started the pastel, I had the cardboard mounted on a 3-ply 100% rag museum board backing to protect the back of the surface from contact with the air. Then I supported the backing with still another board—a white foam-core board which is very sturdy and has a neutral pH factor. With this strong support, and framed under glass, the work won't be exposed to air and thus should last for a very long time.

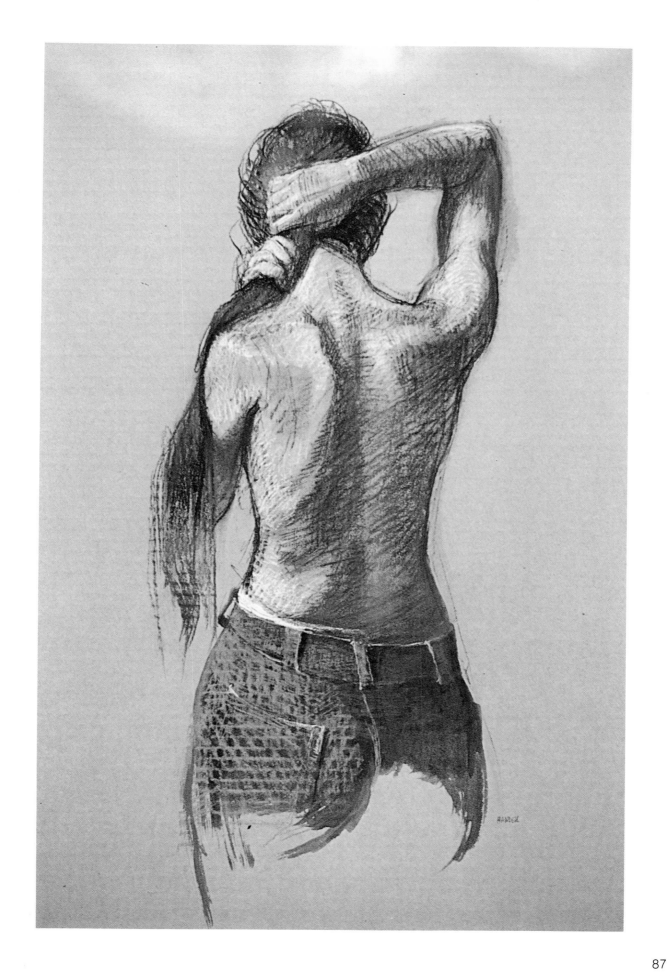

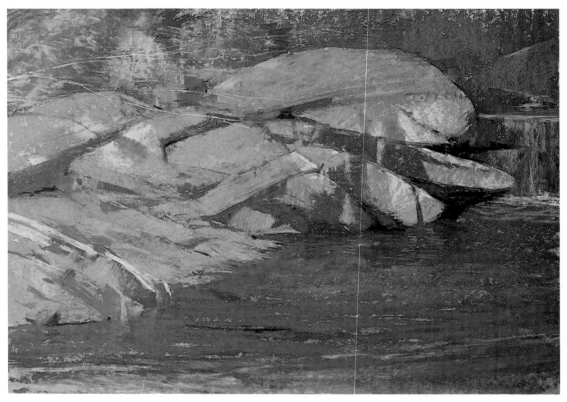

STREAM AT DEVIL'S KITCHEN (*opposite, top*). *Sanded pastel board, 17 × 22" (43 × 56 cm), collection Mr. and Mrs. Malcolm MacCour.* A beautiful play of warm and cool colors is created here as diffused, broken sunlight falls into the deep woods at Devil's Kitchen. Here the weak diluted patterns of sunlight are a mixture of orange and pink tones, quite warm and light in value. The lights on the rocks in shadow, on the other hand, are cooler and are composed basically of a blue gray that borders on a cool, blue purplish color. These warm and cool colors are surrounded by rich, dark greens and browns that accentuate them.

MOMENT DURING SUMMER (*opposite, bottom*). *Sanded pastel paper mounted on a 100% museum-board backing, 14 × 18" (36 × 41 cm), collection Mrs. Harvey Peters.* I once decided to spend the entire day sketching outdoors in pastel. I worked rapidly, allowing about 45 minutes for each sketch by eliminating all detail and by massing and harmonizing the major color areas. I analyzed each color by determining its value, temperature, intensity, and hue (by picturing the color wheel and deciding if a color, say green, leaned more toward yellow or blue on each side). Then I let a few days lapse before evaluating the sketches to give me a chance to gain objectivity.

EARLY NOVEMBER SNOW (*above*). *Sanded pastel board, 18 × 24" (46 × 61 cm), private collection.* Working with a limited palette of about twenty pastels, I established a strong value pattern using basically three values plus the white of the snow. The darkest value is made up of a lot of cool purple colors and represents the shape of the upright foreground trees and the distant hill. The earth is painted basically with raw sienna and yellow ochre combined. The yellow ochre of the earth and the purple are complementary in color to each other. The gray of the sky is simply stated as a single value. The painting is then developed to completion by using the shapes of the white snow as contrasting light-colored patterns to bring out the forms of the sloping land and tree branches.

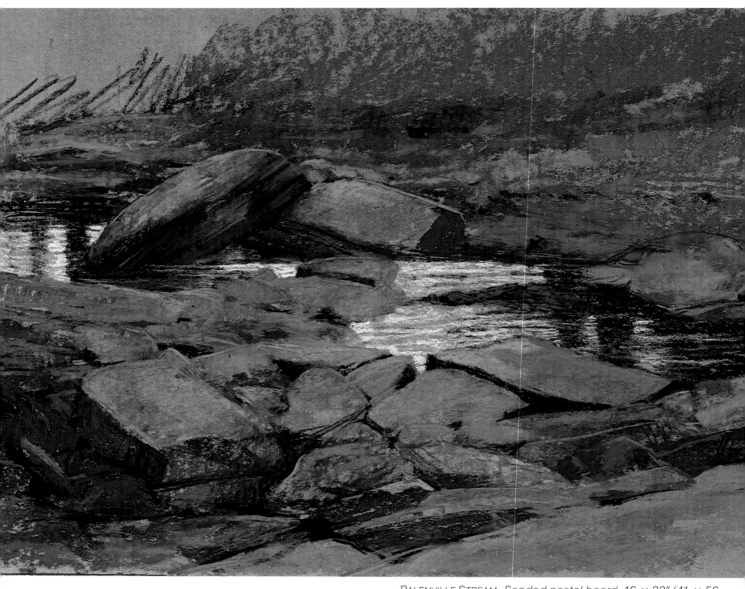

PALENVILLE STREAM. *Sanded pastel board, 16 × 22" (41 × 56 cm), collection Tim and Roberta Remy.* This is an excellent example of how the play of rich, mellow colors can form the essence of a painting. There is a melody of color here, and the combined colors make up a subtle beauty that is basically composed of blue purples, reddish purples, grays, tan, greens, and browns. Except for the bright reflections in the water, which by their value contrast harmonizes the surrounding colors even more, all these colors are quite close in value. The pastel was started on a gray-toned background. This neutral tone also helped to harmonize all the colors, which were applied in rapid open strokes. You can see the gray tone I started with in the upper left-hand area of the pastel.

Part II
Demonstrations

Seeing Colors as Values

Limited Palette on a Middle-Value Ground

In this demonstration I will be working with a limited number of colors that are close in value, establishing a strong unity in the picture through the tonal structure. An understanding of color as *value* is crucial to the successful use of color in a painting. As you learn what is meant by the value of a color, you will become aware of all the different colors that are the same value. You will also learn how to mix colors in pastel. This process is not a necessity in the pastel, where hundreds of shades of each color are available, but through the experience of limiting your pastel colors you will come to know and understand them and thus be able to better exploit all their possible variations.

Working on a Middle-Value Ground

There is a definite advantage to using a middle value as a base. A background tone of middle value shows both dark and light colors equally well so they can be related to and judged against one another quite easily.

Using a Limited Palette

In a painting, all colors must be related to each other and in harmony. The way to do this is by massing or grouping together different colors of the same value—the same degree of lightness and darkness. With the myriad of colors available in the pastel medium, if you don't understand the concept of color as *value*, you will have trouble harmonizing your colors. But reducing the number of colors in your painting—by using a limited palette—you will get an almost immediate color harmony.

A limited palette in pastel painting could mean thirty or forty colors plus black and white. To a beginner that may sound like a lot of pastels, but it is really very few when you consider that a normal pastel tray may contain as many as 250 chalks, each chalk (except for duplicates) a different color. Having so many colors can be confusing, especially if you are new to the medium and unfamiliar with its peculiarities.

Using a limited palette will teach you what is meant by different colors of the same value. It will also train you to see color in terms of value, which will make it easier to concentrate on the value structure of your painting. As you gradually begin to understand how your colors work, you can start increasing the number of colors you use until you have a full palette.

Subject and Composition

There is a wealth of outdoor still life and architectural subject matter everywhere. I particularly enjoy painting subjects such as *The Open Shed*, with all its abandoned clutter. The fact that the entire foreground is in shadow affords an opportunity for massing this large area into simple values. The local colors of the objects within the shadow mass vary, but their values are close. This situation is ideal for a study of colors as values through a limited palette.

Working out a composition with outdoor architectural subject matter is always challenging. The differing sizes of the objects always call for accurate comparative measurements and forces me to group objects together, which is good practice in developing larger overall shapes based on these groupings. I often prefer closeups of my subject matter because I like the intensity that this close proximity creates. In this closeup of an open shed, the composition consists of crisscrossing horizontal and vertical planes, with diagonal lines

and circular-shaped objects for variety. The shapes fill up the entire surface in an exciting way.

Lighting

The lighting in *The Open Shed* is backlighting: warm sunlight behind a foreground in shadow. This type of lighting is excellent for studying color as value. Backlighting means that all the colors in the foreground will thus be seen as cool in temperature and dark in value. The sunlight areas of the background, being light in value and warm in color, are in sharp contrast to this. In short, the whole painting is basically composed of light and shadow contrasts through color and value.

Materials

Sanded pastel board, 18 × 24″ (46 × 61 cm), toned a middle-value neutral gray with an acrylic wash

Thirty-five to forty colors, primarily in values 7, 8, and 2, plus black and white. Dark colors—greens, blues, purples, grays, and browns—of values 7 and 8 were used in the shadow areas and foreground; warm colors of value 2 were used in the sunlight area; and ultramarine blue was alternated with black for dark cool accents. (Again, I am referring to a value scale of grays ranging from 1 to 10, where white is 0 on the scale and black is 11.)

Step 1. Working on a middle-value tone, I keep the layout very simple, using one color—a hard, dark, cool gray brown pastel—to place the entire composition of the old shed. Since the entire foreground is in shadow, I want to keep the value structure simple. I draw in the main structural elements of the old shed to get a good sense of the subject matter and its composition.

Step 2. Working with a limited palette of colors, I pick up two dark, cool colors, both very close in value. I rapidly block in the important upright and horizontal planes with light pressure, using open side strokes. This allows for contrast, yet permits me to keep things simple and uncluttered, which is important in a complex subject like this. The dark colors I am using show up beautifully on the middle-value tone.

Step 3. The entire shed is filled with a clutter of old discarded farm objects. I start developing the shapes of the objects and their relative sizes. By using a limited number of colors and pastels, I can make the underlying structure very strong.

Step 4. Adding more colors, but still keeping to the same values, I block in the interior objects of the open shed in simple tones. By keeping the shadow area simple in value, the entire shed takes on a strong, two-dimensional shape. For variety, I establish the dark accents under the wooden barrel on the floor, which gives me an idea as to how dark I can go within the shadow area. The accents give the shed a sense of weight. Notice how the value structure remains simple, yet the shapes of details within it are becoming clearer. Very gently, and with a very-light-value green, I block in the sunlight behind the shed. I now spray fixative over the painting, which makes all the colors slightly darker.

Step 5. I suggest the dark foreground of the open shed by working darker, using only a few colors. The metal drum is defined by making the side plane darker. The detail under the wooden barrel is indicated, clarifying the shapes of the rocks and the scattered boards. Dark accents on the upright and horizontal beams also add a sense of weight and depth to the interior of the old open shed.

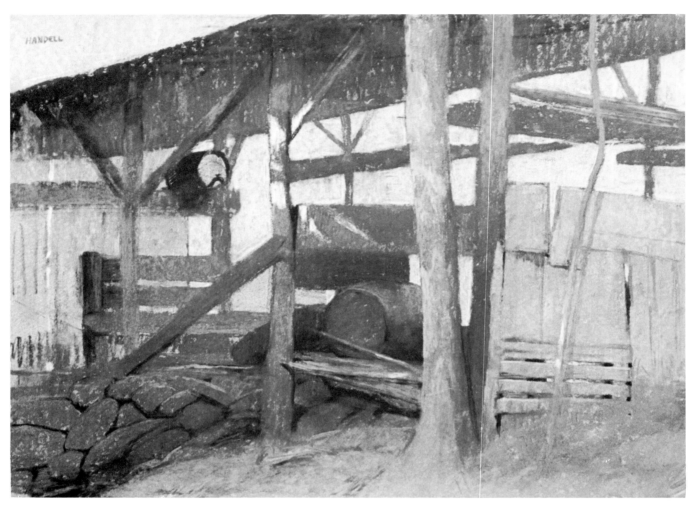

THE OPEN SHED. *Sanded pastel board, 18 × 24 " (46 × 61 cm), collection the artist.* Using soft pastels, I now work on every area of the open shed, pulling together similar values and colors, and at the same time establishing variety through few select details. Notice the variety in shapes and values in the wooden fence on the right. The stones on the ground are painted in and finished along with the haphazard clutter lying about. The lack of detail on the left side of the painting creates a sense of distance within the shed. All of the colors of the foreground remain cool in tone and relatively dark in value. They contrast beautifully with the sunlight colors, which are warmer and lighter. I spray fixative very lightly over the work, making sure my colors don't turn darker. A few more details and soft colors are put in and floated on here and there, and the painting is finished.

Translating Values into Warm and Cool Colors

Limited Palette on a Dark Ground

In Demonstration 1, I concentrated on the value structure of the painting and on seeing the closeness in value of the different colors in the foreground. In this demonstration, *Portrait of Tony*, we will see how you first establish the value structure of a pastel painting, then gradually translate it into warm and cool colors. Only a limited number of warm and cool colors will be used so you can concentrate on learning about the colors on your pastel tray. You will also learn how to work on a dark-value ground and use warm and cool colors to achieve rich dark tones.

Working on a Dark Ground

Working on an extremely dark tone is simple but in some ways limited. First of all, dark colors don't show up well on a very dark ground. Therefore you have to let the dark ground act as the shadow value and paint in only the light and middle-value areas. Also, since there is a tendency for lighter values to stand out too much on a very dark ground, you should not use tones that are too bright. But if you're working on a tone that is only slightly darker than middle value, you will have more flexibility in your value choices. For instance, in *Portrait of Tony* I am painting a dark complexion on a background only slightly darker than middle value w th a limited palette of warm and cool colors. The medium-dark ground gives the pastel colors a special beauty and harmony right from the beginning, and the contrast in color temperature allows me to model the edges in the portrait so I can make the forms appear round and three-dimensional. A limited palette of colors that is also composed of limited values, like the palette for *The Open Shed,* would be less effective here because modeling a head requires more subtlety. I preferred to model the edges and planes of Tony's head with changes in color temperature rather than through contrasts in value.

Selecting a Limited Palette for a Portrait

Because every sitter has a different complexion, your limited palette will naturally vary according to the sitter's natural coloring. So if you're painting an olive-skinned person with predominant tones in the yellow family, you would choose colors like Naples yellow or yellow ochre, and balance them with their complement, purple. But if you're painting a ruddy-complexioned person, the reddish skin tones would be balanced by some cool green tones.

To choose a limited palette for *Portrait of Tony*, I considered both color temperature and value. I selected the main hues I would be using in the painting first, and separated them into two trays, one for the warm colors, and one for the cool hues. Then I choose three or four values (tints and shades) of each hue to expand the value range of each color.

Tony is half black and half Puerto Rican. For his dark coloring, I choose for the shadow areas: chrome green deep plus raw umber—a cool brown. To warm the shadow areas, when necessary, I selected burnt sienna, and to cool and darken the shadow areas, as in the dark parts of the hair, I used ultramarine blue deep alone and in combination with the raw umber. Because Tony's skin is dark, the lightest tones in the portrait were only middle values, except for the cool bluish highlights.

Once I established the basic (pure) hues I would be using, I was able to vary the value range of each hue by adding a dark shade and two light tints of each color. For example, after choosing the ultramarine blue deep, no. 506.5 in its pure state, I then selected a darker shade of ultramarine blue, no. 506.3, and two lighter tints, nos. 506.7 and 506.9. I then had four tones of this cool color. I followed the same procedure with the chrome green deep and the raw umber, keeping the cool colors

in one compartment and the warm colors in another compartment. The resulting limited palette contained about thirteen tones of three cool colors and eighteen tones of nine warm colors.

Because the size and delicacy of Tony's portrait called for refined, detailed work that required much linear stroke buildup, I substituted pastel pencils and hard pastels for many of the soft pastels.

A Suggested Limited Portrait Palette
Since soft pastels are prepared, packaged, displayed, and sold in terms of their color temperature, soft pastels are convenient for experimenting with warm and cool colors. A suggested limited portrait palette follows:

Cool Colors. The following selection of three cool colors will give you a total of fourteen pastels, each representing a tint or shade of these three hues:

Ultramarine blue deep (no. 506.5, purest), plus three other values: a darker shade (no. 506.3) and two lighter tints (nos. 506.7 and 506.9).
Chrome green deep (no. 609.5, purest), plus four values of chrome green deep: a darker shade (no. 609.3), and three lighter tints (nos. 609.7, 609.8, and 609.9).
Raw umber (no. 408.5, purest), a cool brown, plus three tints of raw umber: a darker shade (no. 408.3), and two lighter tints (nos. 408.7 and 408.9).

Warm Colors. Notice that for the warm hues I select more colors, but fewer tones of each color. I choose eight or nine warm colors at their purest state, plus one lighter value of each color.

	Purest Color	Light Tone
Deep Yellow	no. 302.5	no. 202.9
Orange	no. 235	no. 235.8
Permanent Red Light	no. 370.5	no. 370.8
Permanent Red Deep	no. 371.5	no. 371.8
Red Violet Deep	no. 546.5	no. 546.8
Yellow Ochre	no. 227.5	no. 227.8
Burnt Sienna	no. 411.5	no. 411.8

You should also add black and white to this palette, and any five or six additional flesh tints you may wish to have. Notice that although I provide a complete value range in the three cool colors, I only suggest a pure color and a tint of each of the warm colors. The reason is simple. The blues and greens will work as cool colors, and the raw umber

tones will be used to produce grays. But the number of warm values is limited to keep you from getting a muddle of warm tints all over the portrait. Instead, you are forced to use the *cool* colors to modify (raise or lower) the values and to gray (neutralize) the flesh tones. You may also modify the cool colors with other cool colors, but to keep their values consistent, you must only mix colors of the same value. For example, you can blend chrome green deep (no. 609.7) into raw umber (no. 408.7) to make the umber cooler and greener, but if you choose a lighter chrome green (no. 609.9), you would also lighten the raw umber as well as cool it. Experiment with a limited palette like this one, or one of your own invention. It can be a great learning experience.

Subject and Composition
Tony's face is strong and unusual, which is perhaps why I was interested in painting him. I decided to emphasize his individual characteristics by keeping the portrait a vignette. A portrait vignette forces me to get a sense of the likeness early in the development of the portrait, in the drawing. Then I deliberately and slowly build up the painting, working lightly with pastels and drawing with them a lot (as opposed to massing in large areas of color). I then build my colors on top of the drawing.

In a portrait vignette, the beauty of the composition is determined by how well the portrait is placed on the painting surface. The head and the rest of the subject's body that is included must be in harmony with the edges of the board or paper. Here the head and shirt form the positive areas of the painting, and everything else becomes the negative space that surrounds the portrait. The shapes of these two areas form the composition of the painting.

Lighting: Flat Light
Tony was painted in flat light, which is a cool, even, natural light. Flat light is ideal for painting portraits. It is a light that best illuminates the likeness of the portrait, with little or no shadows cutting across it.

Materials
Sanded pastel board, 16 × 22″ (41 × 56 cm), toned a dark-value gray with a casein wash of raw umber
Soft vine charcoal
Limited palette of warm and cool pencils and hard pastels

Step 1. Using soft artist's charcoal, I begin drawing the portrait, trying to get a feel for the likeness. I sense a lot of intrinsic rhythms and underlying forms, so I develop the drawing carefully to bring them out. The body is turned away, yet the eyes look directly at the viewer. This double rhythm or movement is subtle, but very important to the portrait's impact. I decide to make the eye closest to the viewer the center of interest, and so I play down the more distant eye. I continue to define the drawing before introducing color.

Step 2. Now I reinforce and develop the likeness with a strong emphasis on anatomy and rhythm. The shapes and planes of the head and features are important in expressing the sitter's character. Still using artist's charcoal, I define the construction of the head and reinforce the bones of the skull. As I develop the planes of the skull, I work darker in certain areas. I develop the temporal area of the skull above the ear and the frontal lobes of the forehead. Notice how the rhythm and movement of these forms tie in with each other, encasing and framing the sitter's left eye in their bony structures. After reinforcing the lower jaw and mouth area, I am ready for the color lay-in.

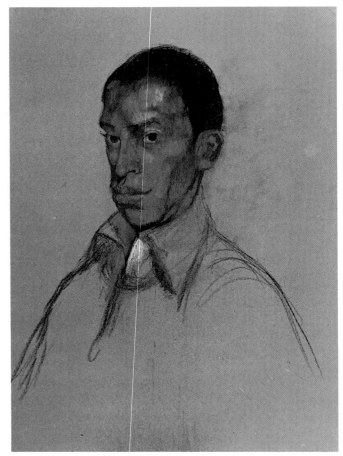

Step 3. I begin to translate the structural part of the portrait with one warm brown pastel color, a cocoa brown Nu-Pastel, no. 253-P. At this stage I don't want to overload the portrait with a dense application of soft pastels but wish to make the transition from drawing to color subtle and controlled. I apply the color with linear strokes, since I am still quite concerned with the drawing. I establish the planes of the portrait with the warm cocoa brown, leaving other areas of the portrait untouched. This allows the cool gray background to bring out the other planes of the portrait. I block in the dark hair with charcoal so its dark pattern can be used as a base to relate lighter values and colors.

Step 4. As I develop the subtle colors of the portrait, I start introducing cool complementary colors. I concentrate on the sitter's eye, nearly completing it as I vary the values and define the drawing where necessary. Notice the side plane of the forehead to the left of that eye. This area is blocked in with ultramarine blue, a cool color, to set off the warm orange tone of the cocoa brown. I also slip the ultramarine blue tone into the forehead. On the bridge of the nose, left nostril, and lower jawline, I use greens, which are also cool in color. I use a combination of blue and green for the side of the cheekbone. These cool colors contrast beautifully with the warmth of the oranges and reddish browns of the other areas of the head. Before putting in the highlights, I stroke a bit of white on the shirt near the face to prevent me from making the highlights on his face too light. Although the highlights are brighter in value, they all contain some cool green or blue, which echoes the cool tones of the studio's flat north light.

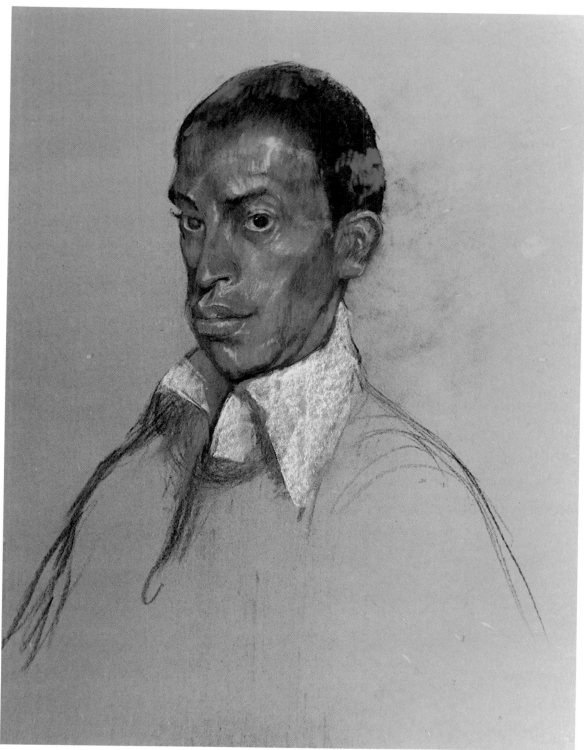

Step 5. I finish developing the head. Because of the sitter's generally warm complexion, I add cool colors wherever I can for variety and contrast. This was also a consideration when I chose a white shirt. I asked myself not only how bright the white is, but also if it is a warm or cool white. I decided to use an off-white with some blue in it. After delicately establishing the cool white of the collar, the background also starts to appear a bit cooler.

These cool colors surround and contrast with the general warmth of Tony's complexion. I can consider the portrait finished at this point, for it already has a beauty and delicacy I want to achieve. However, I wish to lower the entire pitch of the colors of the portrait and subtly bring out even more of the resinous color nuances that fascinated me in Tony's face.

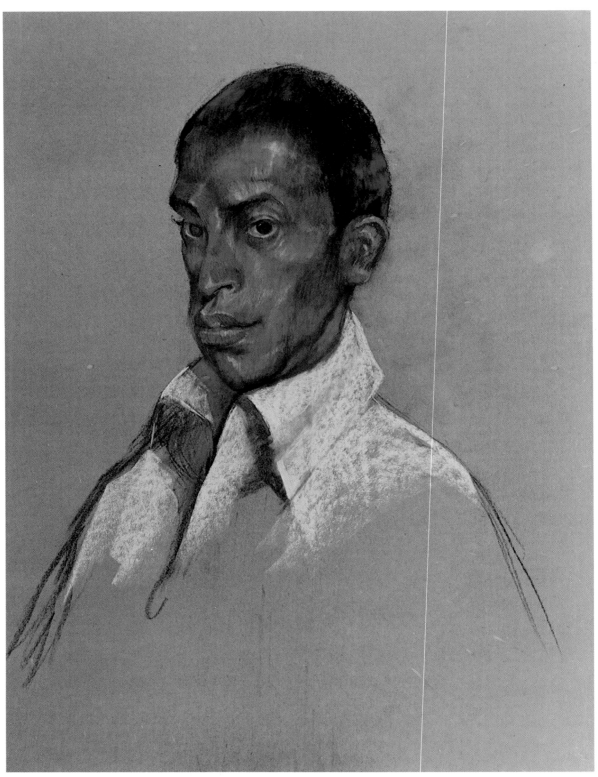

PORTRAIT OF TONY. *Sanded pastel board, 16 × 22"* *(41 × 56 cm), private collection.* With the lightest touch imaginable—a touch as delicate as a feather—I gently glaze the portrait, using the same soft artist's charcoal I started with. By "glazing" I mean floating the charcoal evenly over the entire portrait with an exceedingly light touch. When done correctly, everything of the portrait is there as before, but now all the colors have a deeper and more resonant tonality. The edges also have become slightly blurred and a strong sense of atmosphere and weight now prevails. I then redefine and finish select areas in the portrait with pastel pencils. I also add more white to the shirt and change its shape to work better in contrast with the head and to make the dark-gray background appear more luminous.

More About Values and Colors

Full Palette on a Light Ground

In the first demonstration you were taught to see color as value by observing the painting of a tonal structure on a middle-value background (*The Open Shed*). In the second demonstration you saw how a limited palette of warm and cool colors could be used to make three-dimensional form. The portrait was painted on a rich, darker middle-value ground (*Portrait of Tony*). You also learned that each of these background tones affected the values and colors of the finished painting. I will now demonstrate how pastel is affected by a light ground, including the color considerations you must be aware of when working on this light tone, and I will explain how to harmonize a full palette of colors. This all will be illustrated in a colorful on-location painting of a gray barn in strong sunlight surrounded by summer greenery (*O'Kelly's Barn*).

Working on a Light Ground

In *The Open Shed* we saw that the middle-value background facilitated the rapid buildup of a composition through light and dark values. In *Portrait of Tony* we show that a medium-dark base subtly brought out beautiful light values on a portrait, while permitting the forms of the head to be modeled by playing warm colors against cool ones. Here, in *O'Kelly's Barn*, we will see what happens when the many subtle colors of objects are stated simply as a single local color from the very beginning, to establish the elements of the painting on a light ground.

Working on a light ground changes the pastel colors, and thus the painting techniques, somewhat. On a light value, colors look richer and darker than usual. This allows you to use lighter pastels than you normally would use on darker grounds, thus providing an opportunity to get to know them better and see how they work together. As you establish the local colors in each area of the painting, the colors will merge and blend into each other and appear much darker and richer. Block-ing in the local colors forces you to see your colors of your subject as color harmonies of the same essential values grouped together and making up large shapes that contrast greatly with the light-toned ground.

Using a Full-Color Palette

Since I am chiefly concerned here with color and not value, I will now use a full palette of colors. If I were to use a limited palette on a light-toned ground, I would probably have to keep the pastel more a drawing than a painting. But working with a full-color palette will give me the opportunity to capture all of the colors and color nuances of a scene. For an artist with an awareness of values and color harmony, this can be an exciting and challenging experience.

Subject and Composition

Outdoor architectural subjects fascinate me, especially large old barn structures. The older they get, the more they seem to acquire an abandoned charm and unique personality and character. Their rugged textures and weatherbeaten elements are challenging to paint. O'Kelly's barn is one such structure. I discovered the barn while giving a landscape workshop in the Blue Ridge Mountains of North Carolina. The effects of the sunlight on the barn and surrounding fields created interesting color effects which allowed for extensive use of a full-color palette.

Once I decided on the angle of the barn, I placed it on the board. Again I tend to prefer a closeup view, with the barn itself as the center of interest. I thus played down the surrounding greens and let them frame the barn as large simple shapes.

Lighting Conditions

It was a bright sunny day, and the strong sunlight created rich colors and changing light and shadow

patterns. I first had to decide where to freeze the light on the barn—I would then have to stick with the patterns and shapes I made at that point. The light-toned background enabled me to use lighter colors than I observed, though they seemed dark at the initial stage. Working with open strokes and light pressure on the pastel chalks, I let the light background tone show through as much as possible to add airiness to the colors and a textural qual-ity to the pastel buildup. Even after brushing together the initial color lay-in, the light background still subtly showed through, harmonizing all the lighter colors and giving them more luminosity.

Materials

Sanded pastel board, 18 × 24″ (46 × 61 cm), light buff tone; and a
Full assortment of Rembrandt soft pastels.

Step 1. I design the composition of the painting through the placement of the barn on the painting surface. I sketch in the main elements of the barn with only two hard (Nu-Pastel) colors: a cool gray tone and a cool green pastel, trying to give the barn a sense of weight. I also lightly block in a suggestion of the cast shadow. The two colors I am using, both cool and of the same value, harmonize well together. Since there is a lot of green in this subject, I decide to use green pastel to block in the shadows. Although the cool gray and cool green colors are lighter in value than usual, they look darker because I am working on a light-toned ground. I block in the dark hole of the window lightly with a third hard pastel, a very dark gray, thus establishing the darkest value of the picture.

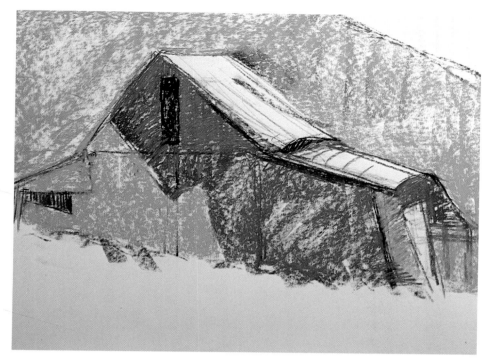

Step 2. Again, using colors that are lighter in value than those I would use if I were working on a darker tone, I block in the remaining shadow and sunlit areas of the barn. I use an open side stroke so the color doesn't get too dense at this stage and the light tone continues to show through. I use the same stroke to block in the light green mass of the background mountain. I then delineate the dark cast shadow under the eaves of the roof with a middle-value gray.

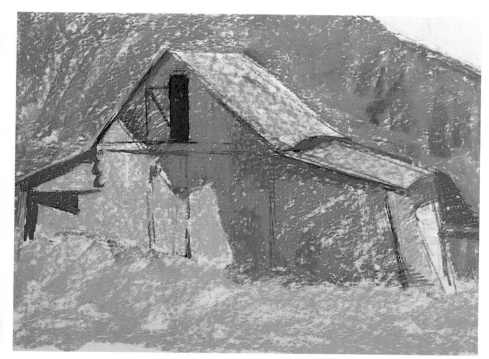

Step 3. I now establish all the local colors in the painting with light, open strokes. This gives me a good sense of the color scheme of the finished painting. The colors are all as yet fresh and unworked and are generally lighter than the colors I'd normally use if the background tone was darker. The painting is still flexible now, and I apply the pastels with light-pressured open side strokes, keeping the colors airy and not cluttering the tooth of the surface with too much pastel. The light background tone still shows through the colors. I block in the red-orange tin roof and solidify the large shadow mass of the barn, putting some ultramarine blue in to keep the shadow cool. I start to bring out the divisions and details of the doors, beams, and individual planks of the barn, again using ultramarine blue to keep these dark color areas cool in color. I then block in the foreground grass using the same warm, light-green color I used in Step 2 to establish the mountain. I then scumble a cooler, darker green over the mountain to make it recede. The small corner of sky in the upper right of the painting is blocked in with heavy pressure to achieve a density through the flat pattern of its light-blue color.

Step 4. At this point I add a variety of strokes and colors to define the foreground grass. I also gently slip some of the light green color into the barn. I put a darker and cooler green in the foreground to indicate a long shadow cast perhaps by some unseen trees, and I also put in some light yellow tans where the grass is less thick and some of the earth shows through. I add some red to the background green to neutralize the mountain and get it to recede still more. I slip some light yellow into the sunlit area of the barn, while in the shadow area I indicate more of the barn's weather-beaten local color, which is a gray with some purple. With strokes that follow the direction of the slanting sheets of tin, I add reds, purples, and warm browns to the roof to indicate rust. The white wall on the side of the barn that is catching a bit of sunlight is painted. Notice how cool the cast shadow is on this white wall.

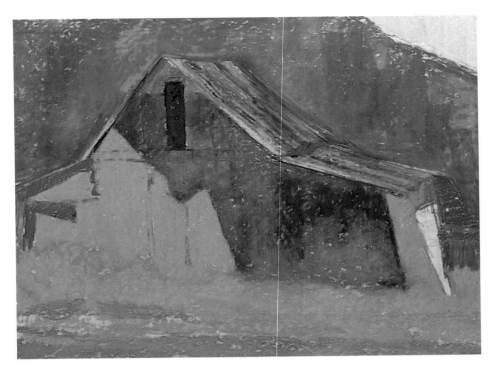

Step 5. To harmonize all the colors, I take a soft, dry bristle brush and gently brush it over every area of the painting with an up-and-down stroke. This brings colors from one area into another while at the same time softening and playing down edges. A general middle tone now prevails and there is an automatic harmony thoroughout the painting. Brushing the pastel like this develops a great sense of atmosphere.

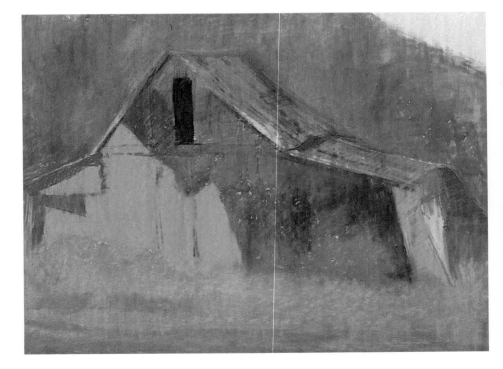

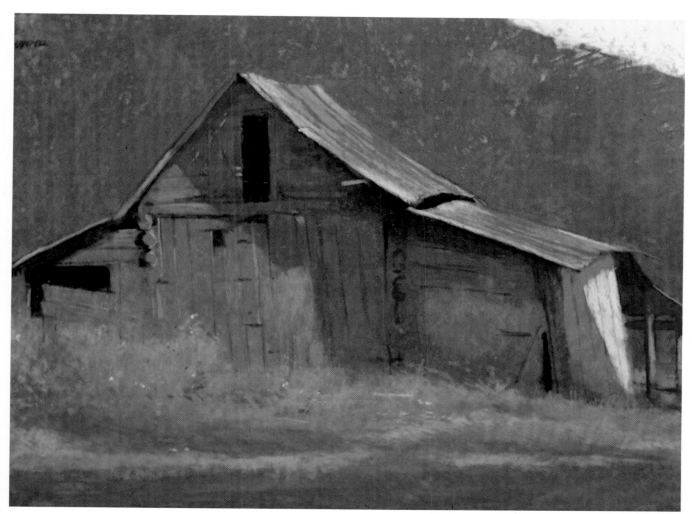

O'KELLY'S BARN. *Sanded pastel board, 18 × 24" (46 × 61 cm), collection the artist.* Because the painting was developed earlier with loose, light strokes, the tooth of the board is not clogged, so reworking the objects with fresh color in the final stage is no problem. Now, finishing the painting is mostly a matter of pulling out and developing important select details. Textures of the old weathered wood are brought out through careful manipulation of various grays, blues, browns, and purples. I also redefine the shapes of the cast shadows. Some light purple color is floated into the foreground green as I work out textures of the grass and field flowers. As I do this, I slightly raise the level of the vegetation in front of the barn, making the barn appear as though it is in front of a slight hill. This slight change in perspective adds age to the structure. I put in details, like the posts supporting the overhang of the old roof, and finish painting the textures and colors of the old tin roof. Details on the distant mountain are suggested rather than stated so it doesn't detract from the foreground barn, where the center of interest lies.

Painting a Portrait with a Complicated Background

Underpainting with Pastel and Turpentine

In *Portrait of Carol* you will see how to change pastel colors into a paint quality to achieve a rich, resinous underpainting. This underpainting is then used to harmonize the multicolored, complicated patterns of the painting. You will also learn how to paint a multicolored, complicated background, and how to harmonize and unify it so it keeps its design element without conflicting with the foreground portrait. In addition, you will study how to paint a portrait in strong half light and how to simplify and relate similar foreground and background values. The harmonizing principle involved will be further demonstrated by the way I use warm and cool colors of the same value in shadows.

Underpainting with Pastel and Turpentine

To underpaint the portrait, I cover all of the color areas with pastel, applying it lightly with open side strokes. Then I dip a clean, soft bristle brush in turpentine and wash the turpentine over each color area. This changes the chalks to a paint quality.

The pastel must be applied lightly to the ground so it only covers the upper layer of the tooth. Then when the turpentine is applied, the color is diluted and spreads evenly over the entire surface. It is also important to note that only the dark color areas of the painting are underpainted with this mixed-media technique. This is because pastel colors become much richer and darker when the turpentine is applied. This does not work well under flesh tones, but it is excellent for middle-value or dark color areas. There it produces a beautiful tone for the pastels to rest upon and adds much to the color brilliance of the finished painting.

Subject and Composition

I prefer to do noncommissioned portraits because they give me the freedom to paint people who appeal to me and to interpret their character as I see it. In *Portrait of Carol*, I wanted to convey the feeling of someone lost in life. Carol's attitude expressed this, and the resulting portrait seems floating in space. The composition is simply the placement of the head and the surrounding similar tones. The dark linear blue patterns of the background rug also act as a frame for the portrait. The portrait and the background rug are near each other but they don't touch, and their juxtaposition is important to the total effect of the finished work. The portrait, which is the center of interest, is not a separate entity but is developed as the entire painting is developed.

Color Buildup in the Light Areas of Portrait

I never use mixed media for the light flesh tones of the portrait. These areas are entirely built up with pastel, and the result is subtle and exciting. The different colors in the portrait are influenced not only by the tone of the light source striking the subject, but by the actual (local) colors on the face. For instance, cheeks and lips are always redder than other areas because there is more blood there. The forehead is yellower because the bone is closer to the surface and there is less blood there. The area below the eyes contains touches of green and blue color.

I begin the underpainting by overemphasizing the colors I see. In other words, I make the red nuances very red, the yellows very yellow and the greens very green. At this moment I'm not concerned about harmonizing and simplifying the values in the light area, but I want to establish strong underlying color tones that will vibrate through the overpainting as the portrait develops.

After I state the colors of the face, I select a flesh color that closely matches the complexion of the sitter and lightly float the color over all areas of the portrait struck by the light. This brings the underlying bright colors into beautiful harmony. I then work toward finishing the portrait by adding the details.

Painting a Complicated Background

Painting a complicated background can present problems. If it gets too busy, the background can distract the viewer from the center of interest. If it contains too many unrelated colors, it can disrupt the general color harmony in the picture. But there is a way to avoid these problems.

To incorporate multipatterned backgrounds into my work, I begin by simplifying the entire area. For example, to simplify a multipatterned oriental rug like the one behind Carol's portrait, I imagine that the entire rug is on a spinning wheel and all the colors are blurring together. The color that dominates is the one I block in the rug with. Here the base color for the oriental rug behind Carol's portrait is red. On top of this red base I establish the patterns and design of the rug, again using strong, pure colors. The job is now to harmonize these colors by adding more subtle tones and details. As I finish the rug I make sure the colors are harmonized, with the underpainted colors only showing through in spots to give an added vibration of color to the finished rug. This procedure can be followed for any complicated multicolored background in a painting: rugs, fabrics, paintings on walls, clutter in rooms, and so forth.

Foreground-Background Relationship: Simplifying Values

In order for a painting to have unity, the foreground and background must relate to each other harmoniously. If their separation is too great, the viewer's eye won't be able to move easily from one area to the next but will be attracted to only one area and remain there.

One way to achieve a harmonious relationship between foreground and background is by keeping some of their values similar. For instance, in *Portrait of Carol*, the shadows on her neck and the section of her hair that is in the light differ only in color; their value is the same. These values are also the same as the overall value of the background tapestry, except for the blue on it, which is darker. This similarity in value relates the figure in the foreground to the tapestry in the background. It also implies that the distance between them is not too great—if it were, the tapestry would have to be significantly lighter in value overall.

Even though the values in these areas were similar, I worked many different colors (of the same value) into the areas and played warm tones against cool for interest and variety. The colors of the shadow on Carol's neck, for instance, are made up of cool grays and blues, while the colors of her hair in the light are warm reddish browns. Also, I muted and neutralized the red color of the rug by adding grays and complementary greens so that even though it is the same value as the hair and neck shadow, its color is quite different. As a result of this treatment, the eye drifts casually in and out of each area, and there is a sense of atmosphere and flow. If I want to direct attention to a particular area, such as the eyes, I can always get the viewer to look there by placing more details and harder edges there.

Lighting: Painting in Half Light

Painting in "half light" means that the model and artist are parallel to the light rays and at right angles to the light source. This position produces strong darks in the shadow areas of the figure that relate more closely to the dark background than they do to any area in light. The entire figure is made up of two dynamic shapes—the figure and the tapestry—of contrasting values. In *Portrait of Carol*, the natural light source was high and to the left, producing the strong shadows on the lower right side of her head.

Materials

Sanded pastel board, 22 × 28″ (56 × 71 cm), toned a light gray
Full assortment of colors: hard and soft pastels and pastel pencils
Pastel fixative
Pure gum spirits of turpentine
Long flat bristle brushes nos. 4 and 6

Step 1. Working on a rough sanded pastel board, I lay out the composition by placing the portrait in relationship to the background rug. I block in the shadow areas of the portrait first. Then, selecting soft pastels that are lighter in color and value than the colors I will eventually end up with, I block in the major color areas of the painting with an open side stroke. I choose this stroke because it will leave open spaces on the tooth of the surface. In step 2, when the pastel is thinned with turpentine, these areas will be covered evenly.

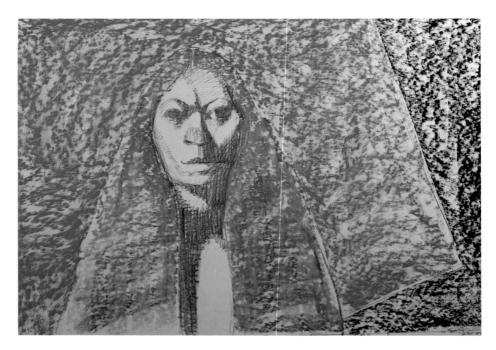

Step 2. Taking a clean brush and fresh turpentine for each color area, I lightly wash over all the color areas, turning the chalky pastel into a paint quality. When the turpentine washes are dry, I begin to build up the color with pastel. I start with the head, strengthening the colors in the shadow areas, and then begin to establish the initial strong colors in the light. I establish the cool highlights and warm shadow areas of the hair and begin to block in the patterns of the rug with a rich blue color. I then spray the pastel lightly with fixative.

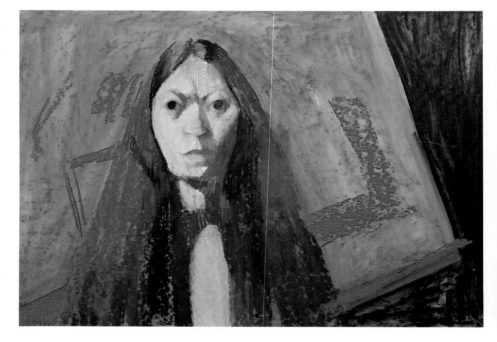

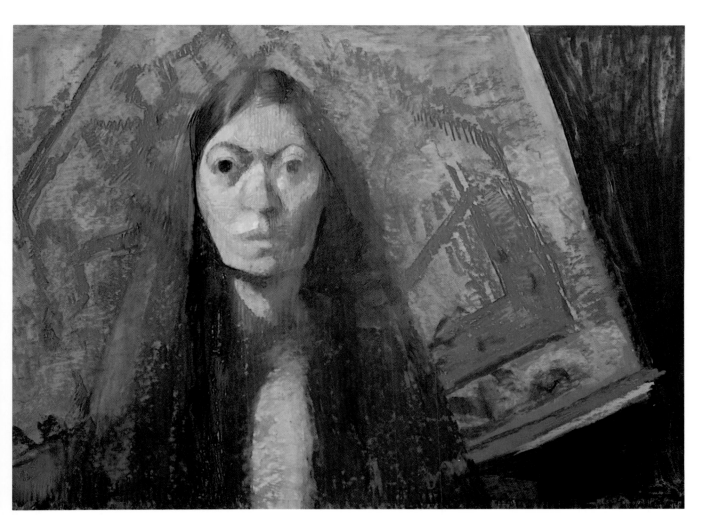

Step 3. At this stage, I add rich colors to both the portrait and the background rug. As I establish the colors in the light areas of the portrait, I overemphasize the colors I see. That is, I make the red of the cheeks very red and a subtle ashen green, a very distinct green. At the same time, the blue patterns of the old rug are laid in with ultramarine blue. I am not concerned that the colors are jumping out of the picture at this point. Instead I make them strong now because I want these rich colors to vibrate through to the overpainting to become part of the harmonic, muted tones of the finished painting. Again, I spray the pastel with fixative until the colors of the painting darken slightly.

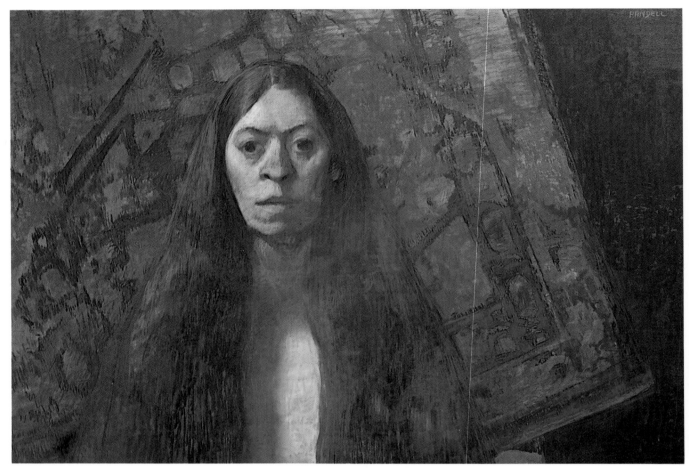

PORTRAIT OF CAROL. *Rough sanded pastel board, 22 × 28"
(56 × 71 cm), collection the artist.* As every area becomes
built up with rich colors, I reach a point where I need to
harmonize them. With a feathery touch, I glaze the entire
portrait very lightly with a Conté pencil. I choose a rich
orange that won't be obvious as a specific color but will be
absorbed into the other colors of the painting. The orange
pencil softens the rich colors, creating the effect of a worn-
out rug in the background, while harmonizing the colors on
the portrait in the foreground. Although the head distinctly
stands out from the background, the orange glaze and
subsequent overpainting with pastel links the two areas. To
add some textural variety to the hair, I paint it with a warm
reddish brown pastel dipped into turpentine. When the
area is dry, I scrape off the excess color with a razor blade.
Notice that although the colors are different, the values in
the light areas of the hair relate to the lighter values in the
tapestry, and that the darker values in the shadow under
the chin and the shadows on the left side of her head relate
to darker values in the tapestry. This creates a flow from
one area to the next while creating a frame for the light flesh
tones in the foreground. As the pastel nears completion, I
continue to develop the delicate colors with soft pastels,
and work into these areas with pencils to accentuate
details. The final painting is composed of layers of color
painted over the initial color lay-in. Some of the strong col-
ors of the lay-in are allowed to show through to give an
added vibration of color to the entire painting.

Direct Underpainting with Color Tones

Underpainting with Casein

The present demonstration, *Portrait of John Greig*, is a complicated study of a figure in an interior. Developing such a painting requires a strong underpainting upon which to build. In this demonstration you will learn how a mixed-media casein underpainting can establish the large color areas of the painting and give you a sense of the color scheme and composition of the painting before pastel is even applied. You will also learn how to vary the application of pastel and manipulate the colors to create exciting textures and color harmony. Finally, you will learn how to keep the work fresh and alive, avoiding the overworked appearance that could result from lengthy pastel painting.

Underpainting with Casein

Casein makes an excellent base for pastel painting. The opaque water-base casein in *Portrait of John Greig*, is thinned out quite a bit before it is applied to the board, to keep the washes slightly transparent. My aim is to establish an underlying tone and color sensation for each area. I also want to avoid a buildup of thick paint, because the textures and colors will be built up and brought out later with pastels. It is important to note that in portraits, I never underpaint the flesh with another medium but develop these areas with pastel alone and let the tone of the board itself act as the underpainted tone.

Underpainting with Diluted Tones

I choose the same colors for the casein underpainting that I will use in the overpainting, but make them weaker and more diluted. Thus I paint the orange couch a weak orange and John's slacks a dark muted brown. The advantage of this type of underpainting is its directness—most of the colors of the finished painting can be quickly established at an early stage. Without an underpainting, working with pastel alone, it would be difficult

to avoid a heavy, clumsy, overworked look in the finished painting. There is only one thing I must caution you about when using casein, and that is to make sure it is not too thick or lumpy. Pastels won't sit well on a dry meaty paint film.

Subject and Composition

There are a number of factors to consider when painting a figure in an interior. Unlike the simple tone behind a portrait, the total environment surrounding a person in an interior must be related to the central figure. This calls for a greater emphasis on drawing and on color, value, and scale relationships. In this case the subject is an intense figure who creates a decisive, intense mood. Therefore the treatment of the surrounding environment must be played down to contrast with and accentuate the subject's strong personality.

In developing the composition, you must also carefully design and relate the shapes and patterns of the foreground and background. Remember that the figure in the foreground is the center of interest and so the shapes there are more important than those in the background and should be the ones most clearly defined, developed, and finished. The background shapes, on the other hand, should be simpler in design so they don't compete with or override the foreground center of interest. Background objects should also be in proper proportion and size to the foreground. For instance, the size of a chair in a background should be smaller than one in the foreground, but large enough to give the illusion that the sitter could walk back there and be able to sit down in it.

Basic Drawing of Subject and Composition in an Interior

To correctly establish the size, placement, and relative proportions of objects, you must note where background objects intersect the foreground fig-

ure. For example, in *Portrait of John Greig*, I noted where the base of the picture frame cut across John's forearm. I also noted that John's head—his left eye and cheek—intercepted the vertical lines of the picture frame and that his upper arm cut off the vertical line of the model screen, and so on. All of these points of contrast are valuable references in measuring and placing the objects, shapes and patterns in the painting.

Foreground-Background Relationships: Flat Patterns vs. Three-Dimensional Forms

You can't treat all areas in a complex interior setting in the same way but must vary your technique from background to foreground to show distance and emphasis. In general, it is best to play down the background and merely suggest objects there, putting the stronger forms and detail in the foreground. One way to accomplish this is to treat background objects as flat patterns and shapes with little or no modeling while treating foreground forms as three-dimensional objects to be modeled and painted with details and accents. In *Portrait of John Greig*, I kept the black drape behind John's head a simple dark shape with no modeling, not even indicating light and shade. The model screen on the right is also simply handled, though its texture is indicated, and the background painting is

reduced to simple patterns. I usually block in these areas with their local colors only, and suggest their forms with their shapes and patterns. On the other hand, I model foreground objects more carefully and in greater detail to attract the viewer's eye to these areas. The more detail an area has, the more the eye is drawn to it and kept there. Notice the three-dimensional depth indicated in John's face and body, compared to the flat patterns surrounding him.

Lighting: Painting in Natural Light

Portrait of John Greig is painted under the steady, cool, natural light of a fine portrait studio. Windows line the entire north and as the light floods into the studio, it progressively lessens in intensity as it travels deeper into the room. North light is a steady light, excellent for bringing out rich nuances or color, especially in the cool light areas of the skin.

Materials

Sanded pastel board, 22 × 28″ (56 × 71 cm), toned a middle-value gray
Full assortment of soft and hard pastels and pastel pencils
Pastel fixative
Shiva casein colors
Flat bristle brushes nos. 2, 3, 5, and 7.

Step 1. At first I am primarily interested in the composition of the painting, in getting the drawing correct, and in placing the figure in relation to the background of the painting, which is the interior of my studio. I must therefore carefully relate the shapes and sizes in the background to John, the center of interest. I also wish to establish a sensation of light and shadow. This is all done with one color, a deep rich, reddish brown hard pastel. Using only one color in the beginning eliminates all the problems of color and allows me to focus in on other concerns—drawing, placement, light and shade—with relative ease. I work with a light hand so I don't fill the tooth of the surface with unnecessary pastel.

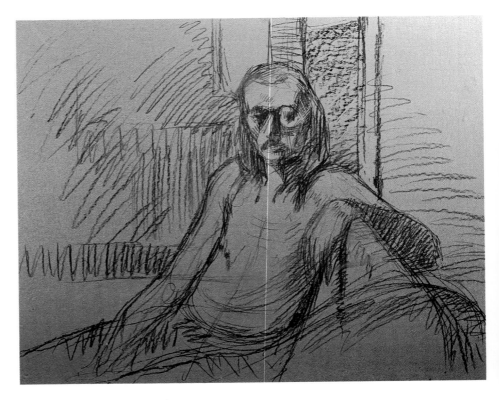

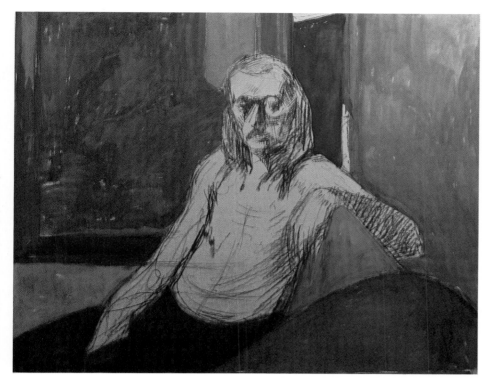

Step 2. I dilute the casein colors with water until they are the consistency of a watercolor wash and, keeping the washes very transparent, I block in all but the flesh tones. The black drape behind and over John's left shoulder is important because it indicates the darkest value in the painting and I can compare other values to it as I develop the rest of the colors. I also establish the black frame, brown pants, green robe, orange couch, and the corner of the model screen on the right.

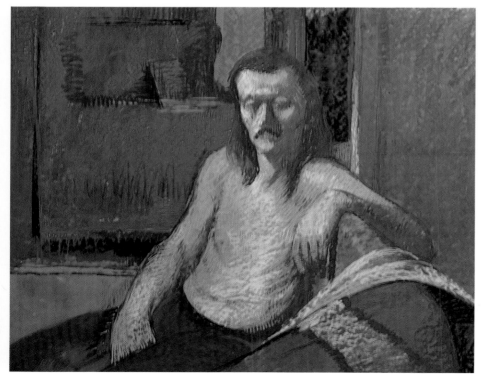

Step 3. When the casein washes are completely dry, every area of the painting is worked over with soft pastels. At this stage the pastels are lightly applied and so the casein washes show through every color in the painting. Now I develop the colors of the face and chest by over-emphasizing them at first. You can see this in the cool bright colors on the right-hand side of the head that flow downward, emphasizing the left-hand side of the chest. The shadow areas, which were lightly blocked in until now, are developed with beautiful rich colors, all of the same value. As I continue to develop the entire picture, I am getting more and more of the pastel buildup of colors and tones. At the same time I am constantly re-drawing and measuring, getting the proportions more accurate. I work on the buildup of the body and head with layers of different colors applied in linear strokes, in different directions. The colors of the body and portrait now stand out from the darker colors of the rest of the painting.

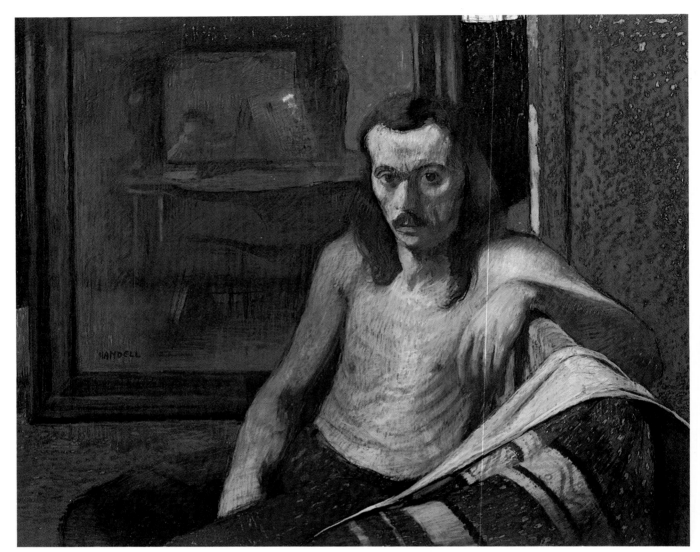

PORTRAIT OF JOHN. *Sanded pastel board, 22 × 28" (56 × 71 cm), collection the artist.* The drawing and proportions of the portrait, including the pose itself, is altered and adjusted slightly with pure, delicate pastel colors. I tilt John's head to the right and lower it slightly. At the same time I lift John's shoulder a bit and completely develop the left arm. These slight changes in drawing alter the attitude of the pose. Now everything is a matter of finishing. I begin with the details of the head, then the chest and background. I again return to the portrait area to bring out additional details. I first harmonize all the color areas by floating a yellow ochre Conté pencil lightly over the entire painting.(I use a Conté pencil because it has a fatter point that the Carb-Othello pencils. It is also somewhat softer, which makes it easier to handle for the subtle work done here.) Starting at the top and moving my way downward, I softly glaze the color over everything in the painting. Details and edges are slightly blurred and all colors are harmonized in a delicate,

hardly noticeable, yellow-ochre veil. I spray fixative over the painting, which makes all the colors become slightly darker. I now work selective finishing details into certain areas: Sharp crisp lines are put into the right eye, and the textures and lights of the forehead are brought to a finish. Dark accents are delicately placed between the fingers of the left hand. The lines between the fingers lead the eye down to the ribs, where the light colors are delicately played down. The floor behind John and the wrinkles of his slacks are darkened with soft side strokes, letting the underbase color vibrate through. The model screen is darkened and the patterns of the foreground robe that is draped over the couch are expressed and finished with a feeling of opacity brought out through the dense use of soft pastels. I then delicately define the shapes in the background painting (a small self-portrait), and define the planes of light and shadow on the molding of the frame.

116

Painting a Self-portrait

Underpainting with Acrylic

I will now demonstrate how to set up and paint a self-portrait. To make this special aspect of portraiture an enjoyable and successful challenge, I will develop the rich colors of the portrait over a mixed-media underpainting. I will also manipulate the pastels to produce various textures.

Underpainting with Acrylic

Acrylic, a water-base paint, can be either transparent or opaque, according to how it is applied. It is quite permanent and, once dry, cannot be dissolved by water (unlike other water-base media). Because of its opacity, rich colors can be underpainted on middle or dark grounds. Since it forms a watertight layer over the surface, the colors aren't absorbed into the board where they can merge with the surface tone and lose strength. Instead, acrylic provides you with a very solid color base to work on in pastel. Again, notice that only the dark color areas are underpainted with acrylic washes to produce large flat patterns whose texture and form will be brought out later with pastel. The light areas of the portrait are too light for underpainting mixed media and so are entirely built up with pastel.

Setting Up a Self-portrait

The simplest setup involves placing a mirror at eye level (to keep the perspective stable), and completely perpendicular to the floor (to avoid distortions of the image). I suggest placing a mirror on an easel or using a large studio mirror on wheels for this purpose. Put the mirror and your painting equipment close together and move them as near the light source as you can because the reflection in the mirror will be slightly duller than if you were working from life. (The farther away you are from the light source, the duller the reflection will become.) Also, position your mirror, painting surface, and colors so that they are illuminated equally by the light source so you can judge your colors correctly.

Working with a single mirror will give you a reversed image of your self-portrait. But if you wish to

do a profile or self-portrait as others see you, you can juggle positions with two or more mirrors to get the proper view. Here, too, always remember to keep the light equal and the mirrors perpendicular to the floor.

Subject and Composition

Painting a self-portrait is a very compelling and emotional experience. Studying your own face for hours on end draws you deep into yourself and as your inner feelings and emotions surface, you begin to know yourself in ways you otherwise may never realize. You can express a profound vision of yourself in a self-portrait, one that reflects how you really see yourself.

My self-portrait is made up of strong patterns of positive and negative shapes. The negative shape (the light cool background) is simple yet frames the foreground in a striking way. The foreground (the portrait itself) contains much variety and textural richness. The hair is a dark, textured mass that effectively frames the light areas of the portrait. The pyramid shape of the clothing leads the eye up to the head, while the flat conical shapes of the ski vest and shirt lead the eye away from the portrait and back to the clothing. The center of interest is the eyes, and the viewer's attention flows from one eye to the other.

Getting a Likeness

To capture a likeness, you must basically get the size, proportions, angles, and distances of the features and head in proper relation to each other. Systematic measuring throughout the development of the portrait, especially in the early stages, is an important step. At first you'll be very conscious of measuring everything, but it soon will become automatic.

Whenever I paint a portrait, I constantly measure and compare everything mentally. It is first important to decide where to place the head on the board, and then to determine its angle: full front view, three-quarter view, or profile. Then you must establish the basic outside shape of the head and

indicate the center line. This imaginary line runs vertically from chin to forehead and divides the nose in half. (The head is easiest to measure correctly when it is in an upright position.)

After I establish the center line, I draw another imaginary vertical line through the face at the inside corner of one eye. The line cuts downward along the nostril and corner of the mouth to the chin, and upward through the forehead to the hairline. I then measure distances on either side of the line and relate them to the line and each other. I also mentally draw a horizontal line through the corners of the eyes and measure how high or low the tops of the ears are compared to this horizontal line. I also check the distance of eyelids and eyebrows from this line and note their shapes. Then I draw a mental horizontal line across the base of the nose and relate the distance of the lower part of the ears, the lips, and chin to it. I also measure and relate the angles of the planes of the head to those lines. If you find mentally envisioning these lines difficult, you may find it helpful to position your easel so that the vertical edge of your drawing board divides the sitter's face in various areas. You can then check the edge of your drawing board and relate features to it, seeing what is directly in line with it, what is to the left or right of it, and their relative sizes and distances. (See also additional hints in Chapter 5 on sight-size measuring.)

Once the initial distances, sizes and angles are determined, I focus on the center of interest, usually an eye. I like to develop it quite a bit and then relate the other features to it. As I develop the portrait, I still continue to measure and readjust these measurements as I work. I then go back to the eyes again and develop more detail in them. At this point the surface likeness should be quite good, and so your concentration can be directed more and more toward an emotional likeness or sense of the person.

Lighting

I painted my self-portrait in natural light which here produces rich colors in an overall middle-tone milieu. The lighting is flat—a direct, even light that brings out the features and complexion.

Materials

Marble-dust board, 16 × 16″ (41 × 41 cm), toned a middle-value gray
Full assortment of hard and soft pastels and pastel pencils
Acrylic polymer colors: cadmium red light, cobalt blue, Mars black
Flat bristle brushes nos. 3 and 5.

Step 1. I lay in the portrait using a number of different colors to block out the planes of the face. I only lightly establish the red and blue ski vest with a few strokes of red, for I know that this area plus the hair will be completely covered with the acrylic underpainting. I block in the beard and hair with black. The shape of the dark hair acts as a frame for the portrait.

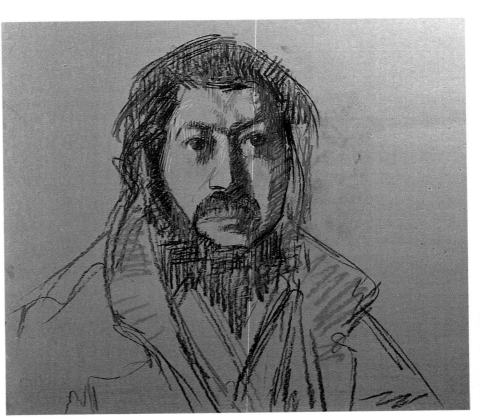

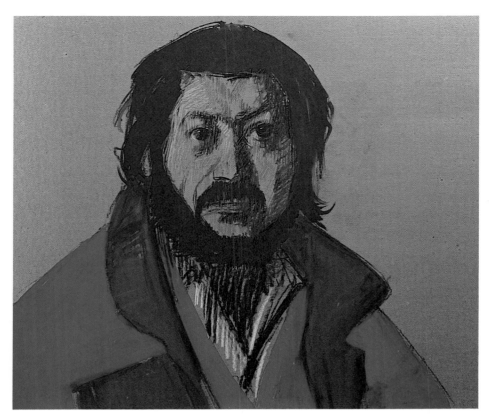

Step 2. Diluting the acrylic so it can be applied in thin washes, I block in the shape and design of the ski vest with cobalt blue and cadmium red medium. I use Mars black for the hair and beard, keeping the edge of the acrylic block-in away from the face so that the hairline can remain soft and flexible so I can adjust it later with pastel. The black acrylic paint works as a very solid underpainting for the pastel, giving it a density and variety that will be kept to the finish. I work on the portrait a bit, laying in the basic colors of the underpainting and deciding where I'll place the features.

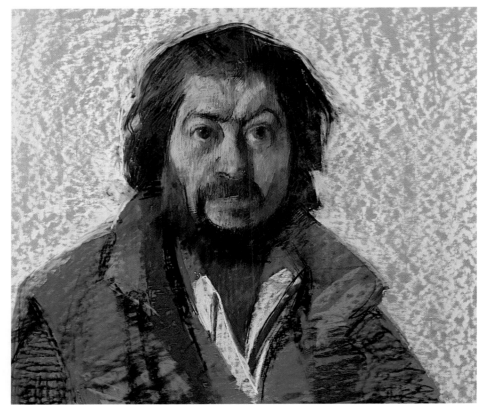

Step 3. I now establish pastel over every area of the painting to get a sense of pastel throughout. I start feeling my way around the background with a few open side strokes, using a cool light blue. I don't want the background to have a heavy, dense blanket effect, so I leave the stroke open to let the cool gray tones of the original surface show through. Here in the middle stages of the pastel buildup, I develop the likeness and three-dimensional form of the portrait using strong colors, still measuring all the time. I begin by developing the planes of the forehead and the eyes. The eyes are important, especially as a reference point for relating other features. This helps to develop the likeness. As I further develop the upper half of the portrait, I leave the jaw alone for the moment. I will later relate the jaw area to the upper areas of the head.

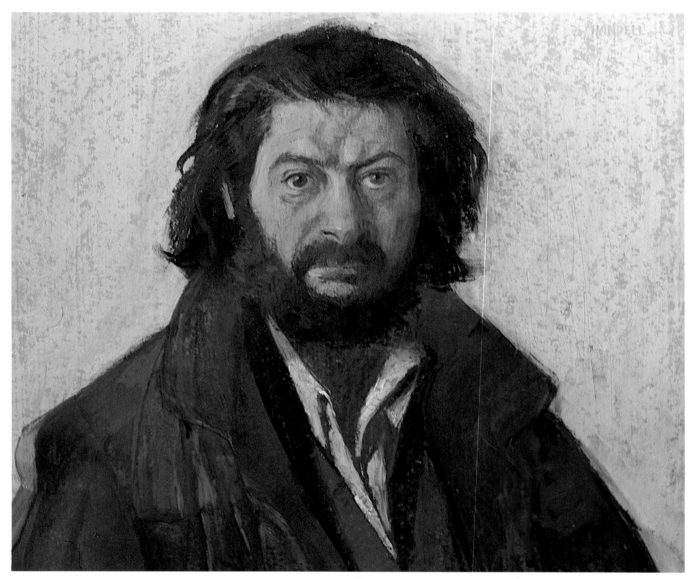

SELF-PORTRAIT. *Marble dust board, 16 × 16" (41 × 41 cm),
collection Vivienne Hodges.* As I continue to develop the
portrait with pastel, I adjust the drawing and proportions to
refine the likeness. I lower the forehead and eyes just
slightly and raise the chin and mouth a touch. Immediately
the proportions improve and the likeness gets stronger.
The pastel is still quite loose and flexible. I reestablish the
eyes and forehead and work down the nose to the mus-
tache, lips, and lower jaw. Notice that I design the shape of
the face in relationship to the shape of the hair and beard.
These major shapes are important to the initial impact of
the likeness. I also continue to develop the colors of the
head, incorporating the color lay-in of Steps 2 and 3 into
the final layer of pastel. I reinforce the reds in the cheeks
and nose, work oranges and yellows into the forehead
where the bone is closer to the skin, and slip greens into the
shadow colors of the cheekbones. I finish the white shirt
and ski jacket. Then I float light gray colors into the back-
ground, still using an open side stroke. The initial color
lay-in and original surface tone vibrate through. I finish the
portrait by putting select details, accents and highlights in
the eyes.

Working with Colors of Contrasting Values

Underpainting with Transparent Watercolor

In the present demonstration, *Winter Trees,* we will see how transparent watercolor produces a rich, luminous underpainting. This time I will use contrasting colors in the initial block-in that will later be harmonized in the pastel overpainting. My subject, winter trees in sunlight, is excellent for illustrating these concepts.

Underpainting with Transparent Watercolors

Transparent watercolors have a richness of color that contrasts beautifully with the opacity of the pastels. The watercolor is flowed onto a surface, making sure the wash is very thin and free of lumps. When using transparent watercolor washes, a light-toned surface is recommended because it best reflects the transparency of the colors. A darker surface would absorb the colors more and thus dull them so that watercolors would lose their transparent quality.

Working with Contrasting Values

My approaches to underpaintings vary according to the particular problems of each painting. I may want the underpainted tones to be close to the colors of the finished work, as in *Portrait of John Greig,* where they worked to establish the color scheme of a lengthy painting. Or I may want the underpainting colors to complement the final overpainting, as in Demonstration 8. Or, as in the present demonstration, I may want to block in the colors of the underpainting in different values from those of the finished work. For instance, I use a darker blue for the sky, which forces me to work with lighter blue pastels over the watercolor wash. At the same time, I block in the background trees with a lighter color than they really are, which will make me work with darker pastels later. Using a contrasting value in the underpainting calls for added thought and manipulation of color as the painting is developed and harmonized. But the

advantage is that it gives me extra time to put in all the color variations and subtleties as I develop and harmonize the colors of the painting. The process of joining and harmonizing color areas that are quite different from the final effect often adds much depth to the work, as it does here in *Winter Trees.*

Subject and Composition

Trees, especially the leafless trees of winter, are one of my favorite subjects. The beauty of their silent existence inspires me and I spend many hours observing, drawing, and painting them. I chose to focus closely on the two trees of the present demonstration to express the textures of their bark and the rhythms and movement of their trunks. Their patterns of light and shadow and subtle colors further emphasize these characteristics. The aerial (distance) perspective in this painting is also a special challenge, calling for subtle variation in the intensity of the colors of the foreground trees to background to create a sense of the distance between them.

The composition is based on the shapes of the two trees and the design they create against the background. The interlocking relationship between these vertical trees also adds to the shapes and patterns they create. The whole painting has a vertical feeling due to the upward growth of the trees. The close values of the winter sunlight colors combined with the contrasts of the cast shadows create even more shapes and patterns within the basic design of the foreground trees.

Lighting: Late Afternoon Winter Sunlight

In winter, the days are short and the light changes rapidly. While doing a series of winter tree paintings last year, I decided to work at the same exact time every afternoon to study the effects of light during those hours. I learned that winter sunlight in late afternoon is soft and cool, producing soft delicate shadows. As the sun gets lower in the sky, the

sunlight becomes weaker and warmer in color. The soft shadows, especially those of the top planes, are very blue as they reflect the blue sky. As in this painting, the upright shadows of the trees are soft browns, grays, and purples, reflecting the local colors of the tree trunks.

Palette

I used an outdoor pastel palette for this painting, with colors carefully selected to describe the lighting conditions of winter. I used soft pastels in particular to capture the textures of the trees.

For the sky I used the lightest tone of cobalt blue, no. 512.9, and for the background trees in sunlight I used a deep yellow ochre, no. 227.3,

combined with raw sienna, no. 234.3, plus lighter tints of these colors. For the foreground shadows on the trees I used a combination of burnt umber, no. 409.5, plus raw umber, no. 408.5, plus a cool bluish gray (which simply is called "gray"), no. 704.5. Of course I modified these areas with other colors, but these are the basic ones I used.

Materials

Sanded pastel board, 16 × 24″ (41 × 61 cm), light buff tone
Outdoor pastel palette, as described above
Watercolor: cobalt blue, cobalt violet, raw sienna, and Van Dyke brown
Soft, flat nylon watercolor brushes nos. 2, 4, and 8.

Step 1. To achieve the effect of a cold winter day, I start to compose the painting in a cool color, an olive green. I decide where I will place the trees, then I draw them on the board. Once I establish the light and shadow patterns on the trees, I have a good sense of the tonal structure of the painting and am ready to block in the entire painting with watercolor washes.

Step 2. When the color washes of the transparent underpainting are completely dry, I pastel the foreground trees with various browns. I also develop the internal rhythms of the two trees by accentuating flowing lines in their bark. I plan to overpaint all areas of the painting with pastel without completely covering the watercolor underpainting. With an open side stroke, I apply a very light blue pastel over the dark blue sky, getting the color close to the final effect and producing a lovely texture as well. Then I redefine and develop the shapes of the background trees and indicate their patterns against the winter sky. Selecting a pastel with a yellow ochre tint, I run the pastel over the raw sienna underpainting of the background trees with an open side stroke. The colors and textures of pastel now begin to dominate the painting.

Step 3. I squeeze out cobalt blue, cobalt violet, raw sienna, and Van Dyck brown from tubes of watercolor, putting a different color in each of the many small compartments encircling the edges of the watercolor palette. (I prefer a John Pike watercolor palette because it has so many compartments for mixing colors.) I then dilute each color in its compartment with lots of water so the colors can be put on as free-flowing washes. I make the cobalt blue sky a shade darker than I plan to end up with, and the background trees (raw sienna) a shade lighter and warmer than they will be eventually. Their cast shadows are a diluted purple (cobalt blue and cobalt violet). I also use a diluted mixture of raw sienna and Van Dyke brown in the foreground trees, with purple and Van Dyke brown shadows. I now have a sense of the painting's color scheme.

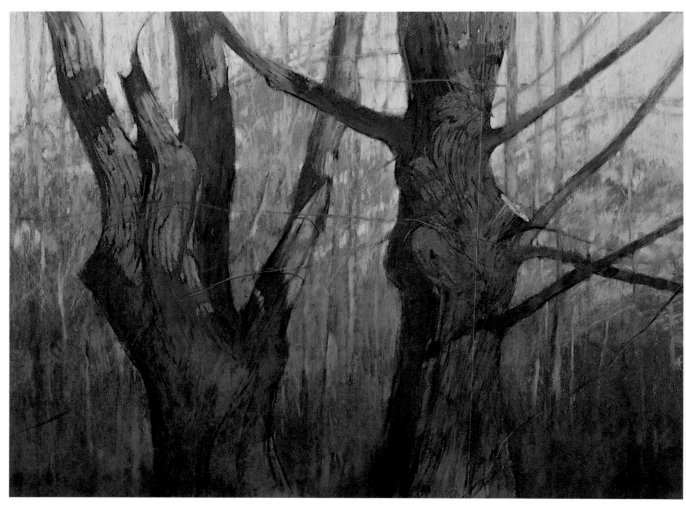

WINTER TREES. *Sanded pastel board, 16 × 24" (41 × 61 cm), private collection.* The color harmonies are developed and carried to a finish using soft pastel colors. As the details are indicated, all the colors of the painting become subtler and darker. The background trees are made to recede as more grays and purple tints are added, helping to capture a sense of distance and atmosphere. The details and textures of the foreground trees are finished with strong rich colors. The meaty bark textures of the tree trunks in the lower foreground are brought out with heavy applications of soft pastel.

Harmonizing Complementary Colors

Underpainting with Tempera

The preceding demonstrations have dealt with a variety of concepts that combine methods of painting in general with aspects particular to pastel. For example, expressing values accurately and translating these values into color, as shown in the first three demonstrations, are essential to successful realistic painting in all media, not only pastel.

In the present demonstration, *Hutchins Hill,* I will show you how a tempera underpainting of contrasting complementary colors can be harmonized through the development of subsequent layers of pastel. In a way this represents much more work than other methods, but it also gives you the opportunity to put more into a painting.

Underpainting with Tempera

The complementary underpainting of *Hutchins Hill* is done in this demonstration with tempera paint. Again I remind you that commercial tempera paint today is known as poster paint and is available in most art supply stores. The opaque tempera in the underpainting of *Hutchins Hill* is first diluted with water and then applied to the board in thin color washes, creating strong contrasting complementary colors of great brilliance. I use orange for the warm-toned, reddish water and a cool blue-gray for the dark-brown rocks.

Using Complementary Colors

The contrast of complementary colors is both an advantage and a disadvantage. The advantage is that, although a contrasting underpainting requires you to work harder in the overpainting to harmonize your colors, it also offers you the opportunity to work longer on your painting and get more subtleties. Also, the complementary colors will show through the overpainting to add their color vibrations to the finished work.

The disadvantage is that the contrast between the two complementary colors can be so great that you can have trouble bridging the gap between them in developing and finishing the pastel. But should this happen, try again. As you gain more experience in the medium, you will have less trouble tackling this challenge.

Subject and Composition

Rocks and water running over streambeds are favorite subjects of mine. The endless variety of rock shapes, forever changing under different lighting conditions and fluctuating water levels, offers me an endless source of study.

After a heavy storm, in the fall of 1979, the streams in my area ran orange with silt for several weeks. I was studying streams at the time and suddenly my world was changed from green and dark blue water with light-value colors reflecting the brilliant sky overhead, to orange and warm brown reflections. The effect on color pattern was immediate. It also inspired this pastel.

I decided to build the composition of this painting through the shapes and patterns of the rocks and water, with the white patterns of the snow adding an extra dimension. I defined the planes in the rocks with decisive pastel strokes. The large rock that is the center of interest is firmly placed in the upper center of the picture, leading the viewer's eye there.

I used rhythms to get a sense of movement. For example, everything above the rocks in the upper portion of the picture (such as the water and distant rocks) moves horizontally. On the other hand, in the lower two-thirds of the painting, the water swirls and flows in circular shapes, its natural flow blocked by the horseshoe shape produced by the lower rocks and white snow. This shape encases the water and at the same time leads the viewer's eye to the center of interest. The shapes of the rocks and snow contrast with the horizontal rhythm and movement of the water and the distant rocks.

Through this sharp contrast, the rhythms and movement of each area are complemented and intensified.

Lighting: Overcast Sky, Late Afternoon

Hutchins Hill was painted on location on a winter afternoon. There was no direct sun that day, so there were no strong patterns of light and shadow to break up the patterns made by the rocks and water. The overhead light from the sky was diminishing as I worked on the painting, so I put some blue-gray into all the colors, especially the top planes of the rocks, to express the effect of this light.

Materials

Sanded pastel board, 16 × 22″ (41 × 56 cm)
Full palette of pastel colors: soft and hard pastels and pastel pencils
Tempera poster paints: Payne's gray (a blue-gray) and cadmium orange deep
Long, flat bristle brushes nos. 2, 5, and 7.

Step 1. I lay out the important shapes of the painting, using one color, a warm-brown hard pastel. I build the composition around the center of interest, the large rock. I place the large rock high in the picture to give me enough room to design the shapes of the lower half of the painting to lead the viewer's eye to the center of interest.

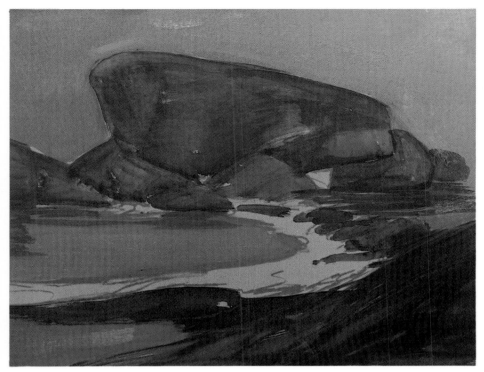

Step 2. Diluting cadmium orange deep tempera with water, I block in the large flat shape of the water above and below the center of interest. Then, diluting Payne's gray with water, I paint all the rocks. This cool bluish-gray color has an element of blue in it that contrasts beautifully with the orange of the water. I wait for the underpainting to dry before beginning work in pastel.

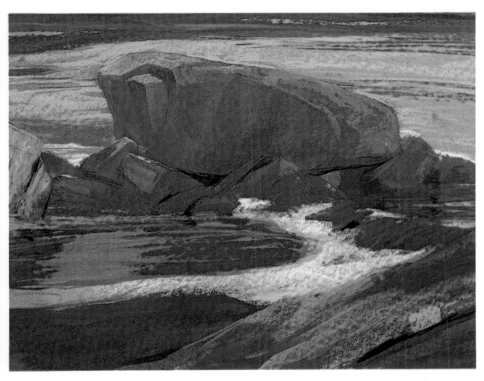

Step 3. Working with various brown and gray colors, I begin to harmonize the two basic color areas of the painting, the rocks and the water. They are separate from each other but are beginning to relate harmoniously. I develop detail in the foreground rocks with dark brown colors. I then define the planes of the foreground rocks. The side plane on the left of the large rock is developed with raw umber and blue grays. The top planes of the rock are painted with lighter blues and light blue grays to reflect the coolness of the overcast day. I develop the water with gradations of oranges and reddish browns. I also drift warm dark browns into the rocks, and cool browns and grays into the water. The areas are still clearly separate but are less isolated from each other now.

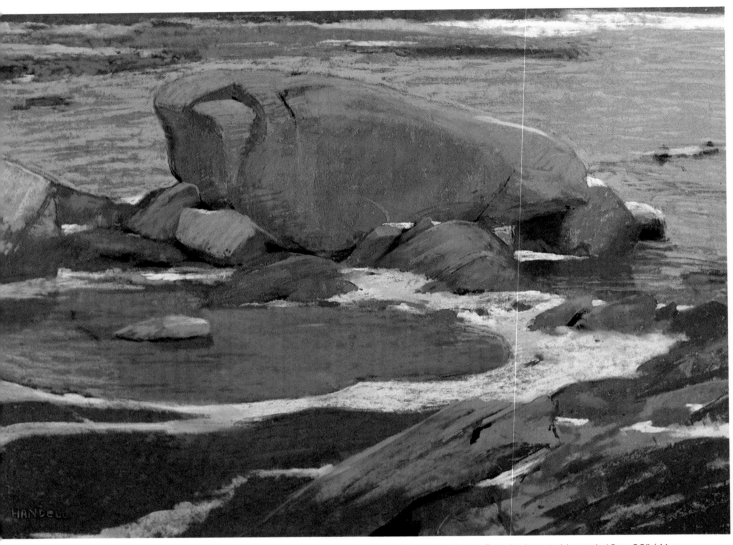

HUTCHINS HILL. *Sanded pastel board, 16 × 22" (41 × 56 cm), private collection.* The painting is finished with pastel and makes good use of the tempera underpainting. I continue to add subtle details in the rocks. I also define the white snow more accurately and make it more important to the design of the painting. I keep working to harmonize all the colors in the painting and add details as the overall tone of the painting becomes cooler and subtler. The colors of the finished painting represent the cool color harmony of a cold, overcast winter day.

TREES ALONG GLASCO TURNPIKE. *Sanded pastel board, 16 ×
22" (41 × 51 cm), courtesy Gallery of the Southwest, Taos,
New Mexico.* I have drawn and painted watercolor studies
of these trees many times. But the light was so special this
particular winter afternoon that, even though I was enroute
to another painting location, I just had to stop when I spied
these trees. The painting was done on the spot, with just a
bit of reworking and finishing in the studio. Although the
foreground tree stands out from the background, the val-
ues and colors of both areas are much the same — except
for the darks in the foreground tree. Those darks — plus a
few lighter colors, which bring out the details and textures
on the trunk—bring the tree forward and separate the fore-
ground from the background.

Appendix

Making Your Own Materials

Artists have a strong curiosity as to how artists' materials are made. At times they also feel they can do a better job of making their materials than manufacturers by adding fewer extenders and more pure color in their pastels. Making the chalks themselves thus gives them complete color control. The following are recipes for making pastels and other materials.

Making Pastels

With the extensive variety of excellent pastels on the market, I see no necessity to make your own. However, pastels are relatively easy and economical to make and the experience gives valuable insight into the medium itself. It teaches you to mix colors, to realize what consistencies mean, and to strive for strength and richness in making pure color. Somehow the mysteries of the medium become less intimidating as you acquire a knowledge and understanding of its composition. The materials required and more detailed instructions can be found in Ralph Mayer's *The Artist's Handbook of Materials and Techniques* (Viking, 1970), but basically the procedure is as follows:

Materials. The materials for making pastels are shown in Figure 1. They include:
Gum tragacanth, dry pigments, whiting or precipitated chalk (calcium carbonate, gypsum)
Palette knives of various sizes
Glass jars, measuring spoons, measuring cup
Mortar and pestle (usually not essential with today's finely ground pigments)
Nonabsorbent surface (glass or marble slab)
Newspapers
Distilled water.

Procedure: Mix a weak solution of gum tragacanth and water in a glass jar or bowl. This mixture will be used to obtain the purest colors. To obtain lighter tones of the same color, place part of this mixture in a separate jar to form a white base. Add 50% titanium white and 50% calcium carbonate and mix thoroughly to a doughy consistency. To make darker pastel colors, make a dark base by mixing the gum tragacanth solution with ivory black. Mix a third solution of just gum tragacanth and water and keep in a separate jar. Keep all three solutions very liquid. Placing a wet rag over the mouth of the jar before sealing will help prevent loss of moisture.

Forming the Pastel into Sticks. Mix measured proportions of pigment with each mixture until the color is uniform. Roll and knead the mixtures on the blotter to absorb excess water and remove air bubbles. Shape the sticks into desired forms and allow them to dry. To insure thorough drying, bake the sticks for ten minutes in a moderately low oven.

Experimenting with the different colors and different amounts of gum tragacanth will teach you much about them. For instance, most earth colors contain more clay than, say, the cadmiums, and will mix differently with varying amounts of the gum tragacanth solution. With experience, you will learn how much pigment to use.

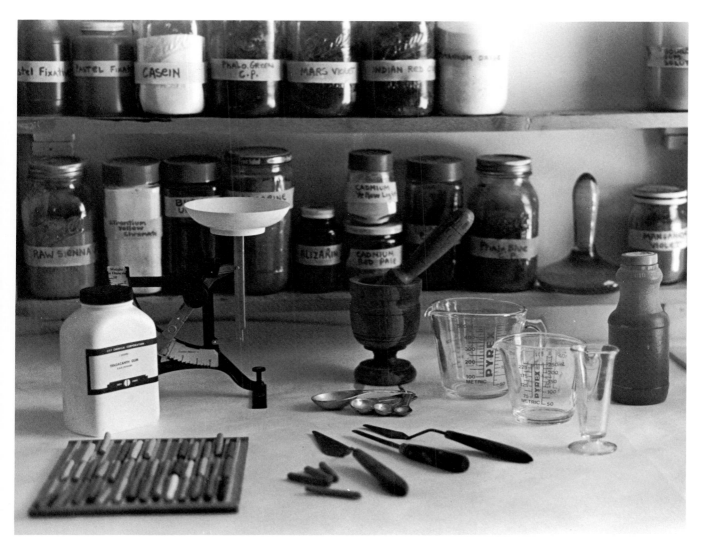

1. Materials for Making Pastels. Clockwise from the left: gum tragacanth, a scale for solids, a wooden mortar and pestle for grinding pigments, three different-size measuring cups, a bottle of gum tragacanth solution (you'll probably need to make several bottles of gum tragacanth solution of varying strengths), palette knives, and a tray of homemade pastels. Jars of color pigments are located on the shelves behind the materials described.

Making Marble-Dust Boards

Even though these excellent surfaces are no longer commercially available, you can prepare your own. Marble dust comes in many different qualities. Always use the finest grade. It can be purchased by mail from the Mohawk Company in Amsterdam, New York. Quartz or other hard, fine-powdered substances can be substituted.

Materials. Materials, shown in Figure 2, are:
Marble or quartz dust
Acrylic gesso
Water
100% acid-free, rag museum board, ¼ to ½" (64 to 127 mm) thick (illustration board, Masonite panels, or mat board can also be used)
3" (75 mm) housepainter's brush or commercial spray gun
Glass jar or can
Measuring cup
Hand eggbeater.

Procedure. Mix a tablespoon (15 ml) of marble dust into a quart (1 liter) of gesso. Stir the mixture well with the eggbeater, and slowly mix in half a cup (about ⅛ liter) of water into it. Keeping the panel flat, brush the mixture onto the surface with the housepainter's brush. The mixture can be brushed on evenly or unevenly or can be sprayed on with a commercial spray gun to create the even surface that I prefer. Allow the first coat to dry before applying a second. Apply as many coats as you wish until you have the texture on which you will want to work.

Varying the Tooth. The preceding proportions will give you a smooth-textured marble-dust board. For a rougher texture, add another tablespoon of marble dust. For an even grainier surface, you can add up to four tablespoons (60 ml) of marble dust. You can also make sanded pastel boards using a similar technique (Figures 3 and 4).

2. Materials for Making Marble Dust Boards. The above materials are needed to make homemade marble dust boards. 100% museum rag board is the surface to be prepared. Always use the heavy stock rather than the thin sheets. The materials resting on top of the rag board are: 3" (75 mm) house brushes, an electric paint spray gun to achieve even surfaces, acrylic gesso, and finely ground pumice stone. The Rainbow brand pumice stone shown here can be found in most large hardware stores, and is much like a heavy talcum powder. Rotten stone, finely ground marble dust, or finely ground quartz can also be used instead of pumice stone.

3. Materials for Making Homemade Sanded Pastel Boards. Sanded pastel boards can easily be made at home with the above materials. Use 100% museum rag board, cut at least ½″ (13 mm) larger than the piece of sanded paper to be mounted. When mounting stained sanded paper, turpentine-base stained papers can be stained before mounting; water-base stained papers must be stained after mounting to avoid buckling. The Blair Spray Stik shown above with the roller-type squeeze used to smooth out the mounted surface is one of several types of spray photo mounts on the market.

4. Adhesive Materials for Making Sanded Pastel Boards with a Dry Mounting Press. This heavy-duty dry mounting machine rests on a strong, flat table. The papers mounted to boards in this manner are adhered to the surfaces with an adhesive tissue called Fusion 4,000 Tm. It comes in rolls as pictured above, or can be purchased in sheets. It has the advantage of being able to be made resoluble to correct mistakes in mounting placement.

Toning Boards

Basically the same procedure can be followed for toning both papers and boards. But more care must be taken with papers because they're thinner and more vulnerable to wrinkling or buckling when wet solutions are applied to them.

Toning Marble-Dust Boards. For a toned surface, a tone of diluted acrylic paint can be added to the gesso mixture before it is brushed on. Or when the board is completed it can be toned by brushing on a light-colored wash of acrylic or oil paint.

Alternate Methods. Although the above method is the one that I follow and find most successful, alternate methods also produce fine results. One is to coat the board with a strong glue solution of gum tragacanth or starch paste and sprinkle the marble dust onto the board. Additional methods and information are given in Reed Kay's *The Painter's Companion* and in Max Doerner's *The Materials of the Artist and Their Use in Painting* (see Bibliography).

Toning Papers

The only papers I tone are the sanded pastel papers, since they are manufactured only in a buff color. There is no need to tone Canson paper because it already is available in so many shades. To tone sanded pastel papers I use *oil* washes diluted with turpentine, and never have a buckling problem. But since *water* will cause the surface to buckle, I only use water-base stains like casein or acrylic to tone boards. The materials I use to make transparent turpentine stains are in Figure 5.

Procedure. To tone papers with oil paint, mix a color in a clean empty coffee can with lots of pure gum spirits of turpentine, making sure there are no lumps left in the oil paints. Test this mixture out on a scrap of mat board before applying the stain. Then, place the sheet of paper or board face up on a flat surface. Dip a large 3″ (75 mm) brush into the stain and brush it onto the surface. For an even tone use horizontal strokes, sweeping with an even, steady pressure across the surface. For an uneven tone, cover a portion of the surface or make a shape with the stain. Next, dip a clean 3″ brush into clean turpentine and brush over the entire surface. A beautiful uneven tone will be achieved. You can even vary the uneven tone by combining different tones in this manner on the surface. Or you can splatter the toned surface with turpentine and tilt the paper or board, allowing it to drip and form patterns. I find toning surface this way an exciting way to create inspiring backgrounds for paintings. Some of the color combinations I find successful are:

1) black with turpentine,
2) raw umber with turpentine, and
3) black and raw sienna.

This same procedure should also be followed for water-soluble paints, like casein, acrylic or watercolor. But you must remember to mount the paper to prevent its buckling. Should there be buckling, however, then after the tone is applied and is thoroughly dry, and before you start working with pastels, have the paper dry mounted onto 100% rag acid-free museum board, and the wrinkles will disappear.

5. Materials for Making Transparent Turpentine Stains.
Turpentine-base stains for sanded pastel boards and papers can be made, using various forms of colored pigments, which are mixed into and diluted in the turpentine. Pictured above are: tubes of oil paints (any brand will do), jars of powdered pigments, powdered pigment as purchased from Fezardie and Sperle, Inc. (111 Eighth Avenue, New York, N.Y. 10011) and a can of Min-wax stain. Also needed is pure gum spirits of turpentine, empty cans and jars for mixing the stains, 3″ (75 mm) house brushes, a wooden spatula for mixing stains, and an electric spray gun if you wish to spray on the stains instead of brushing them. The materials are resting on sanded border and papers to be stained.

Making a Pastel Tray

On top of one of my studio tables is a pastel tray I specifically designed to hold my pastels (Figure 6). It is constructed of ¼" (6 mm) tempered Masonite and measures 3 × 4' (1 × 1.3 m). The Masonite's smooth surface prevents dust becoming imbedded into it. The board is divided into four equal compartments and there is a raised border around all the edges to keep the pastels from rolling off. The procedure for making such a tray is basically simple.

Materials. The materials needed, shown in Figure 7, are:
¼" (6 mm) thick, tempered Masonite
½" (13 mm) stripping
Elmer's glue
Wood clamps
Hand saw.

Procedure. Cut four pieces of stripping to fit around the edges of your Masonite board. Glue them on with Elmer's glue and clamp them down until dry, which should take about half an hour. Then cut crossbars of wooden stripping to divide the board into four equal compartments, and glue and clamp them onto the board. The compartments will keep the pastels grouped and organized. (For additional information on how to organize the pastel painting palette in these compartments into warm and cool colors and light, dark, and neutral tones, see Chapter 6.)

6. Pastel Tray Setup (*opposite, top*). My studio setup includes my homemade pastel tray, with its three compartments, plus tiers of duplicate soft pastel backup colors (shown here on the left). I also keep small boxes of duplicate colors most often used close at hand. Brushes of various sizes, a pencil sharpener, masking tape, charcoal, and fixative are also kept where they can be easily reached when needed.

7. Materials for Making a Pastel Tray (*opposite, bottom*). This pastel tray with its three compartments is like the one I made and use. The materials pictured above needed to make such a tray are: a ¼" (6 mm)-thick sheet of Masonite 24 × 30" (61 × 76 cm) or any other size you prefer, a hand saw, strips of ½ × ¾" (13 × 19 mm) parting stops to be used as a frame and for partitioning the pastel palette, Elmer's (or other) wood glue, and clamps.

Making Painting Racks

Painting racks provide ideal storage space for relatively small areas. The 1 × 2" (25 × 50 mm) strips of furring that separate the upright areas into compartments, are set 12–14" (31 × 36 cm) from each other. Racks are useful for storing finished framed works that are ready to be shipped to shows. They're also good for holding paintings in progress and for keeping canvases and sanded papers mounted on drawing boards. You might wish to hang draperies across the face of the racks to protect the paintings from accumulating dust. My painting racks are pictured in Figure 8.

STUDIO RACKS. (*opposite*). *Oil on Masonite panel, 24 × 30" (61 × 76 cm), collection Mr. and Mrs. David Lowe.* This painting was done while I was living in Salt Lake City. At the end of each day, some sunlight would slip into the studio, throwing off my values but adding visual excitement. I did several drawings first, before I tackled this pastel. It's important to understand the construction of a complicated subject like this before beginning to paint it.

8. Painting Racks (*below*). These racks are in my Woodstock studio. They reach from ceiling to floor and are divided horizontally to give me two levels upon which to rest canvases, drawing boards and frames.

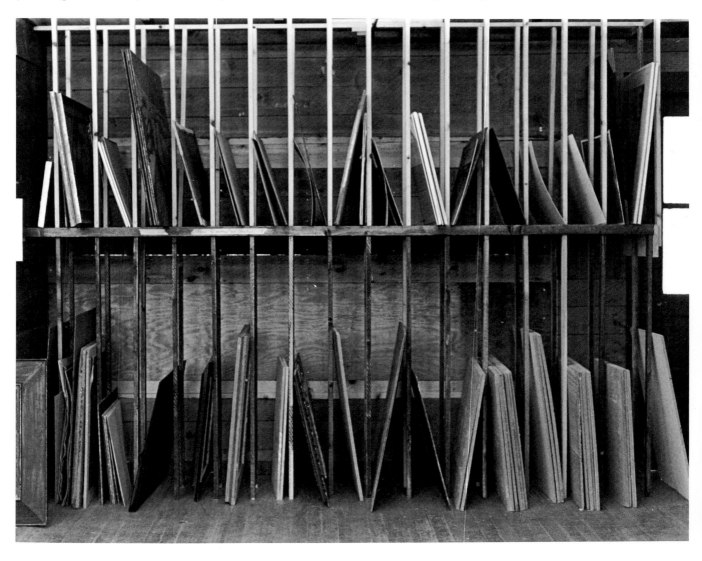

Making Fixative

Instructions for making fixative are found in Ralph Mayer's two books, *The Artist's Handbook of Materials and Techniques* and *The Painter's Companion,* and in Max Doerner's *The Materials of the Artist and Their Uses in Painting* (see Bibliography). I also have my own procedure, which I will share with you.

Materials. The materials I use in making fixative, pictured in Figure 9, are:

Casein
Measuring spoons
Dismantled air brush or a mouth atomizer
Glass measuring cup
Distilled water
Cooking pot
Alcohol.

Procedure. Soak ½ oz. (15 cc) casein in 5 oz. (148 cc) water for six hours. Add ammonia, drop by drop, constantly stirring until the soaked casein has dissolved into a thick, honey-like mass. (If you use household ammonia, you will require greater amounts of it because it is not pure.) Add a cup (0.26 liters) of alcohol, mixing it in well, and then add enough water to bring the total liquid level to one quart (0.95 liters). (If isopropyl alcohol is used instead of pure alcohol, the solution will turn distinctly pinkish.) Filter the mixture before bottling it. After the fixative has been standing for a while, fine particles may fall to the bottom of the bottle. If that occurs, pour off the liquid without disturbing the residue and discard the deposit. The fixing strength of this solution may be greater than you required, so test it first before applying it to your painting. Then dilute it with water until it is weak enough to avoid undesirable color changes.

9. Materials for Making Casein Pastel Fixative. The above materials, from left to right, are: casein, two jars of the finished product, measuring spoons, a dismantled air brush for applying the fixative to the pastel surface (a mouth atomizer can be substituted for this), a glass measuring cup, a bottle of distilled water, a cooking pot, and alcohol. The jars on the shelves behind the fixative materials are pigments used in making pastels.

Bibliography

Boggs, Jean Southerland. *Portraits by Degas*. Berkeley and Los Angeles: University of California Press, 1962.

Browse, Lillian. *Degas Dancers*. London: Faber and Faber, n.d.

Bullard, John E. *Mary Cassatt Oils and Pastels*. New York: Watson-Guptill, 1976.

Cooper, Douglas. *Pastels by Degas*. New York: The MacMillan Co., 1953.

Doerner, Max. *The Materials of the Artist: And Their Use in Painting*. New York: Harcourt Brace and Company, 1949.

Frank, Frederick. *The Zen of Seeing, Seeing/Drawing as Meditation*. New York: Vintage, 1973.

Gauthier, M. *Watteau*. New York: Thomas Yoseloff, 1960.

Greene, Daniel E. *Pastel: A Comprehensive Guide to Pastel Painting*. New York: Watson-Guptill, 1974.

Julien, Edouard. *Lautrec*. New York: Crown Publishers, Inc., n.d.

Kay, Reed. *The Painter's Companion*. Cambridge, Mass.: Webb Books, 1961.

Mayer, Ralph. *The Artist's Handbook of Materials and Techniques*, 3rd ed. New York: Viking Press, 1970.

Richmond, Leonard, and J. Littlejohns. *Fundamentals of Pastel Painting*. New York: Watson-Guptill, 1978.

Savage, Ernest. *Painting Landscapes in Pastel*. New York: Watson-Guptill, 1970.

Sears, Elinor. *Pastel Painting Step-by-Step*. New York: Watson-Guptill, 1968.

Singer, Joe. *How to Paint Figures in Pastel*. New York: Watson-Guptill, 1976.

―――. *How to Paint Portraits in Pastel*. New York: Watson-Guptill, 1972.

Valéry, Paul. *Degas-Manet-Morisot*. New York: Pantheon Books, 1960.

Werner, Alfred. *Degas Pastels*. New York: Watson-Guptill, 1977.

Index

Edited by Bonnie Silverstein
Designed by Jay Anning and Jim LaTuga
Graphic production by Hector Campbell
Set in 11-point Helvetica light